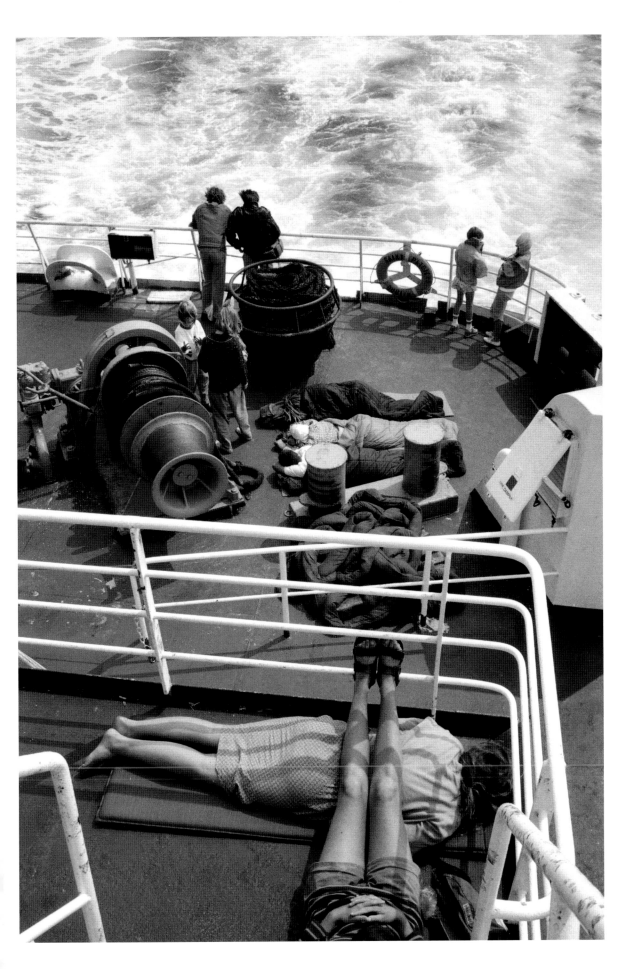

Jean Gaumy. On the ferryboat from Le Havre to Ireland, July 1989

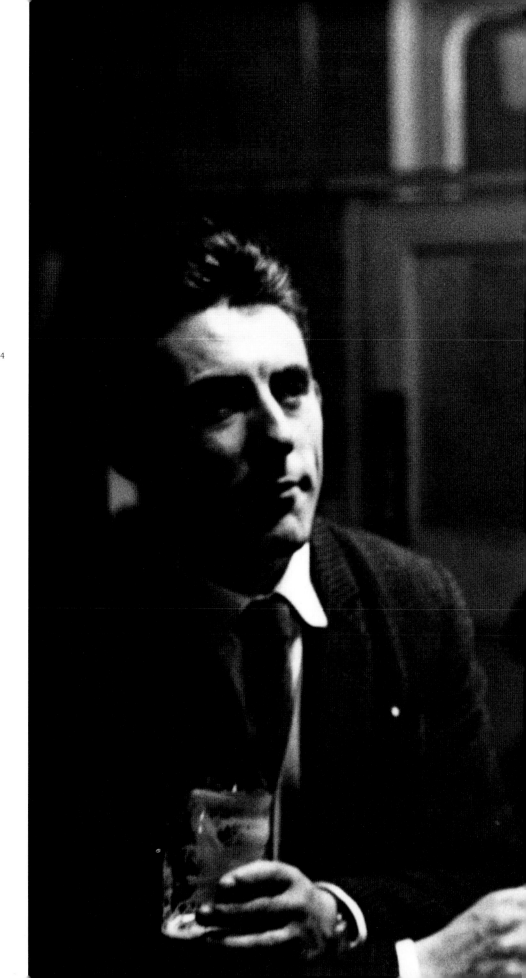

Erich Hartmann. Joyce's 'Bloomsday' ballad singers in a pub, Dublin, 1964

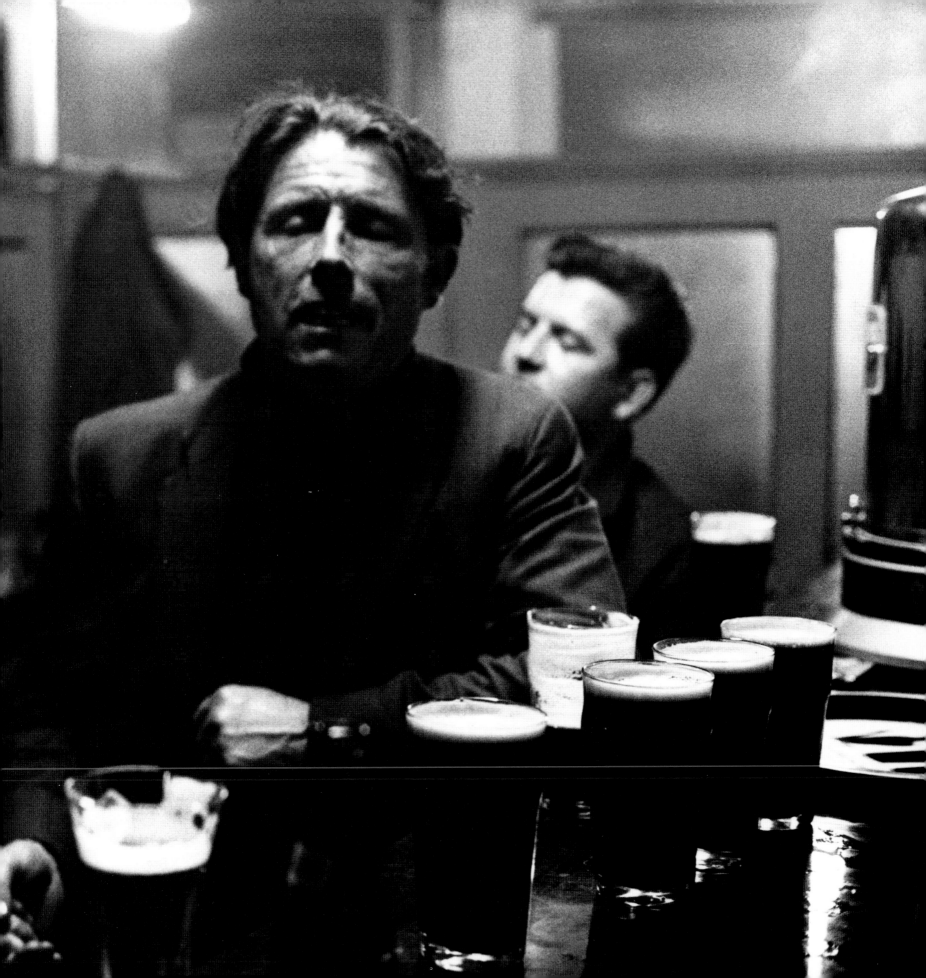

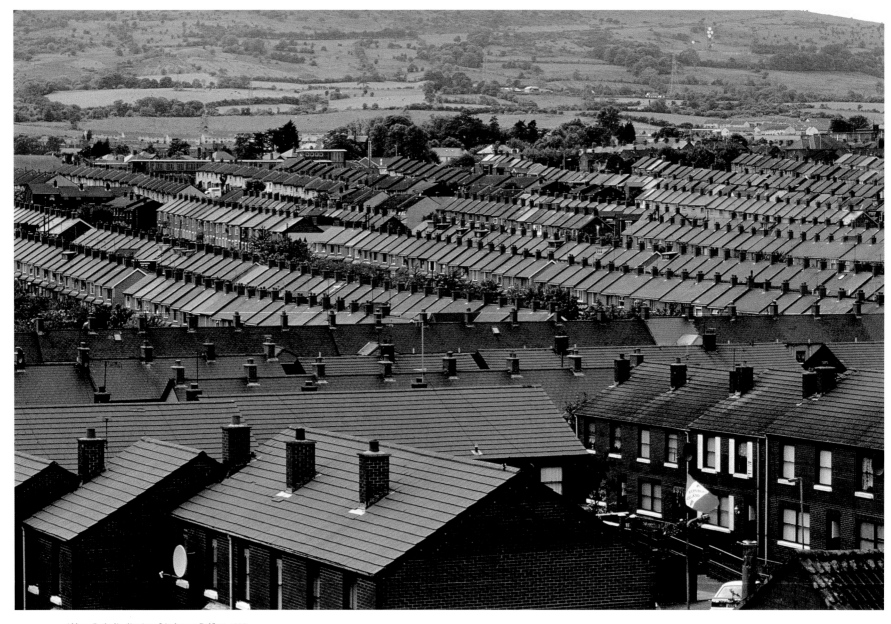

Abbas. Catholic district of Ardoyne, Belfast, 1997

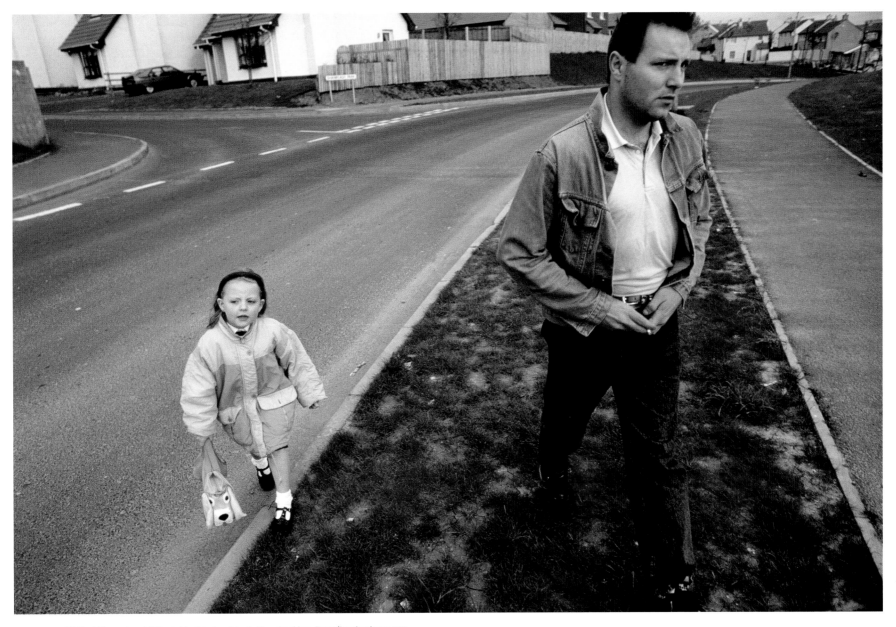

Eli Reed. Unemployed father taking his daughter to the school bus, Derry/Londonderry, 1991

following page
Harry Gruyaert. Galway, 1988

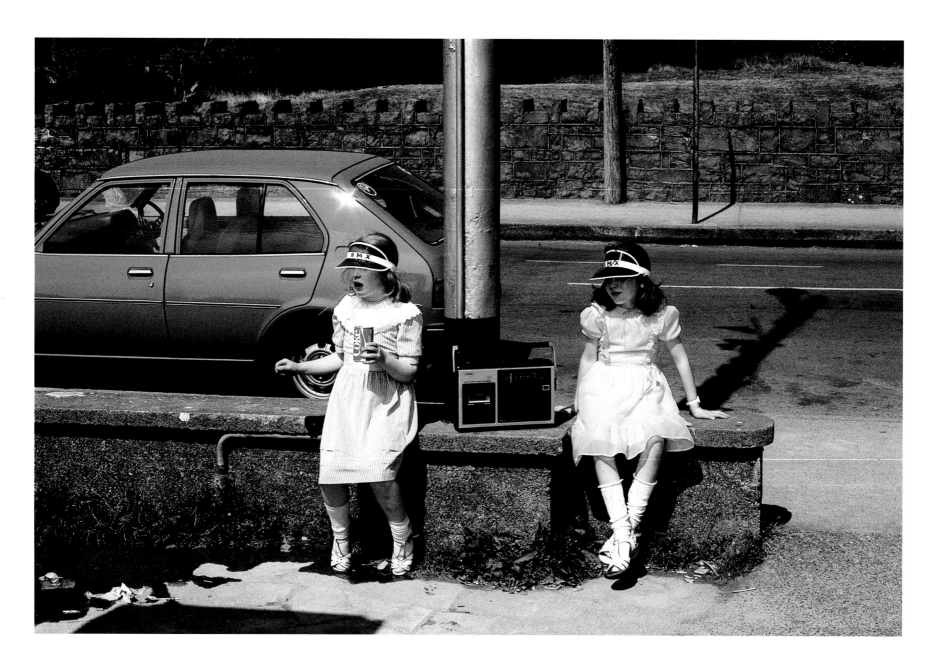

Introduction by John Banville

Magnum Ireland

Edited by Brigitte Lardinois and Val Williams

With essays by Anthony Cronin, Nuala O'Faolain, Eamonn McCann, Fintan O'Toole, Colm Tóibín, Anne Enright

With 236 photographs in color and duotone

Thames & Hudson

First published in hardcover in the United States of
America in 2005 by Thames & Hudson Inc.,
500 Fifth Avenue, New York, New York 10110

thamesandhudsonusa.com

Library of Congress Catalog Card Number
2005900273

ISBN-13: 978-0-500-54303-0
ISBN-10: 0-500-54303-8

Printed and bound in Germany by Steidl

Contents

Preface

The idea for this book, and the exhibition it accompanies, came about during a visit by Brigitte Lardinois to the Irish Museum of Modern Art. She told me that there had never been any collaboration between Magnum and IMMA, and I came up with the idea of a group show of works by Magnum photographers, taken in Ireland. I was sure that we would find many unfamiliar treasures. Brigitte reacted extremely positively to the idea and left with the plan of assembling images and finding out if the photographers of the agency would be willing to participate. Subsequent meetings took place and a wealth of material was found, way beyond my expectations, by Magnum members including Eve Arnold, Henri Cartier-Bresson, Raymond Depardon, Elliott Erwitt, Josef Koudelka, Inge Morath and Marc Riboud.

Conflict, political and social, attracted the attention of many of the Magnum photojournalists while in Ireland. As one would have expected, there are many especially strong images of the Troubles in Northern Ireland. Other images record a disappearing way of life, as Ireland becomes increasingly affluent. The photographs of Erich Hartmann from the 1960s, for example, seem to have come from another age or place, while recent images by Martin Parr are like humorous critiques of contemporary society. Other photographers, such as Donovan Wylie, coincidentally the only Irish-born member of Magnum, focus on a darker side of society through his subtle political statements.

Among the earlier discoveries, there is a group of powerful images of the shipbuilding yards in Belfast from the '50s by Erich Lessing and peaceful views of Dublin in the '60s by Cartier-Bresson. In general, there are more images of people than landscape, although the contexts of these portraits are both urban and rural. The most striking feature of this book and exhibition, however, is how different all of these visions of Ireland are, and how unstereotypical. These visions may reflect, in some cases, a nation's traumatic past, but in doing so, also deal with the universal dilemmas of the human condition.

The images have been grouped in chapters which correspond to decades from the 1950s onwards. These chapters include introductory texts by some very well known Irish writers, which complement the images of the photographers by adding both a literary and local perspective: I would like to thank John Banville, Anthony Cronin, Nuala O'Faolain, Eamonn McCann, Fintan O'Toole, Colm Tóibín and Anne Enright for their immediate willingness to participate in this project. I would like to thank Brigitte Lardinois as well as Val Williams for all their help in the development of the exhibition. I would like to thank everyone at Thames & Hudson for the publication of this very beautiful book – the beginning, I'm sure, of a fruitful relationship. Finally I would like to thank all of the photographers participating for the energy and unique vision which they have brought to our shores.

Enrique Juncosa
Director, Irish Museum of Modern Art

Foreword

When Brigitte Lardinois and Enrique Juncosa, Director of the Museum of Modern Art in Dublin, first discussed an exhibition of the work of Magnum photographers in Ireland, they decided that the value of the project lay in the archaeology of the archive. While the peace process is still holding in the North and the economic boom faltering in the South, it seemed an appropriate time to take stock. Thus began the exploration of Magnum's rich photographic record of the country – a record that serves as a visual history of Ireland's rapid social and cultural change, and at the same time shows the evolution of photographic practice in the second half of the twentieth century.

Magnum Photos is an international co-operative of sixty independent photographers founded in 1947, with members elected from all over the world, so contributors to this book hail from many European countries as well as from Iran, Japan and the USA. Given that the Irish excel as writers, it seemed appropriate to invite key figures from Irish literature and journalism to complement the photographs taken by the members of Magnum.

The number of photographs of Ireland in the Magnum archives is vast, and they date back to the early days of the agency. Some of the photographers spent prolonged periods in Ireland. Elliott Erwitt has been back and forth for countless commercial shoots; Martin Parr lived in Ireland for two years early in his career; other photographers visited either for editorial assignments or, like Josef Koudelka, to work on wider personal projects. Belfast-born Donovan Wylie is the only Irish member of Magnum.

For this book many pictures have been unearthed. From the thousands of pictures in the archive we have selected 236, illustrating almost six decades of Irish history. Much of the work shown here has never been published before, or appeared many years ago in newspapers and magazines. Curator and writer Val Williams was invited by Magnum to work with Brigitte Lardinois on the selection of the photographs, bringing to the project her expertise and knowledge of photographic history.

It was exciting to find colour work made in the 1950s by Inge Morath, and satisfying to be able to find a context for a set of Erich Lessing's small black and white vintage prints of 1950s ship workers at the Belfast Harland and Wolff yard. Earlier this year, the last surviving founder of Magnum, Henri Cartier-Bresson, died. The final contact we had with him was when we received his selection of lyrical portraits of everyday Irish life.

From Bruce Davidson's previously unseen series on the Duffy Circus which travelled Ireland in the 1960s, to Philip Jones Griffiths' never-before published colour photographs of the Twelfth of July celebrations in Belfast, when the Troubles had not yet erupted and children from both sides of the sectarian divide helped to build bonfires as a neighbourhood event, many stories conjure up visions of a world which has disappeared. It was a challenge to edit the enormous amount of material in the Magnum archive from the North, with the conflict at its height in the 1970s and 1980s. The large selection of hard-hitting black and white images of the Troubles taken by Abbas, Ian Berry, Bruno Barbey, Leonard Freed, Chris Steele-Perkins, Philip Jones Griffiths and many others accounts for only a fraction of the holdings from this period.

The depiction of the economic boom of the 1990s is represented by photographs made by Stuart Franklin, who has photographed Ireland extensively, and culminates in a series made specifically for this book by Carl De Keyzer in 2005.

The book ends with a colour sequence of prison cells in Donovan Wylie's Maze project, quietly contemplating this controversial and historically layered space. The now empty Maze prison is soon to be converted into a huge sports and leisure centre, catering for both sides of the community.

The writers commissioned to contribute to this book each have a distinct voice, they share their delight in and concern for their homeland with us. We thank them for their generosity and commitment, especially John Banville, who guided this part of the book with insight and balance. We thank the Magnum photographers who so generously gave of their time and who found work that was previously unknown to the archive. We would like to thank the staff at Magnum London, specifically Sophie Wright, Nick Galvin and particularly our Project Manager Emily Field, without whose painstaking organization we would often have been lost. Thanks also to Christine Redmond from Dublin and Luke Dodd, Director of the *Guardian* newsroom in London, who gave valuable support and advice. We thank Enrique Juncosa, for his initial and ongoing support for this project and to the staff of the Irish Museum of Modern Art for their work on the exhibition that will accompany this publication. The advice and guidance given throughout by Des McAleer has been invaluable.

Brigitte Lardinois and Val Williams

Introduction: John Banville

Time fits itself with remarkable readiness to the divisions we impose on it. The decades, those arbitrary intervals, may leak into each other at either end, yet they have an eerie way of making their individual stamp. The 1960s were wholly different from the 1950s, even if the famously swinging decade did not properly begin until it was a third or so of the way through its calendar term. What flower child in the Age of Aquarius would have foreseen the ferocious 1970s? And in the 1970s, who would have anticipated the end of the Cold War between East and West at the close of the 1980s or, in the 1990s, the onset of a distinctly warm one between the fundamentalist versions of Islam and Christianity?

Perhaps it is not Time that observes the ten-year rule, but something in ourselves, a decimal limitation hard-wired into human sensibility that is triggered at the end of each decade and sets us casting about in search of change. Or it may be that what seems change to us is no more than a ripple in the changeless continuum, a shadow of the wind upon the sea. September 11th 2001, the date on which the 2000s had their true inauguration, set the airwaves abuzz with chatter of new endings and old beginnings, as history, which less than a decade earlier had been pronounced by the new New Hegelians to have definitively concluded, lurched into bloodied life again. Suddenly the tragic note was re-sounded –

> *The broken wall, the burning roof and tower*
> *And Agamemnon dead*

– but was anything different, really? No doubt the few who survived the sacking of Troy believed that nothing would ever be the same again, but ah.

The great upheavals that convulsed eastern Europe at the beginning of the 1990s had a less reverberant but distinct echo over here at the far western extremity of the continent, where monolithic Ireland, fixed fast for half a century in the thraldom of confessional state-hood, began a rapid transformation, succinctly charted by Colm Tóibín's essay here on that excitable final decade of the old millennium. The Catholic Church was the first pillar of state to totter – of state, yes, for the Church in Ireland, as many of the essays in this book demonstrate, had been for centuries as much if not more a political than a spiritual institution; indeed, as we have subsequently discovered, the Holy Ghost, which for long we had thought our reigning spirit, turned out to be a rare bird indeed within these shores.

The ecclesiastical power-failure in Ireland was precipitated by media revelations of scandals within the Church, scandals which, as indicated in Fintan O'Toole's and Colm Tóibín's forensic examinations of the 1980s and the 1990s respectively, the Church authorities had succeeded in covering up for decades even though many people, including many journalists, knew of them. Why the long, forbearing silence over the doings of peccant bishops and paedophile priests, and why suddenly the rush to print? Besides the draconian libel laws under which they were compelled to operate, Irish newspaper editors since the foundation of the state in the 1920s had gone in fear of being on the receiving end of what used to be called a 'belt of the crozier', that is, a public rebuke from one of our princes of the church, who were among the most powerful and arrogant public figures in the country, or were so until the early 1990s, at least. One could lose one's job at the wave of an episcopal wand. However, even Ireland felt a waft of the winds of change that blew across Europe after the toppling of the Berlin Wall. There is no exact equivalent in the English language, or in the Irish, for the word glasnost, but suddenly things were being said aloud in Ireland that we had thought we would never hear uttered in public.

The unfolding of events in Ireland is never a rising curve but rather a series of bumps, at each one of which we feel a jolt like that which the sleepwalker experiences on being violently awakened. Something occurs, and opening our eyes and expecting to see our known and cosy if somewhat stifling bedrooms, we find ourselves instead teetering on a vertiginous staircase in the midst of unfamiliar and electric light. The rude awakenings the Irish spirit has suffered over the past fifteen years have been both unnerving and invigorating. In a country so spellbound by religious and secular authority, the shocks we experienced throughout the 1990s and into the 2000s might have been expected to precipitate a national trauma, but no: roused from the sleep of centuries, we rubbed our eyes, gave ourselves a shake, and went on down the stairs to join the wild party that had begun in the rest of Europe at the end of the 1980s, even if, on the way down, as Anne Enright suggests in her essay on the present decade, we are afflicted by an uneasy sense of all that we have lost by having gained so much.

If this sketch of how we have handled our recent history smacks of approval, it is not intended to be so. It might be suggested, to put it no more strongly, that the fact that there has been no crisis in Irish public consciousness following the revelations of clerical scandal and widespread political corruption is an indication not so much of maturity as of moral laxity. Was it ever otherwise? As Anthony Cronin suggests in his elegant essay on the decidedly inelegant 1950s, it was neither the Church nor the State that the

intellectuals of those days considered the enemy, but the Irish people themselves, sunk as they seemed to be in 'suffocating conformity and stasis'.

In recent times we Irish have discovered in ourselves, to our intense bemusement, a depth of cynicism hitherto barely suspected. Or perhaps cynicism is not quite the word. We do take the long view. Contemplating the Church and State upheavals of the past fifteen years, many would echo what Zhou Enlai is reputed to replied when asked if he considered the French Revolution to have been a success or a failure: it is too early to say. An Irish novelist who lives in the heart of the country reports a neighbour remarking apropos the revelation of some new Church enormity, 'Ah, it was always the same; first it was the druids and now it's this lot.'

New wealth washes at old memories. In the lush 2000s, so perceptively portrayed here by Anne Enright, it is easy to forget how meagre life was before we became a major exporter of computer software and Viagra, and how that meagreness persists in the darker pockets of the Irish psyche. The people in Inge Morath's photographs of rural Ireland in the 1950s would hardly recognize as their direct descendants the partying youngsters depicted by Stuart Franklin in the Dublin of 2003, yet when one looks closely at both sets of pictures one easily sees the family resemblance: there is the same tentativeness of expression, the same faintly desperate dreaminess, the same longing, the same air of having been, to echo Philip Larkin, pushed to the side of their own lives. Part of the legacy of so long a colonization – the first Anglo-Norman robber barons crossed from Wales to Ireland in 1169 – is our sense of deracination within our own country. The language we speak is not our own, even after a century and a half of English: listen to any Irish conversation, at whatever class level, and you will clearly hear the suppressed melodies, as well as the hesitations and disjunctions, of the deep grammar of Gaelic.

Only the dourest curmudgeon would deny the improvements that have occurred in Irish life since the 1950s – or, indeed, since the 1960s, for Ireland, as Nuala O'Faolain tells us, took a long time before it began, ever so tentatively, to swing – even if those improvements were expensively bought. At the beginning of the third millennium the young know a freedom, intellectual, spiritual, financial, that their parents would not have allowed themselves to dream of. So what, the young will say, if the price is high? Nothing will come of nothing, as Shakespeare's very old king observed.

Northern Ireland is the chronic illness that has been afflicting the Irish body politic for the past three and a half decades, and which has been there for far longer than that, if one counts the centuries before 1969 when the cancer lay more or less dormant. Eamonn McCann's account of what we call the Troubles – the Irish have a special gift for euphemism: World War Two was known here as 'The Emergency' – is an upbeat take on a terrible time in the North in the 1970s. His version of the '70s sounds remarkably like what the '60s were for other, less riven societies. Change comes tardily in Ireland; as Nuala O'Faolain nicely observes, our 1960s were embedded in the decade that preceded it, and it might be said that the '60s did not properly arrive for us until the '70s. Recent Irish history can be dizzying to contemplate.

The release of energy in Northern Ireland in the '70s which McCann celebrates had its effects in the South. Yes, we sang, some of us, the IRA recruiting songs, yes, we burned, some of us, the British embassy – but did we know what we were doing, what a terrible beauty, in Yeats's by now clichéd formulation, we were helping to unleash? The South's indignation over the North's torments did not last long. As the photographs here of the Northern struggle show all too clearly, violence has an awful sameness to it. When you have seen ten street riots you have seen them all. Yet something of the pathos persists, even now. The pictures of all those young men and women, hardly more than children, most of them, in their flares and flowered shirts, heaving stones and Molotov cocktails at British soldiers, the majority of whom, for their part, were hardly older than their assailants, are a testament to waste – wasted energies, wasted opportunities, wasted lives.

Just as we impose order on Time, so Time in its turn imposes order on our past, as Eamonn McCann wisely observes. Photography is a temporal medium, but one that stills Time. Yet a flick through the fragmentary moments collected here provides a kind of kinetic vision, a peep-show display, of five and a bit decades in the life of a country – or two countries, depending on the shade of your politics. Roland Barthes suggested that the peculiar potency of the photograph rests in the fact that the people in it are dead, or soon will be. At the end of this book, Donovan Wylie's empty rooms, pregnant with presence, have the look, appropriately, of last things, last places – us or those curtains, one or the other will have to go – the final spaces awaiting Cartier-Bresson's children of the 1950s and Stuart Franklin's young party-goers of the 2000s alike. All go into the dark. Let us be thankful for these remnants of the light of other days.

'50s

Henri Cartier-Bresson

Erich Lessing

Inge Morath

The '50s – Anthony Cronin

Stagnation is the word the Russians use to describe the Brezhnev era. There is no agreed descriptive term for the 1950s in Ireland. But James Joyce's word for the Ireland of his own youth and young manhood might be as good as any: the diagnosis he arrived at was paralysis.

And a time traveller from 1904 might almost have thought that in spite of two world wars and a revolution of sorts no cure had been found for the condition Joyce had identified. The 1950s was at least the last decade in which Joyce's Dublin, the Dublin of 1904, was immediately and visibly present to the visitor stepping off the boat at Dunleary or the North Wall. True, the trams whose routes were so lovingly listed in *Ulysses* had disappeared in favour of double-decker buses at the close of the war. The Harcourt Street railway line, another favoured Dublin institution, commemorated in Samuel Beckett's *Watt* and *All That Fall*, did not fall to the economist's axe until the great railway massacre of 1958. The axing of the trams and the Harcourt Street line was progress. When both were restored together early in the new millennium, that was progress too.

But if the trams were gone for the time being, Dublin still presented the same aspect of past elegance and present decline that it had in 1904. Nelson stood on his pillar, his hand on his sword hilt. Brown Thomas and Switzers still catered to those whom the advertisers were still inclined to call ladies and gentlemen of fashion. And within a few yards of the main thoroughfares were the evidences, and sometimes even the smells, of poverty. The little streets that Yeats had feared a half-century before would soon be 'flung upon the great' in violent revolution still knew their place. There were small shops in the meaner streets which sold everything from coal to bacon in the minutest quantities, enough coal for a night's firing, a few pence worth of tea or sugar, five Woodbine cigarettes for tuppence. The surviving tenement streets and squares, Cuffe Street, York Street and, on the north side, Henrietta Street, North Great George's Street and Mountjoy Square, still looked much the same as they had when Sean O'Casey was writing his great plays in the 1920s. There were the same yawning doorways, the same much broken Georgian fanlights, the women gossiping on the steps, the swarms of chanting children spilling out on to the pavements and even into the traffic; in Ezra Pound's phrase, 'the unkillable children of the very poor'.

Pawnbroking, the recourse of the very poor and often of the would-be respectable too, was a flourishing business still in the 1950s. It was also a deeply traditional one. Most pawnbrokers hung out the three brass balls on an iron rod which was the ancient sign of their guild. The receipt you got was written with an iron-nibbed pen dipped in black ink dried by a sprinkle of sand. Clothes were pawned on a Monday and redeemed on Friday and Saturday for Sunday wear, smaller garments being parcelled up together and not identified on the receipt. 'Articles green' the pawnbroker would cry out and the clerk would write accordingly. There was little shame attached to such transactions and the pawnbroker was usually regarded as a friend in need.

What social progress there was proceeded convulsively, in fits and starts. When De Valera had come to power in 1932 his government had created industrial employment and embarked on large re-housing schemes with such speed and apparent determination that the *Irish Independent* and some of the bishops spoke of communism.

But time which slows the fleetes had not had overmuch trouble slowing the pace of social change. By 1948, Dev had been there for sixteen years, a European record for a democratically elected politician. Both the cabinet and the front bench of the principal opposition party were composed entirely of grizzled veterans of 1916 and what Dev's *Irish Press* had christened 'The War of Independence'. The pace of change varied from non-existent to minimal. In 1948 Dev's Fianna Fáil government had been succeeded by a coalition which included a new party, Clann na Poblachta, widely regarded as a radical new departure. Its leader, Seán MacBride, the son of a 1916 rebel, John MacBride, and the legendary beauty Maud Gonne, had been brought up in France and had a French accent. Perhaps for that reason rather than his own record as a Republican activist and successful lawyer, he had some glamour and a vaguely progressive aura.

Pronouncing – or not pronouncing – his r's in the French manner, he had promised policies would reflect 'Ch'istian justice, Ch'istian charity' and in the first year of the new decade the coalition seemed about to deliver some measure of these things. A health scheme for maternal and infant care was proposed. In October the Roman Catholic hierarchy informed the young Minister for Health, Noel Browne, a member of Seán MacBride's party, that the scheme was not acceptable to them because it undermined family responsibility and therefore was contrary to Catholic teaching. Browne, youthful, idealistic and also rather vain, pressed on. In April of the following year, 1951, the bishops publicly condemned the scheme and Browne was immediately disowned and deserted

by his Cabinet colleagues, including his seemingly progressive party leader, MacBride. A week later he resigned. It was the first big political crisis of the 1950s and it had ended without result. Convulsion followed by renewed paralysis was still the order of the day.

But if Ireland was not a model social democracy in the 1950s, the Irish people seemed to themselves more of a community than they have ever been since – at least those of them who belonged to the overwhelming Catholic majority in the newly proclaimed Republic. To most of them, Northern Protestants, even Northern Catholics, did not count. Though the political parties made occasional feeble anti-partitionist gestures, most people were agreed that Ireland stopped at Newry. Irish unity was on a long list of things to which everybody paid lip-service, another being the restoration of the Irish language. It was assumed that the population of Ireland was homogenous and a powerful myth of common origin, suffering, and shared struggle was tirelessly propagated by politicians and the educational system. All apparently professed the same religious doctrines, shared the same sexual orientation, confessed much the same unspectacular sins when they had any at all to confess. The poor might be very poor, but the rich were not on the whole very rich.

Virtually all spoke with the accents of their native place. No Irishman was judged by the way he spoke as the English were. If questioned on the subject most would have agreed that there were no class divisions in Ireland. And everybody seemed to share the same simple enough amusements. Dublin had the largest number of cinema seats per head of population of any city in Europe, yet there were long queues for most of the heavily censored Hollywood films on view. Since only a few rather louche pubs, which called themselves 'Lounge Bars', made women feel at all welcome, the cinema was the most acceptable form of dating. The most acceptable form of encounter between the sexes was the dance-halls, 'The Classic', 'The Olympic', 'The Four Provinces'. The men stayed in the pub for as long as possible; the women fox-trotted around with each other until the men arrived, most of them a little jarred. During the last quick-step the men would pop the question, 'Can I see you home?' – after which the lucky ones would embark on the long tramp through the transport-less city to be followed by some 'coorting' in the doorway or the front garden of the girl's home.

Marriage was lifelong and indissoluble: the unhappy to the drink, the great national solvent. To most bright young men in the

country – women in this context did not exist – the attainment of a permanent and pensionable job under the state involving silence and cynicism about politics and most other matters was the desired objective. Pieties, religious and patriotic, were the staple of every occasion. If it sounds boring, it was. If it sounds like living under the Taliban, it wasn't quite.

Literary dissent, it is true, had almost vanished. Yeats, a volcano likely to erupt on rare occasions, had died in 1939; Joyce in the following year. Francis Stuart was working as a night-porter in the Victoria and Albert Museum in London. O'Flaherty was a burnt-out case; O'Faolain, a courteous Catholic, dissented solemnly but courteously about book censorship. The Abbey had not had a playwright of consequence for years.

The long war between Ireland and its writers seemed to be over. Most of the writers remaining had permanent and pensionable jobs in the radio station or the civil service. In the Pearl and the Palace Bars they had table service and were protected by the staff from female or any other unwelcome intrusion. A few large whiskeys was for most of them an affordable indulgence. Nearly all were family men and Catholics. Some looked upon themselves as 'Catholic novelists'. There were even Catholic poets who had some acquaintance with the works of Péguy and Claudel.

In 1950, John Ryan founded a literary magazine, *Envoy*, whose headquarters was McDaid's 'Lounge Bar' in Harry Street, already a pub where confluences, bohemian, anarchist, déclassé and déraciné, met. Writers now gathered there, including Patrick Kavanagh, Myles na Gopaleen, Brendan Behan, myself. Here, with the aid of alcohol, irreverence and irony, pieties and conformism, including literary conformism, could be kept at bay. Though a fashion has grown up of speaking as if Ireland in the 1950s had fallen under the twin tyrannies of De Valera and the Church, neither Catholicism nor patriotism, some of us felt, were particularly the enemy. The enemy, thought those of us who dissented, was the Irish people, who had somehow brought this doom, this suffocating conformity and stasis, sometimes even masquerading as liberalism and progress, upon themselves.

Early in the decade the Abbey Theatre burned down. Shortly afterwards the *Irish Times* caught fire. I went down with Kavanagh to assess the damage. 'If the GPO' – which housed Radio Éireann – 'went up in flames now, we'd have a clean sweep,' he said longingly.

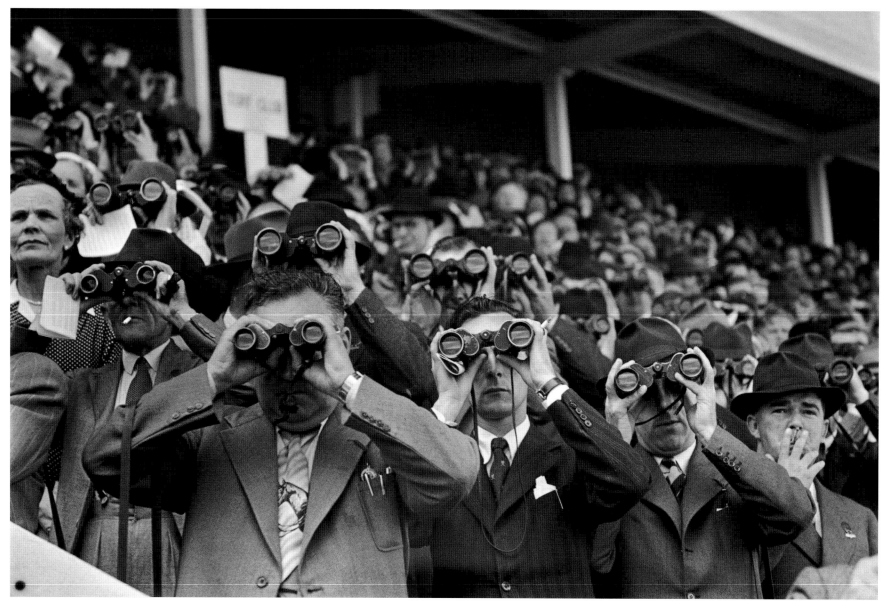

Henri Cartier-Bresson. Horse racing, Thurles, County Tipperary, 1952

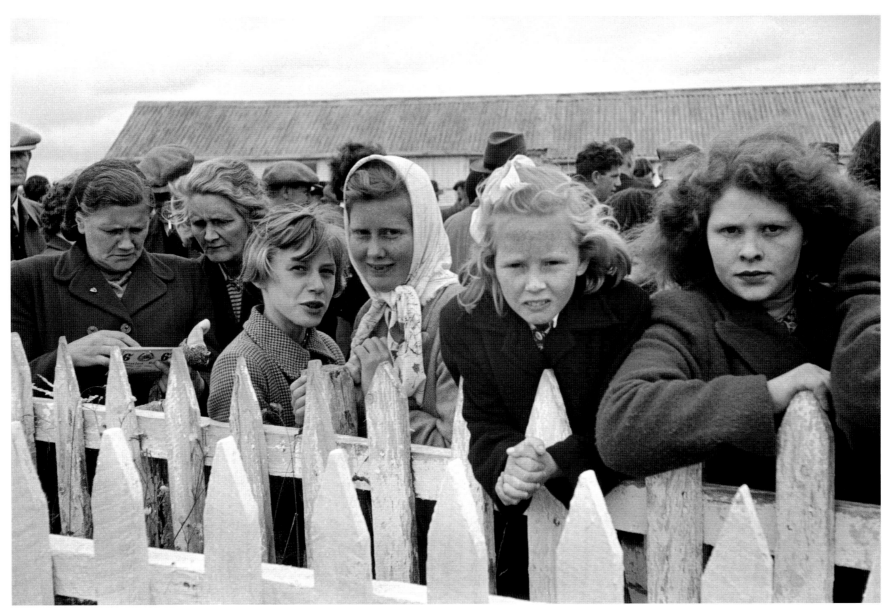

Henri Cartier-Bresson. Horse racing, Thurles, County Tipperary, 1952

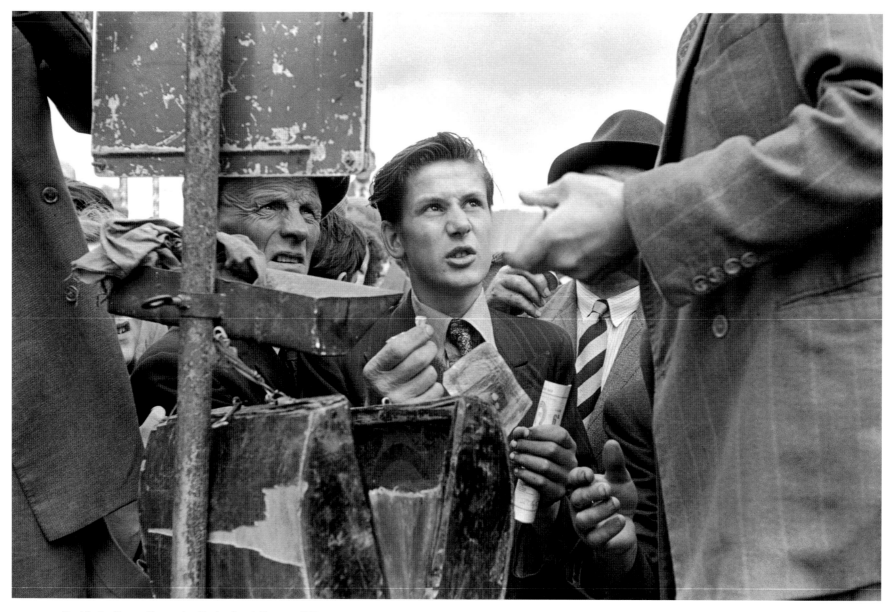

Henri Cartier-Bresson. Horse racing, Thurles, County Tipperary, 1952

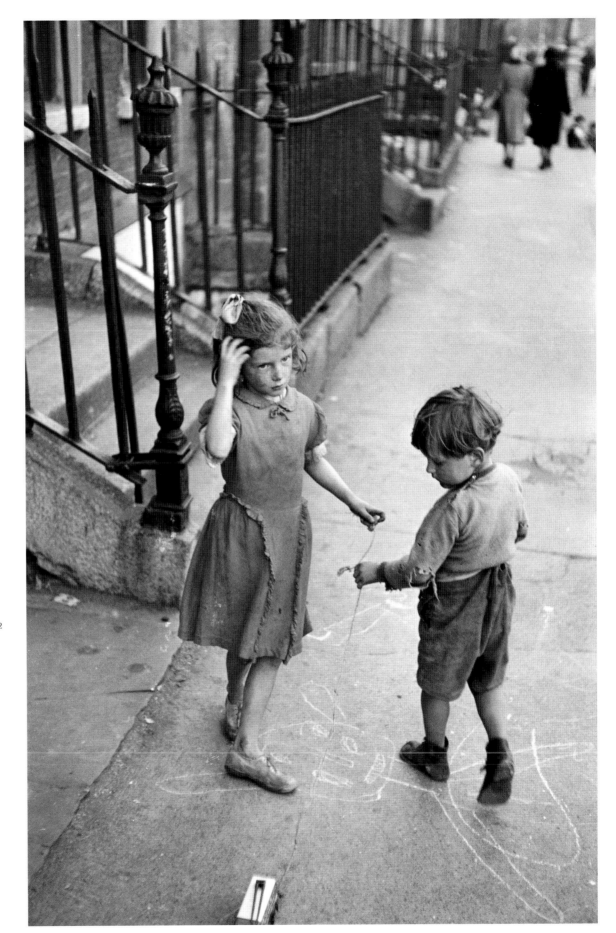

Henri Cartier-Bresson. Dublin, 1952

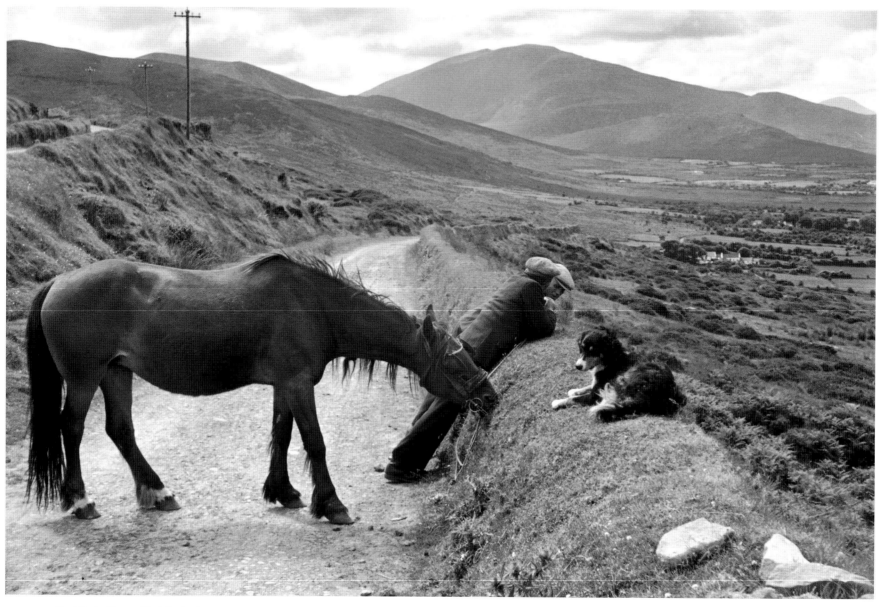

Henri Cartier-Bresson. Dingle Peninsula, County Kerry, 1952

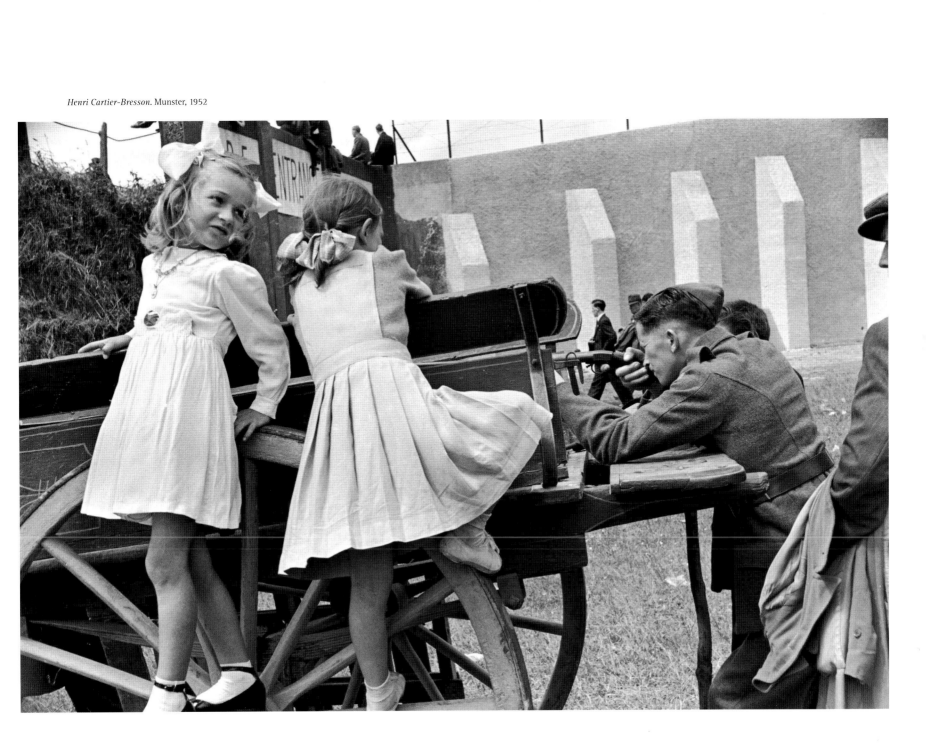

Henri Cartier-Bresson. Munster, 1952

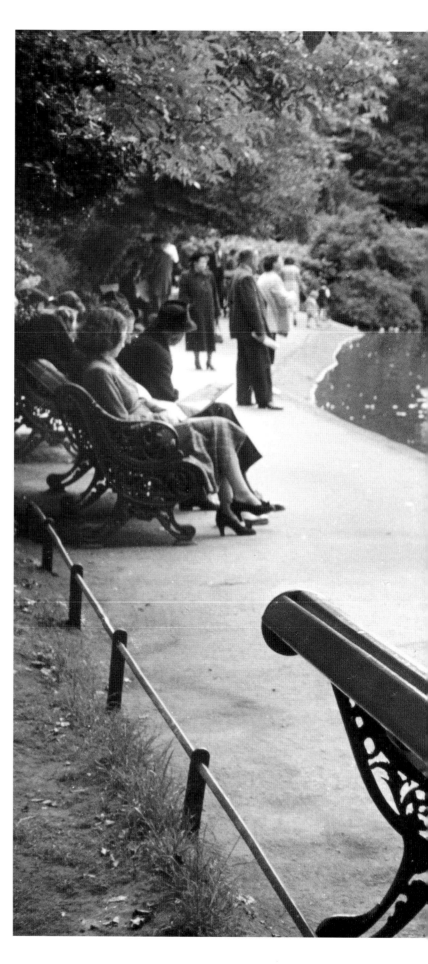

Henri Cartier-Bresson. St Stephen's Green, Dublin, 1952

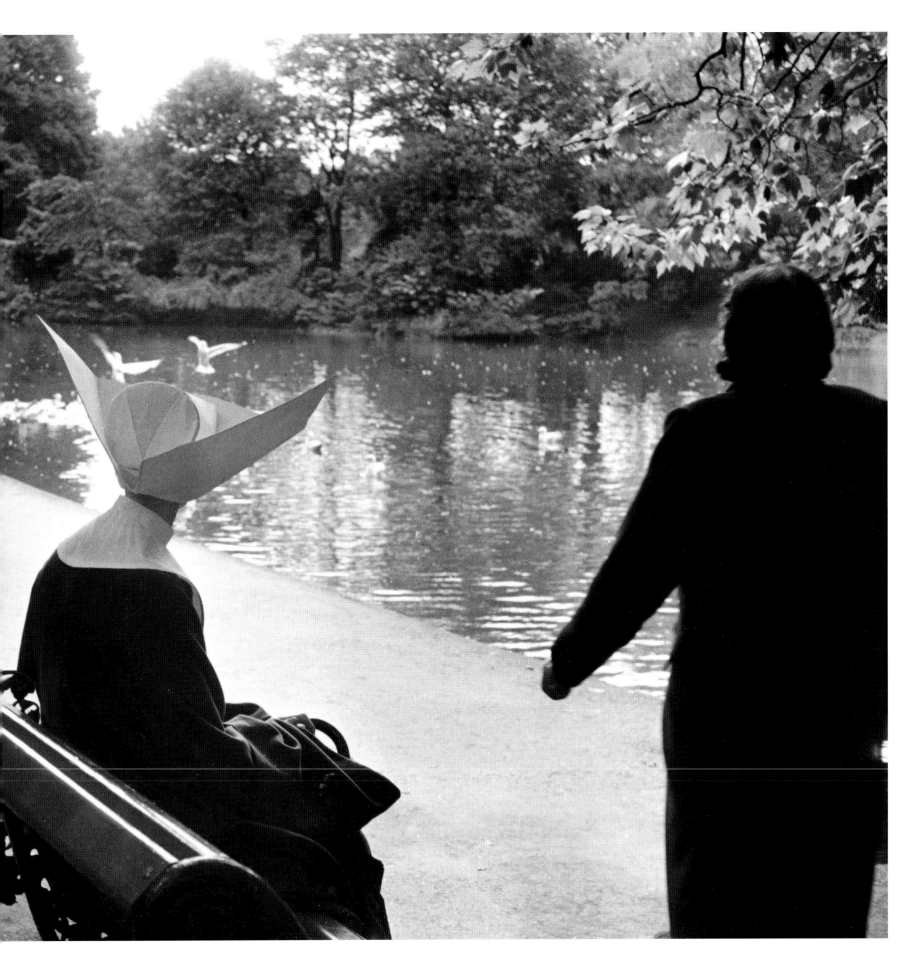

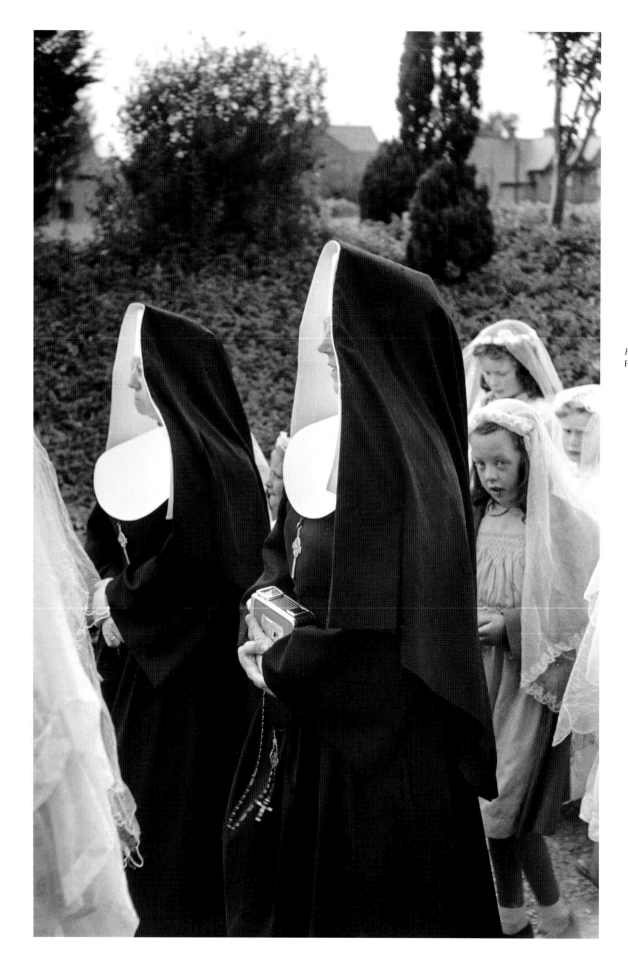

Henri Cartier-Bresson. Procession of the Blessed Sacrament, Feast of Corpus Christi, near Corpus Christi Church, Dublin, 1952

Henri Cartier-Bresson. 1952

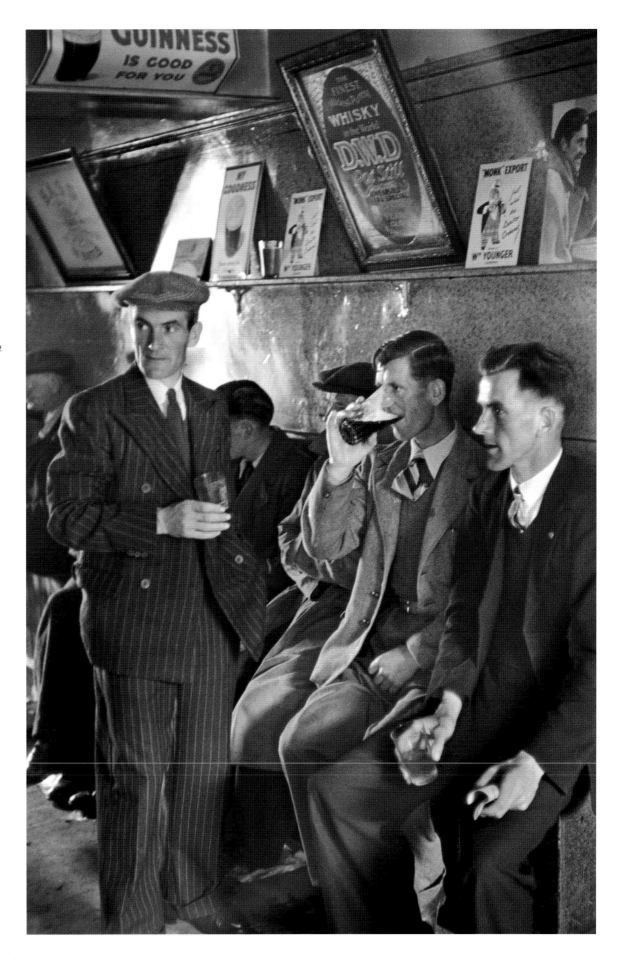

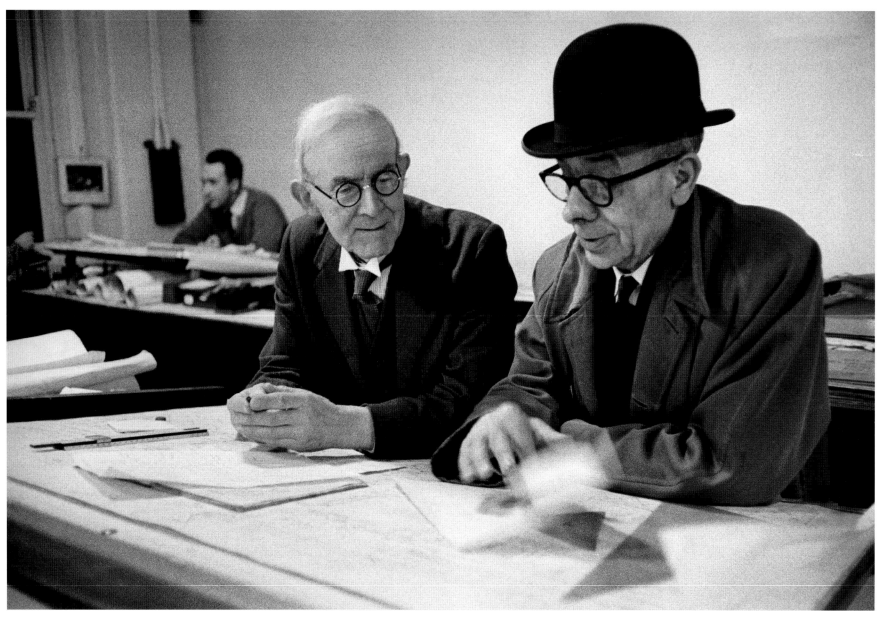

Erich Lessing. Shipbuilding at Harland and Wolff, Belfast, 1958

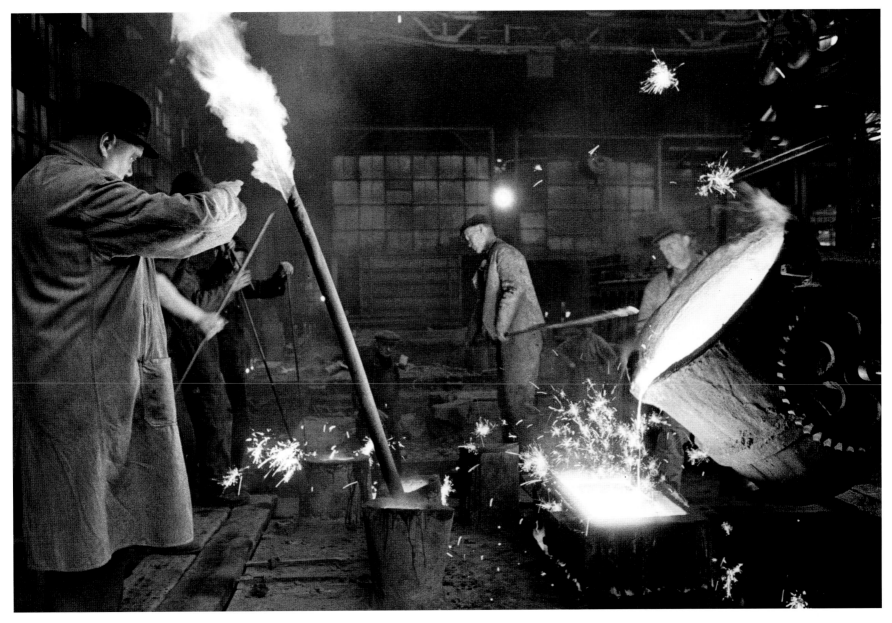

Erich Lessing. Shipbuilding at Harland and Wolff, Belfast, 1958

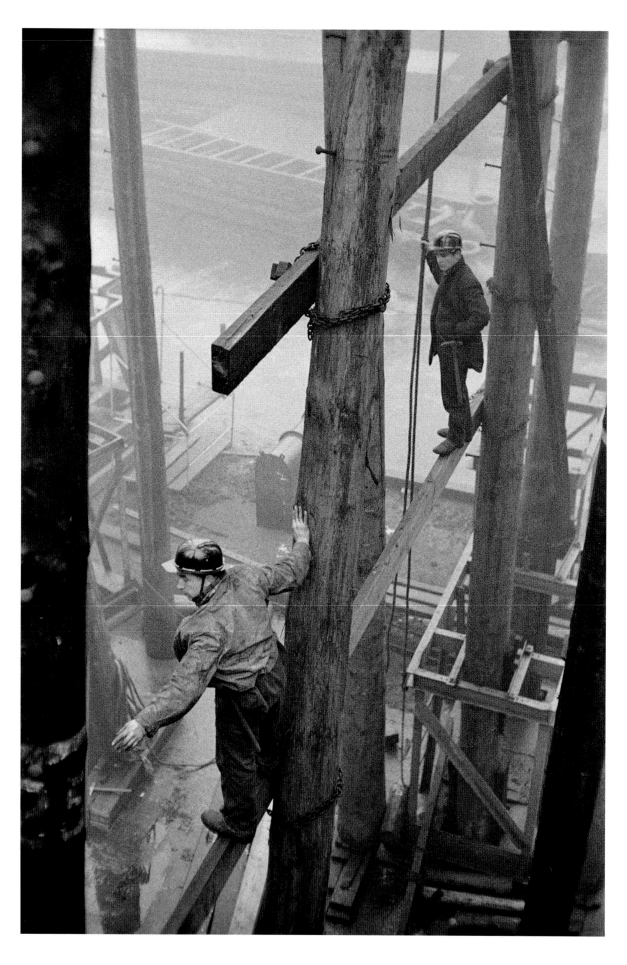

this page and opposite
Erich Lessing. Shipbuilding at Harland and Wolff, Belfast, 1958

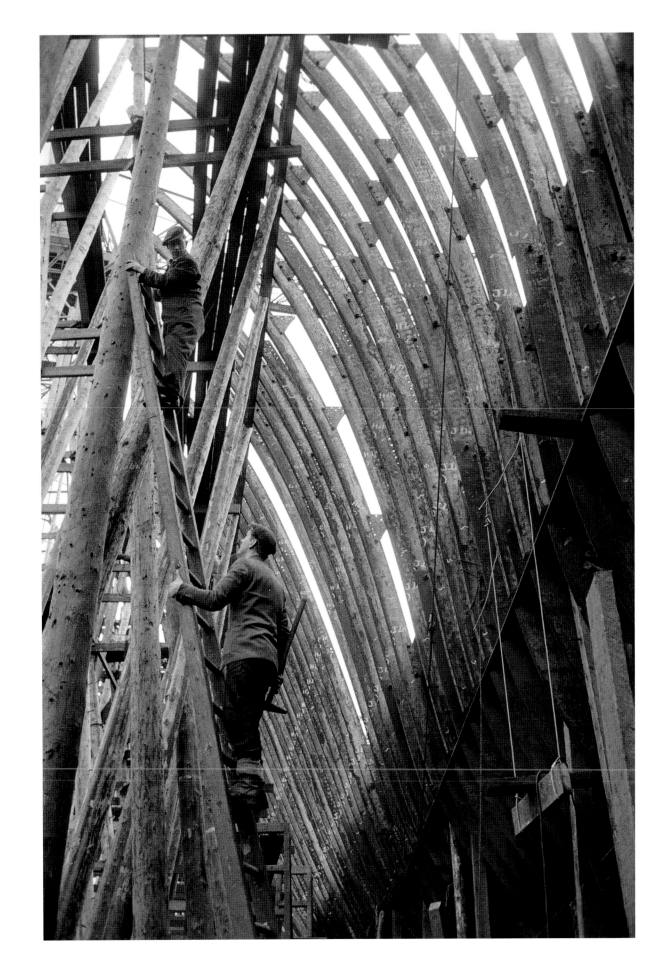

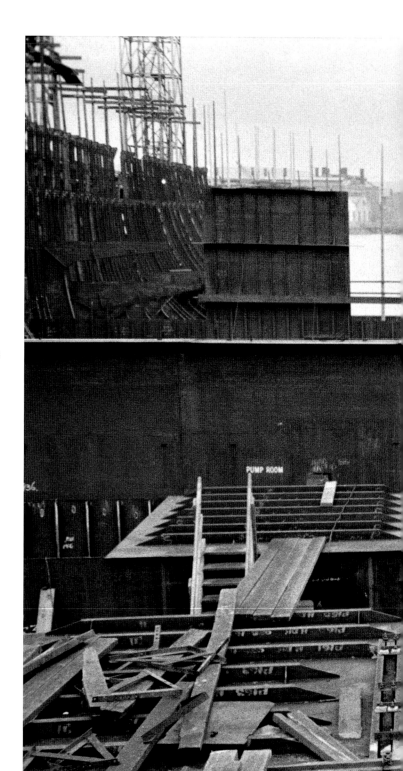

Erich Lessing. Shipbuilding at Harland and Wolff, Belfast, 1958

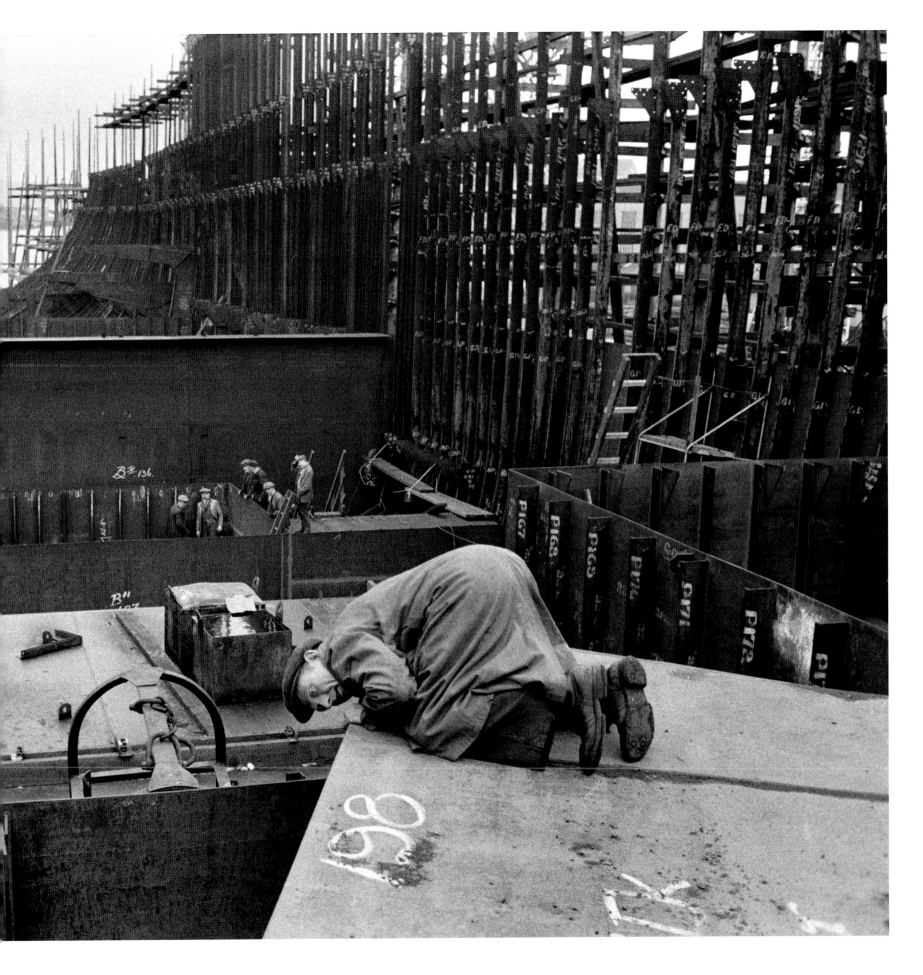

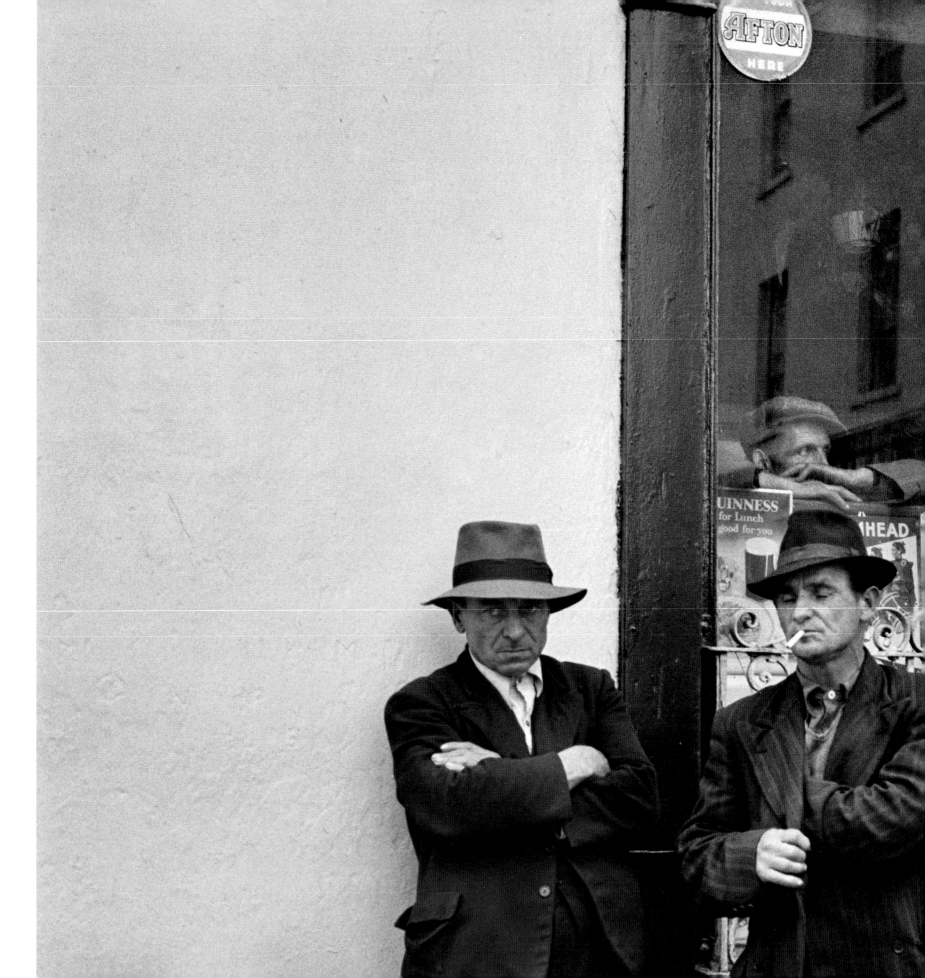

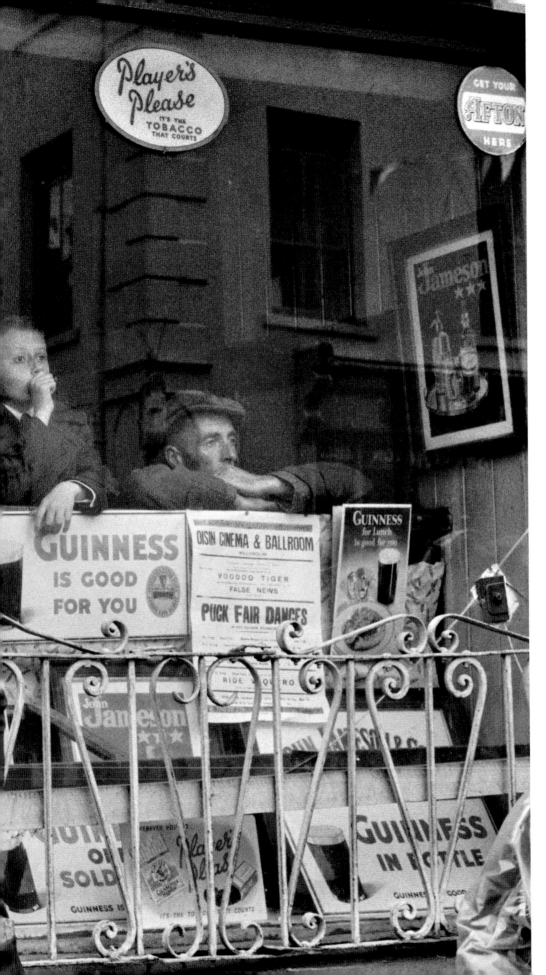

Inge Morath. Puck Fair, Killorglin, County Kerry, 1954

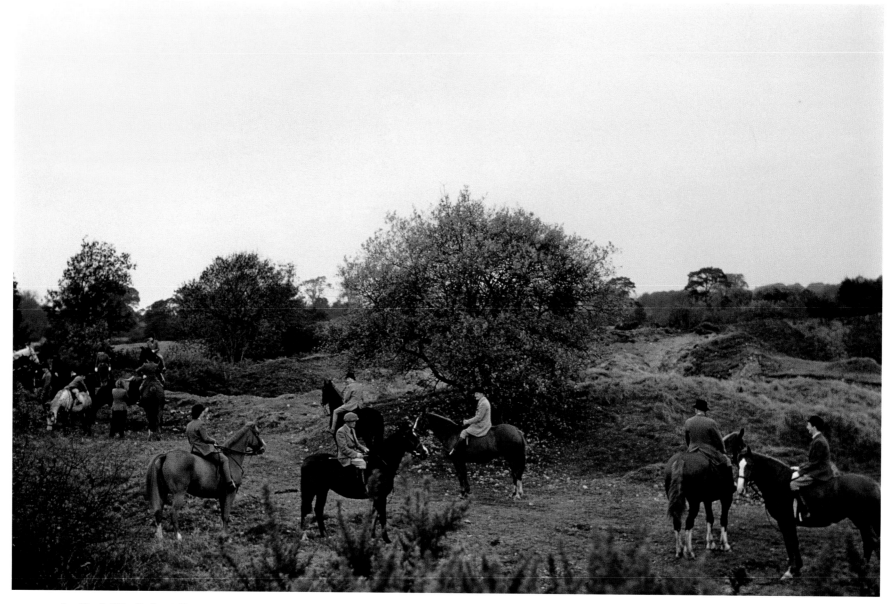

Inge Morath. Killorglin, County Kerry, 1954

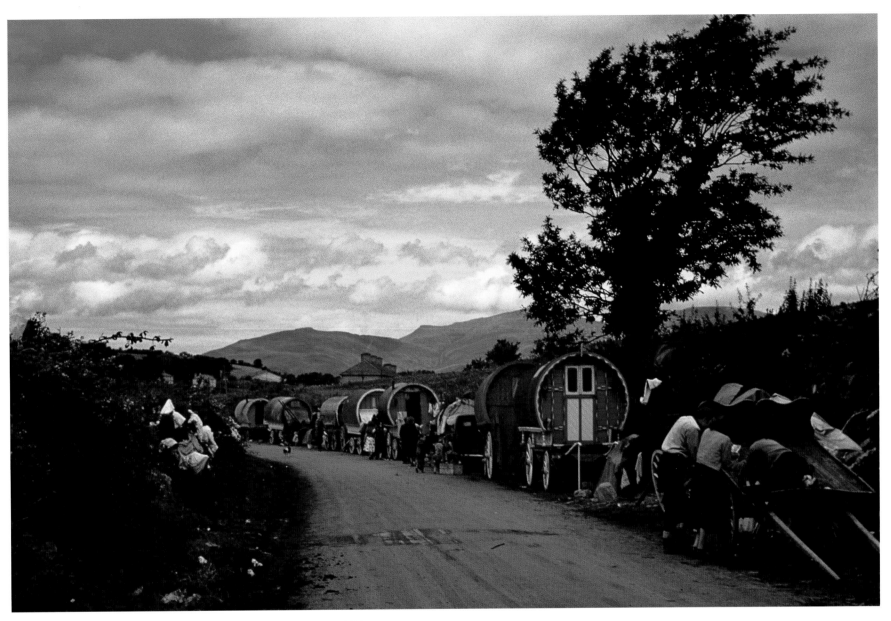

Inge Morath. Tinker carts line up on the night before the opening of the Puck Fair. Already half an hour after the horses are unharnessed, washing is hanging on bushes and fires are ready to cook the evening meals. Killorglin, County Kerry, 1954

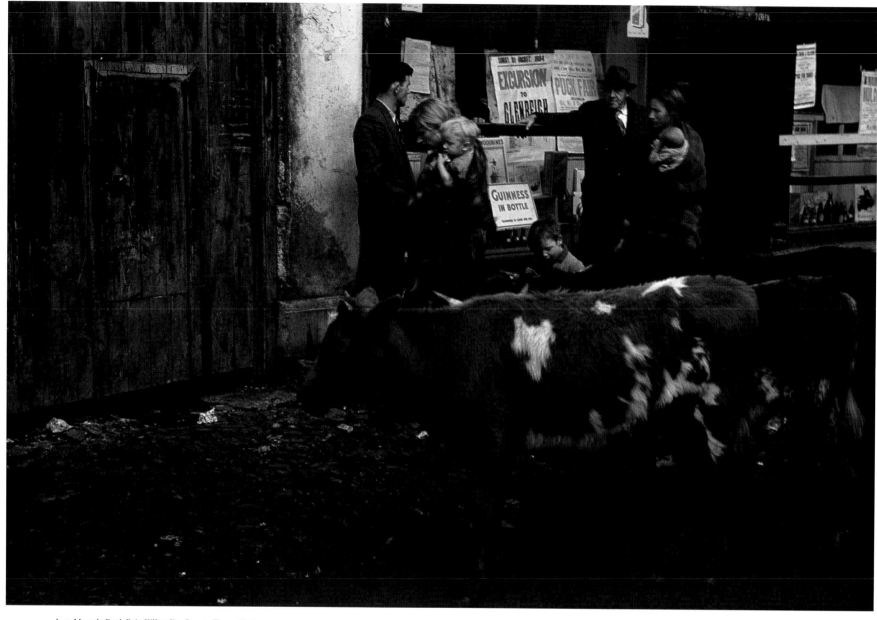

Inge Morath. Puck Fair, Killorglin, County Kerry, 1954

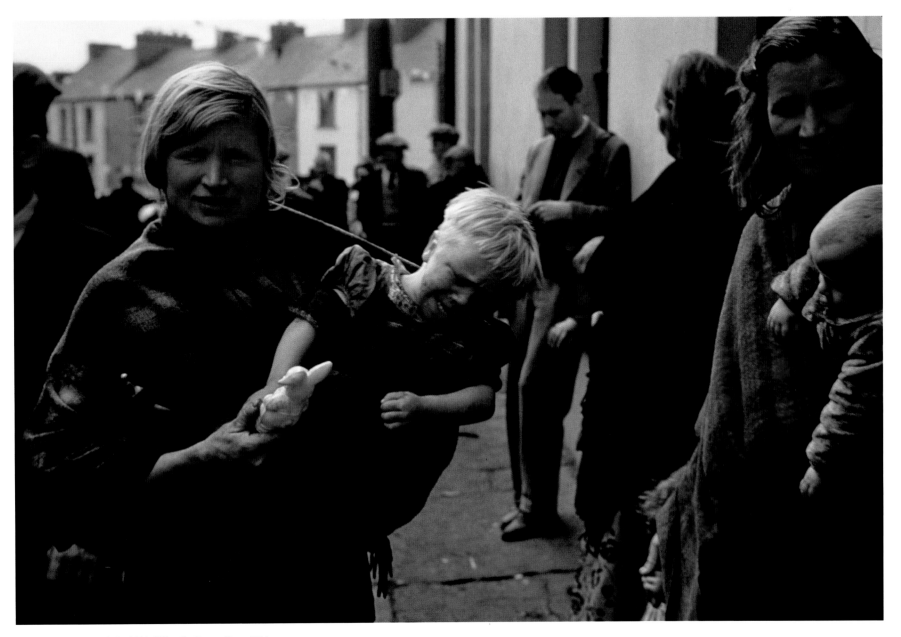

Inge Morath. Puck Fair, Killorglin, County Kerry, 1954

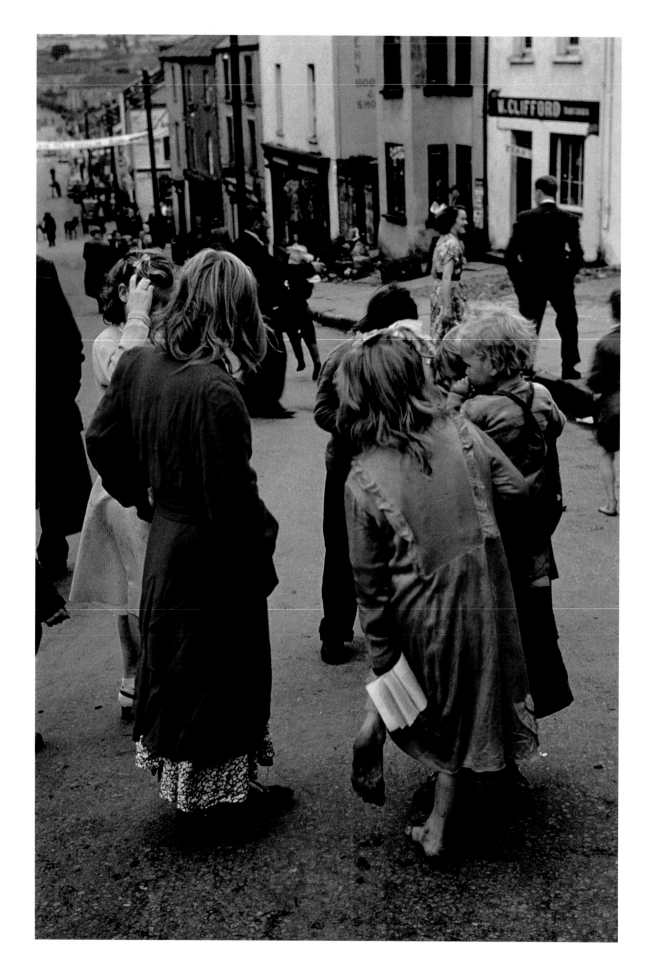

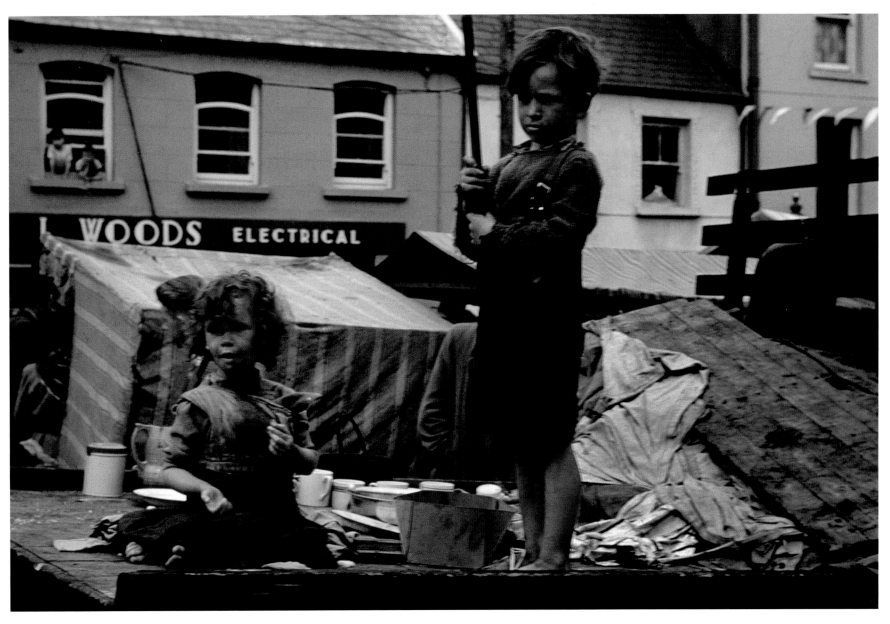

this page and opposite
Inge Morath. Puck Fair, Killorglin, County Kerry, 1954

top
Inge Morath. Killorglin, County Kerry, 1954

bottom
Inge Morath. Puck Fair, Killorglin.
A wild goat is made King of the Fair for
the three-day period. County Kerry, 1954

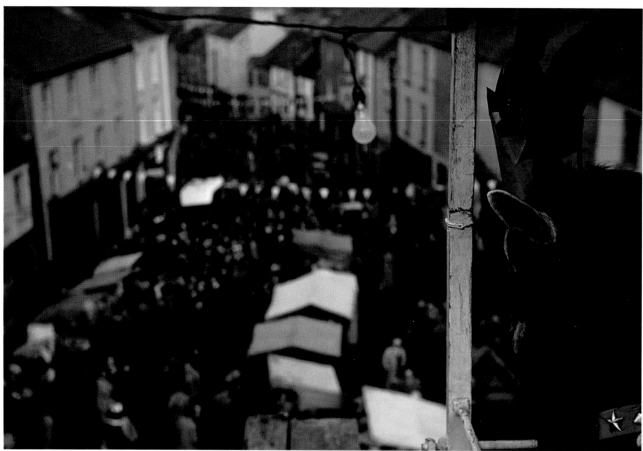

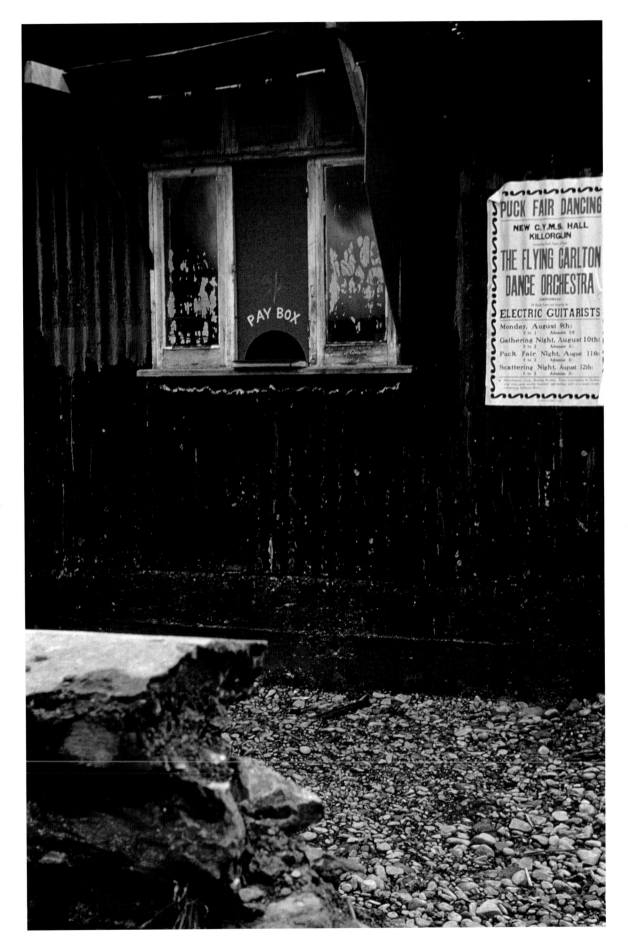

Inge Morath. Killorglin, County Kerry, 1954

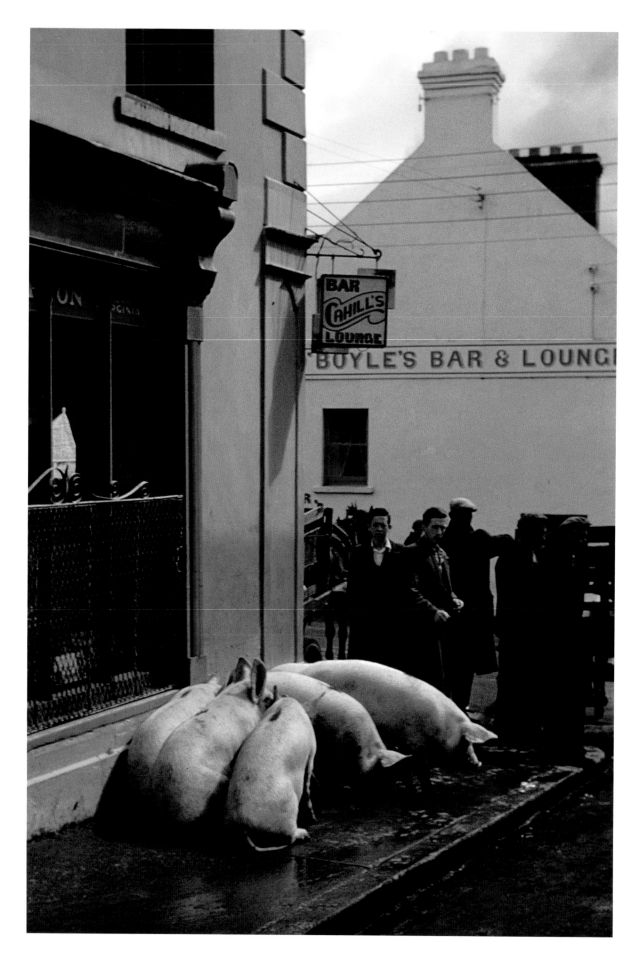

Inge Morath. Puck Fair, Killorglin, County Kerry, 1954

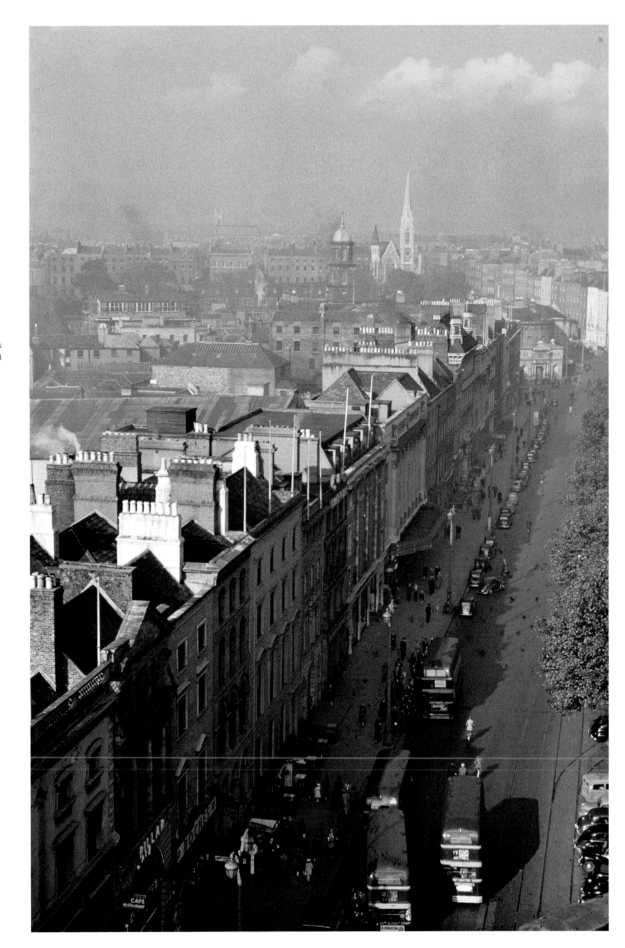

Inge Morath. O'Connell Street looking towards
Parnell Square, Dublin, 1954

'60s

Elliott Erwitt

Henri Cartier-Bresson

Bruce Davidson

Erich Hartmann

Philip Jones Griffiths

The '60s: Nuala O'Faolain

1. THE CIRCUS. THE SWIRLS OF DESIRE AND DREAMS

When I was a child in the flat countryside north of Dublin –
empty, then, between its villages – nobody came in. People left,
but no new people arrived. Hardly anybody visited. The circus
people were the only exotics ever to come to the tufty fields at
the edge of small, grey housing estates or to the waste grounds
that in later times became car parks and now are stacked with
townhouses. I know that when Duffy's Circus came – thrillingly
heralded by posters that blossomed on treetrunks – it was
assaulted by a queue of children pullulating with imagination,
jostling to get into the space where they would see the universe
transformed. Afterwards, I would not leave the site of the magic
because I wanted to crawl through the smell of crushed grass to
behind the shabby marquee to peer underneath the tarpaulins at
the way the circus people lived in caravans with tin basins on
their steps beside horses hobbled together the way they were in
cowboy movies. Even a circus cat – I see in a photograph here
(p. 64) – was marvellously different from our plain cats. I feasted
my eyes on other lives.

The Ireland of the 1950s that I remember was grim and simple,
and the 1960s were embedded in it. At the beginning of the
decade the only hope of living with lightness was to leave home,
stumble away from it in a welter of drink and heartbreak and
anger, and hope to be lucky in a new life elsewhere. But as the
1960s progressed, Ireland itself strained towards glittering and
lightness and bareback daring and expertise in trickery and girls
in tights and spangles and clowns who could make even the stolid
laugh. Other ways of living were offered to us, besides being silent
Catholics. No hopes were realized, but hope stirred.

2. THE PRIESTS AND THE STONE BUILDINGS

I was a student in University College, Dublin in the first half of the
1960s and a teacher there in the second half, and college was the
right vantage point onto those years in which the young came
together as a tribe. A confused tribe, of course, and uninformed.
None of us had travelled, none of us had seen much TV, Irish radio
exuded the same paternalistic, rural-accented ennui as school-
books had done. We'd come out of huge institutions built of
granite, and the Catholic church was not just out there processing
across quadrangles in soutanes but inside us, where we were still
apparatchiks, seeking to be loyal, at least in our earnestness, to
the priests and the nuns. I remember, for example, that the bright

UCD students who were involved in college drama took on
Claudel and Mauriac and Strindberg and Gorky, though they were
not European intellectuals except in their heads. They were not
much more than children who lived at home with their parents,
wearing heavy, old clothes, walking because they had no money
for the bus, permanently penniless unless they toiled all summer
in an English factory. Trinity students did revues and skits. They
were like English people. We native students were still laden.

3. FROM BALLROOM TO DISCO

It took years for self-confidence to collect inside us, even though
college students were the most privileged young people in the
country. Look at the photograph on p. 53. The image has its
natural elegance, but the place would have smelled of sweat and
'Evening in Paris' perfume and hot Brylcreem – the smell of the
era that was the '50s-within-the-'60s, when dances were all there
was of sensuality and out of the sheer need to move their limbs to
music a woman would dance with her woman friend if no man
asked them up. In other parts of the world joy had already located
itself in the young, autonomous body, but the Irish didn't begin to
look young until well into the 1960s. The music was the bridge.
Dance music. Rock 'n' roll.

4. THE ROUTE TO PRIDE

And the sound of the old Irish music, too, creeping out of the
frozen tundra of the '50s. When the film *Mise Eire* came out in
1959 the music score was a stunning arrangement for orchestra of
melodies that people like me, who had grown up with no link to
tradition, had never heard. Except in enclaves, knowledge of the
ancient Irish heritage had gone underground. Children from the
east of the country were ritually sent to the west around the age of
puberty to sleep away from home and manage their first freedoms
in the supposedly highminded and chaste atmosphere of a rural
Irish community. But that was all we knew about the past of our
own people – that it seemed that the Irish of long ago ate fish and
brown bread and spoke Irish and it stayed light so late on summer
evenings in the places that were like that that if you sneaked off
with a boy you were sure to be caught. I had hardly ever been
anywhere in Ireland, but suddenly when there was a Fleadh Cheoil
in a place like Swinford or Gorey I was among the fringe audience
of people from cultureless Ireland who for a few days and nights,
high and exhausted from drinking and emotion and rain and the

first hamburgers from mobile vans, piled in a group into a bed or the back of a car or slept like puppies under a wavering tent. We were young, free to hitchhike and to be together in relative innocence. When we were in the presence of a great singer or player we saw – for the first time in our own country – a disinterested commitment to excellence. And we saw passion.

5. GLEAMS OF SELFHOOD, AND THEN DARK FALLS AGAIN

In the mid-'60s, teaching night students in college, I used to sneak in mention of Edna O'Brien's Country Girls books – the first for young women – and it was as if her name was a secret sign; afterwards women would be waiting to see me, to whisper tales from their true lives. But there are as few girls in these photographs as there were in that Ireland; there are, instead, women in hats.

The plaster statues of the Blessed Virgin here (p. 72) are abandoned and unvalued. The Church did not crack open with Vatican Two, though for a while it balanced between the old and the new like a bareback rider guiding two horses. The debate about sexual behaviour that seemed to start on the *Late, Late Show* did not deliver freedom, because the old men still had all the power. Sex seemed to be everywhere because of the explicitness of things seen, like miniskirts from Carnaby Street, or Mick Jagger's pacings, and because of the transient sensualities of the dance hall. But unseen, there was no contraception available in Ireland and no help for women pregnant outside marriage. Even within marriage, the Papal encyclical *Humanae Vitae*, which forbade artificial contraception, took the sexiness out of the bedroom. Irish women were still enslaved by their own fertility – a slavery endorsed with enthusiasm by local politicians. There is one modern face here – one – in the picture on p. 74 – but wait for that young energy to be drained by the life of an Irish woman.

6. INTO THE TROUBLES, BUT INTO THE FUTURE

Yet what everyone means by 'the '60s' did happen in Ireland, later, between the mid-'70s and the end of the century. Students aren't as excluding and as tolerant of exclusion as their less educated fathers and mothers, and after the proclamation of free secondary education in 1966 there were going to be more and more students. And students have always had their own traditions of protest which were re-activated in this decade, to great effect, in the United States and France. And in Ireland, too, it was students who began to crawl out from under the grim and punitive patriarchy. By 1969 they were everywhere. The political squalor behind the picturesqueness of Northern Ireland at last impinged on the imagination of the South, and it was students in Belfast and Derry who fleshed out the protests begun by civil rights activists. Back in Dublin students were learning how ruthless the moneymen can be as they sat in, fruitlessly, against the destruction of the Georgian streetscape of Dublin, however derelict – as recorded in some of these photographs – Georgian Dublin had come to be.

Students mounted a vigorous challenge against the smug and self-serving academy where I was teaching. They 'occupied' a hallway for only a day or two, but theirs was an assertion of self-respect so utterly unexpected that not just my older colleagues but young people who had become institutionalized, like myself, were shocked. I saw not just the decade end when I saw real fear in my older colleagues' eyes – I saw the past begin to end. The Ireland I had grown up in begin to end. The clowns had taken over the Big Top. The life that boils in the children photographed here has conquered their deathly place. How right the old men were to be unreasonably afraid.

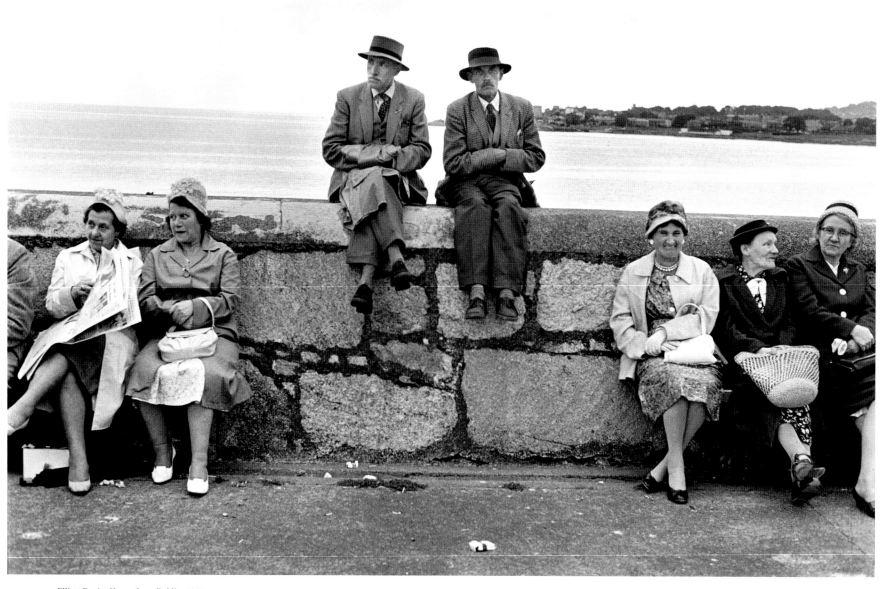

Elliott Erwitt. Horse show, Dublin, 1962

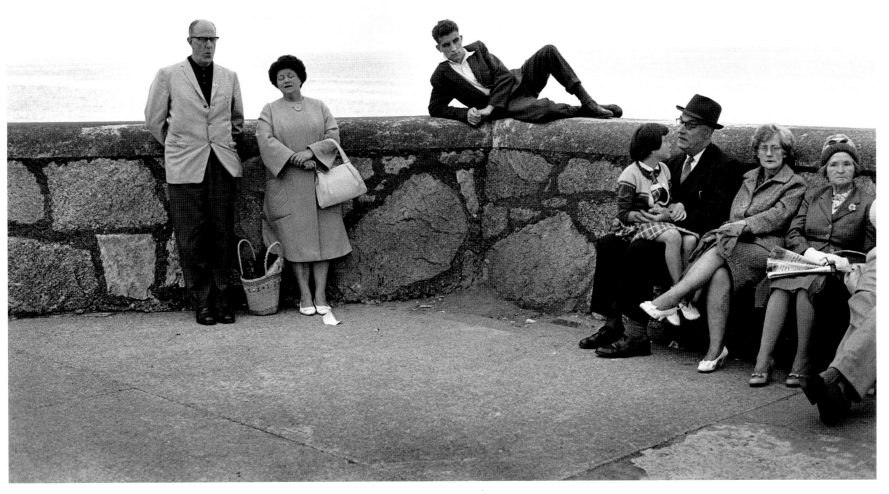

Elliott Erwitt. Horse show, Dublin, 1962

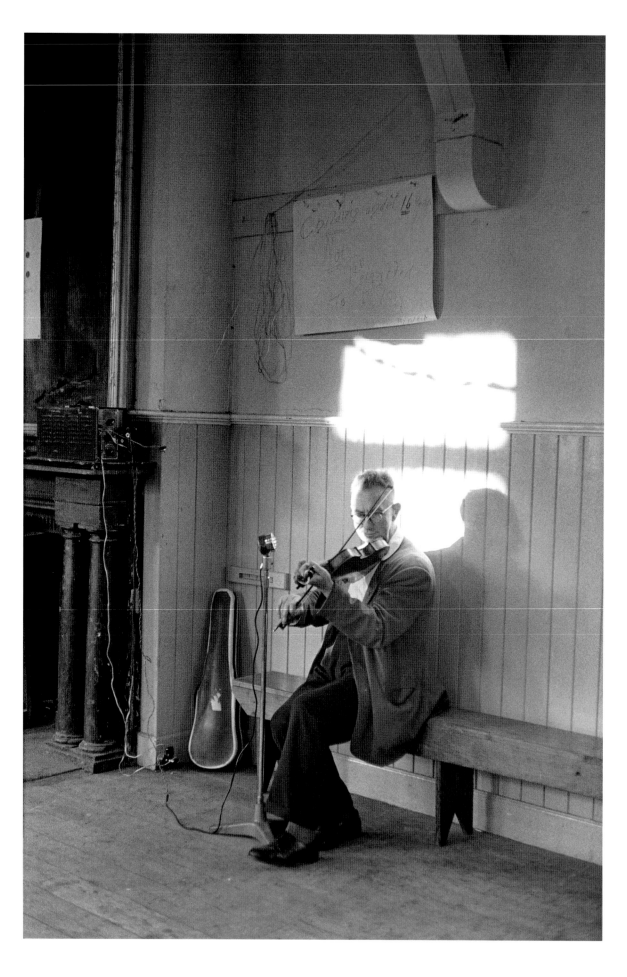

Elliott Erwitt. 1962

Elliott Erwitt. Horse show, Dublin, 1962

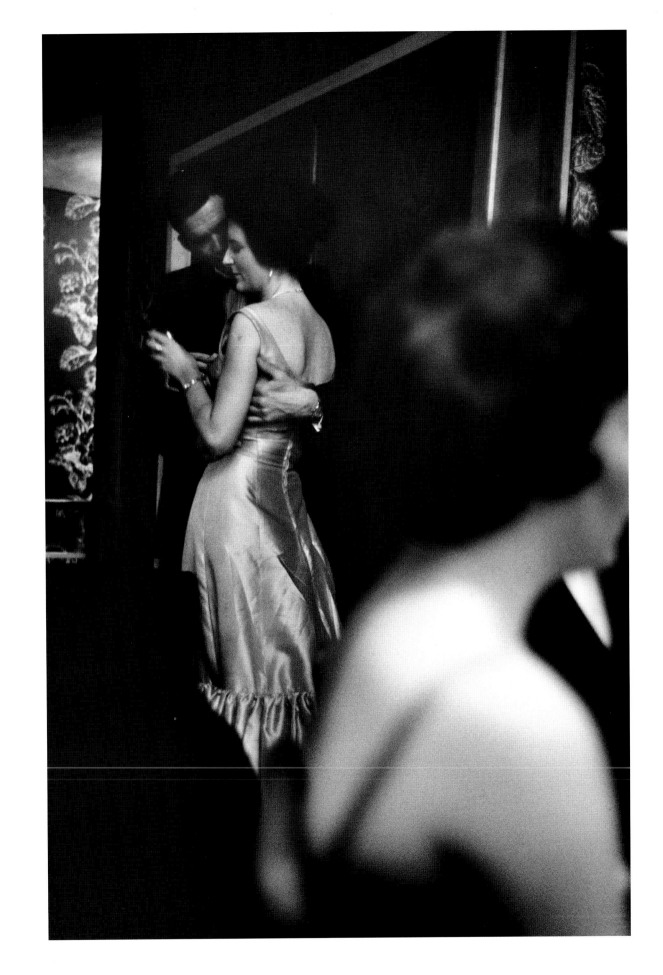

Elliott Erwitt. Aran Islands, 1962

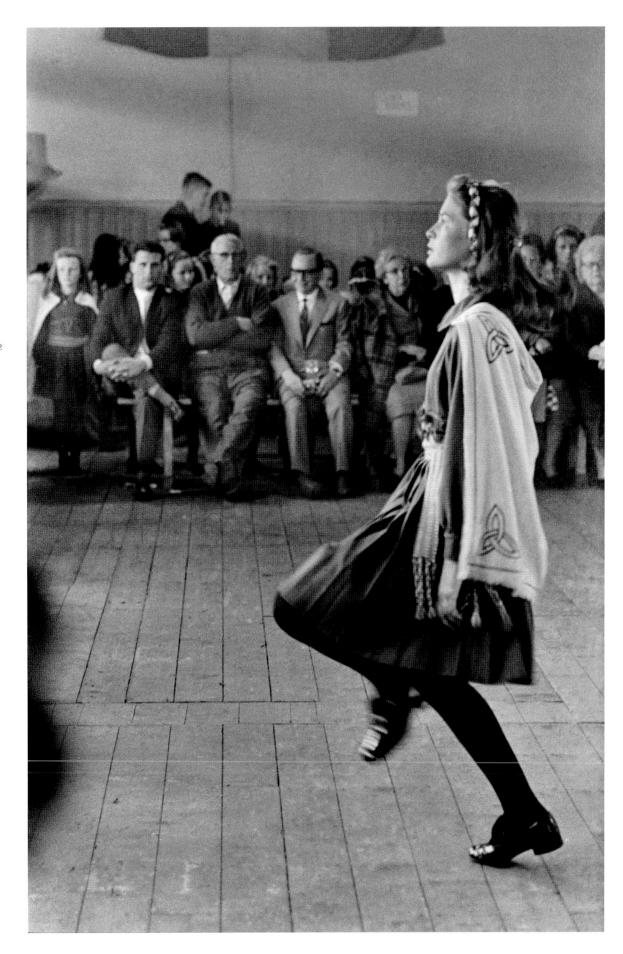

Elliott Erwitt. County Cork, 1962

Elliott Erwitt. 1962

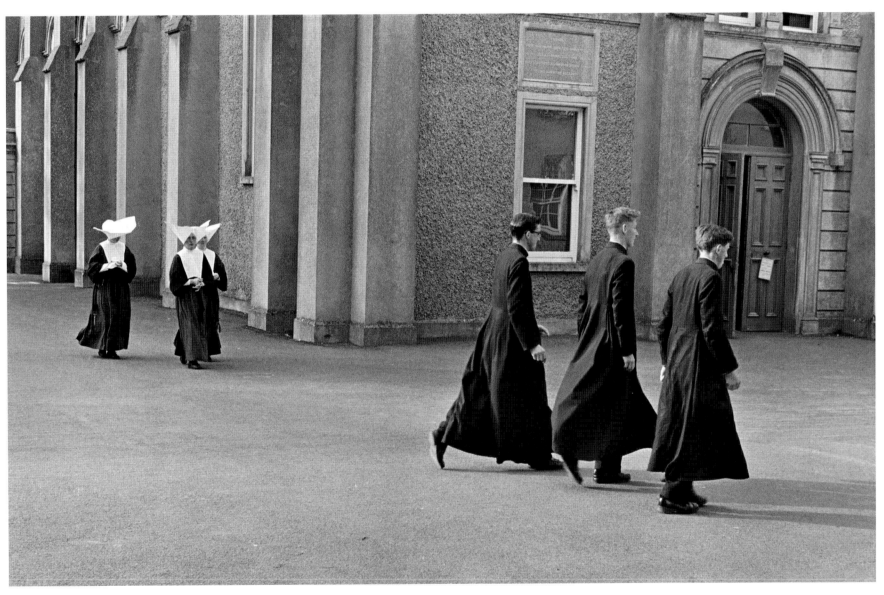

Elliott Erwitt. 1962

following pages:

left
Elliott Erwitt. Dublin, 1962

right
Elliott Erwitt. Dublin, 1962

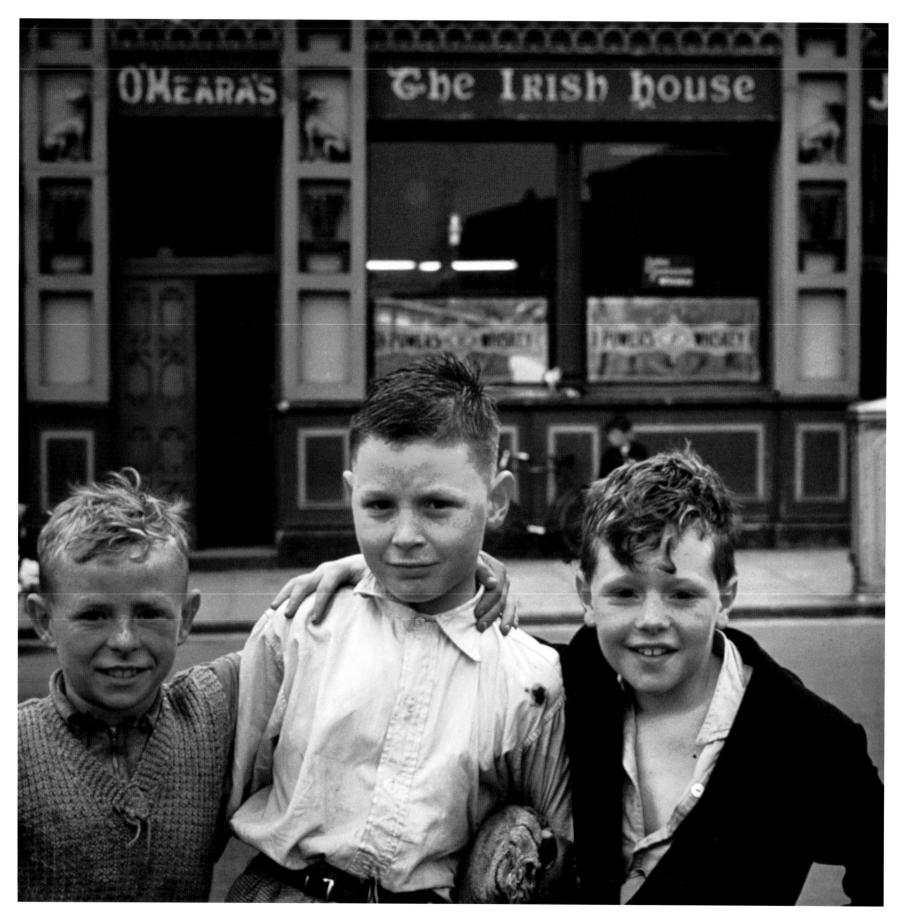

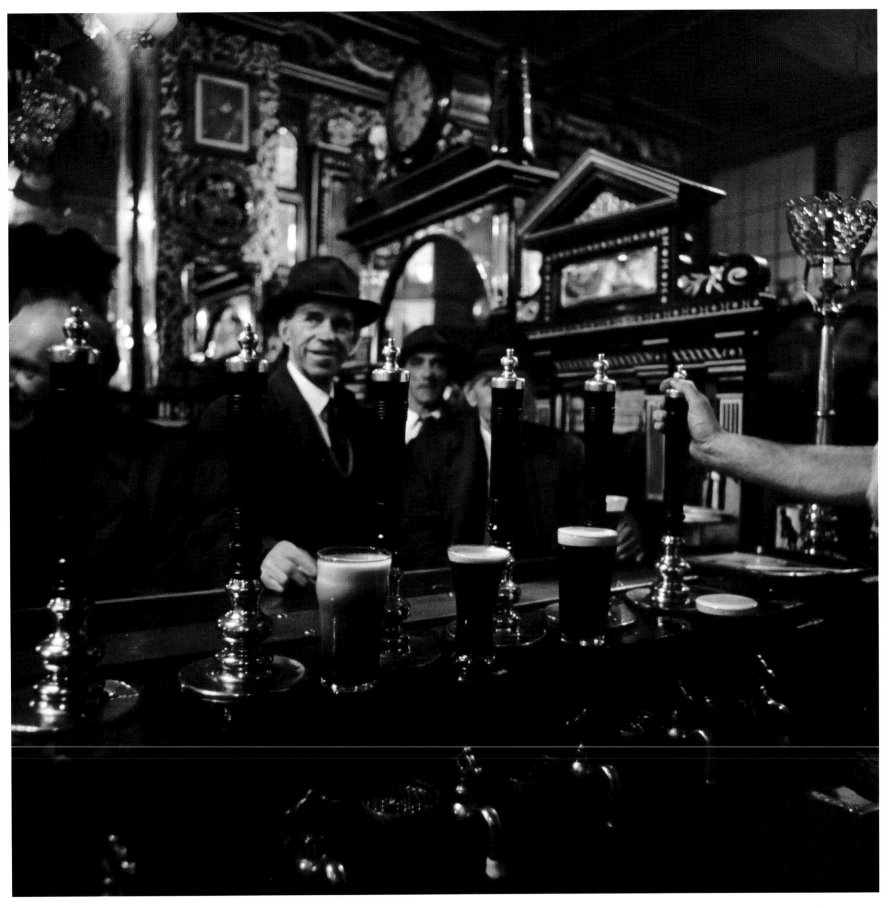

Henri Cartier-Bresson. The Curragh Racecourse, County Kildare, 1962

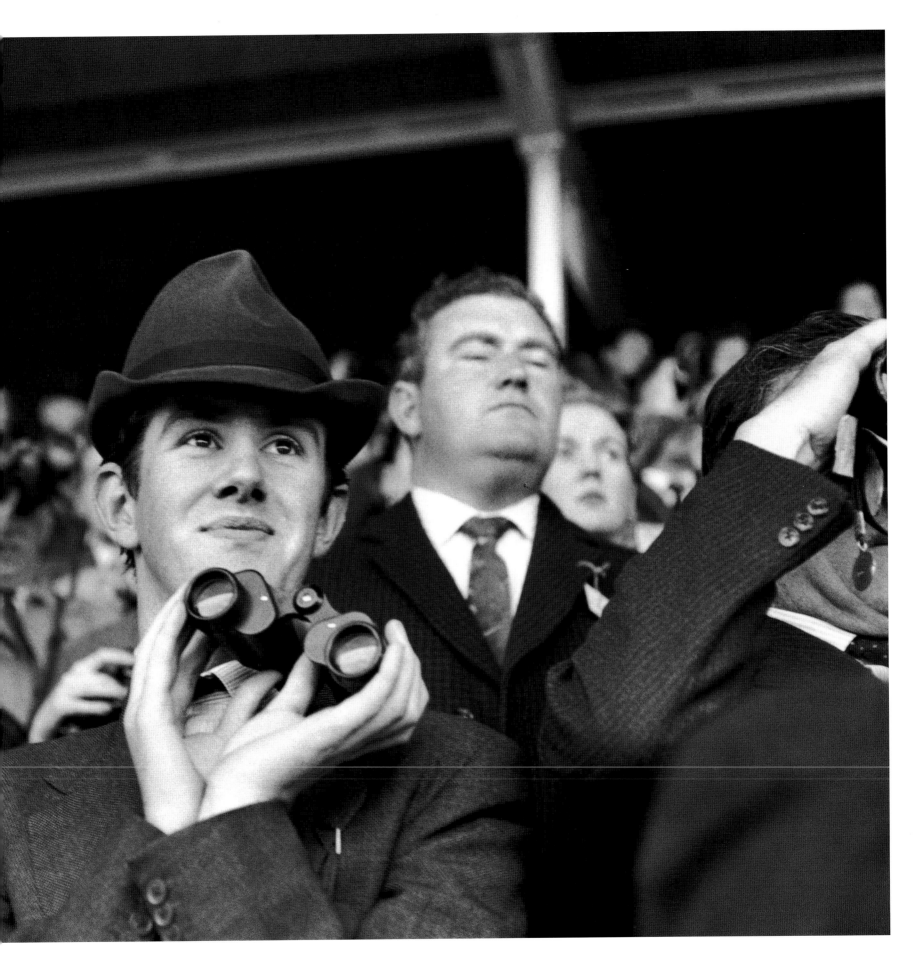

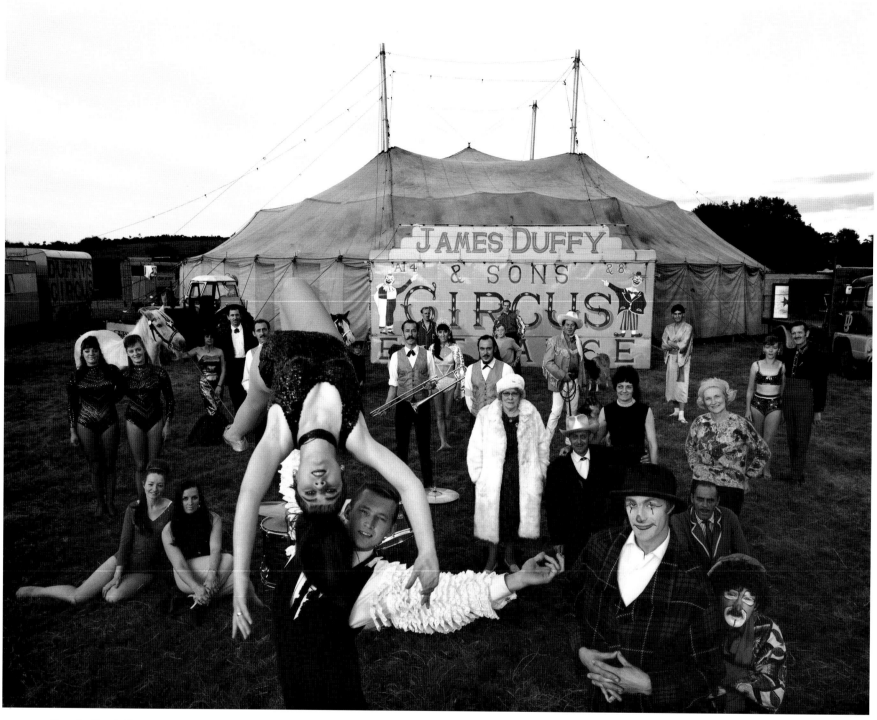

Bruce Davidson. Duffy Circus, 1967

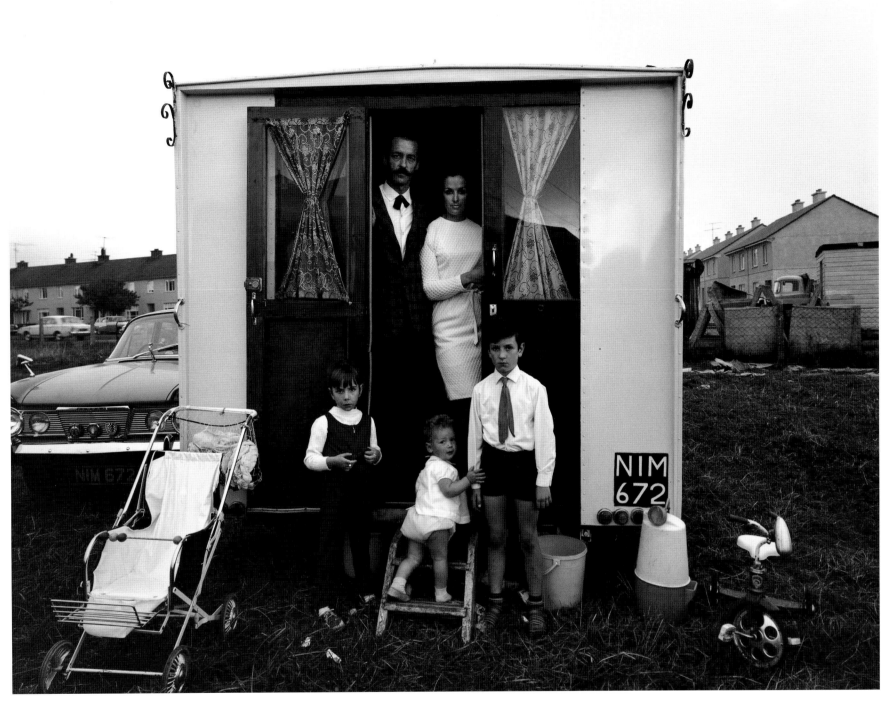

Bruce Davidson. Duffy Circus, 1967

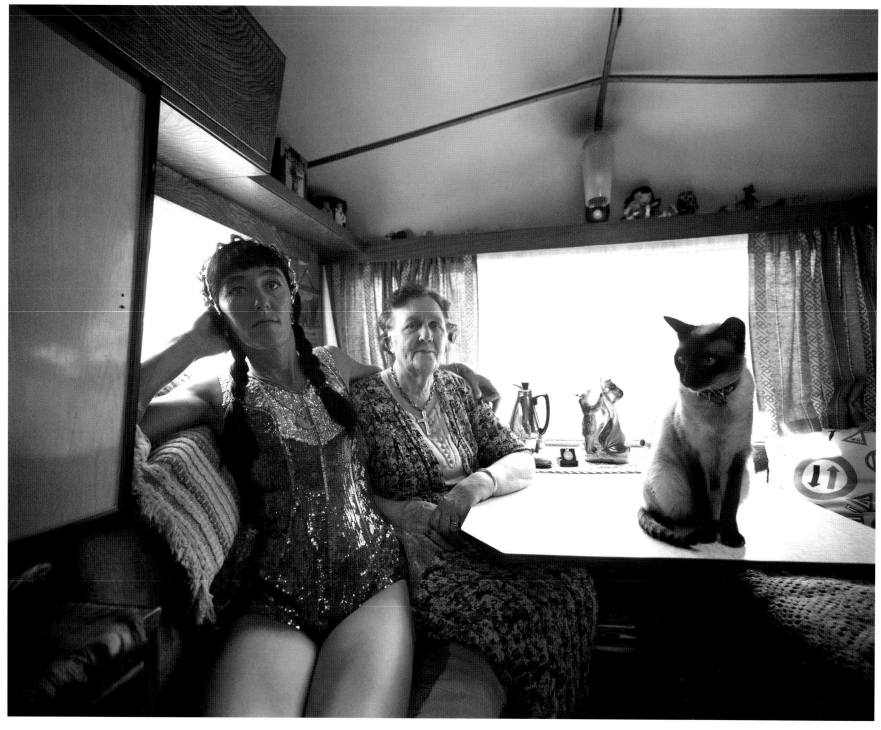

Bruce Davidson. Duffy Circus, 1967

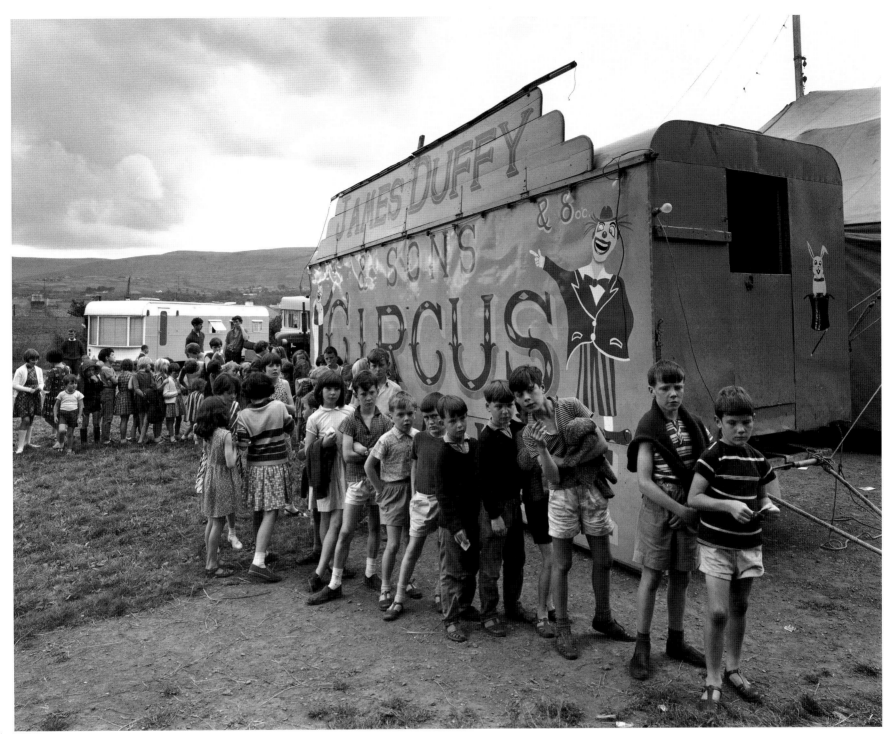

Bruce Davidson. Duffy Circus, 1967

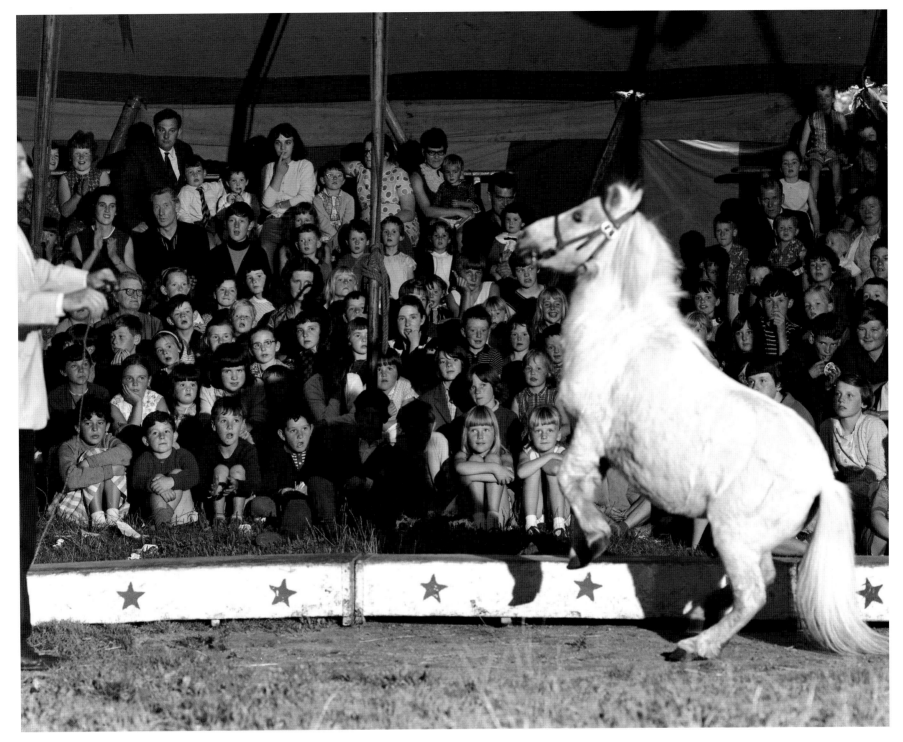

this page and opposite
Bruce Davidson. Duffy Circus, 1967

Erich Hartmann. Along Essex and Wellington Quays by the River Liffey. Dublin, 1964

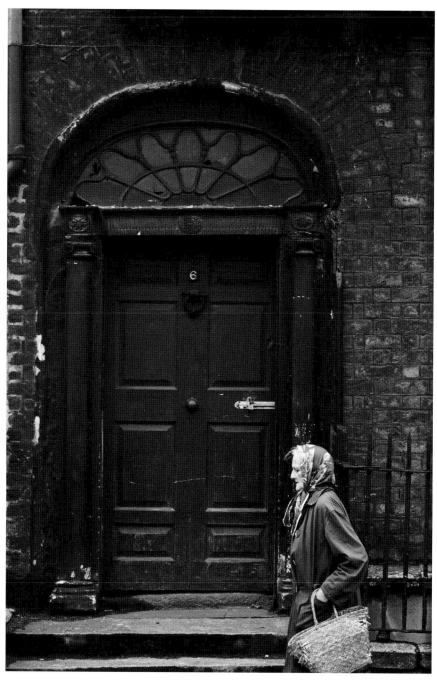

Erich Hartmann. Window on quay overlooking River Liffey. Dublin, 1964

Erich Hartmann. Along Essex and Wellington Quays by the River Liffey. Dublin, 1964

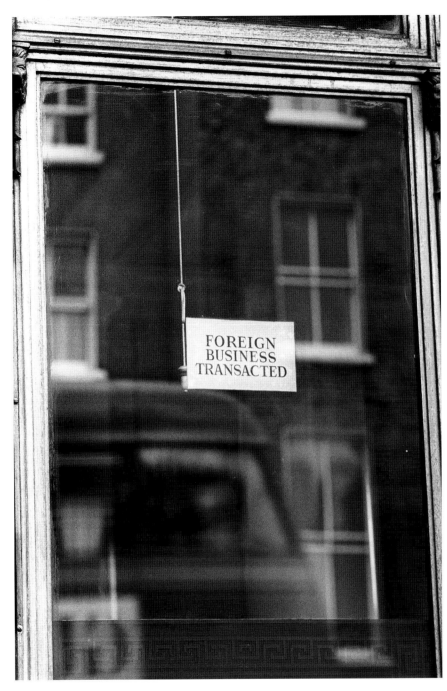

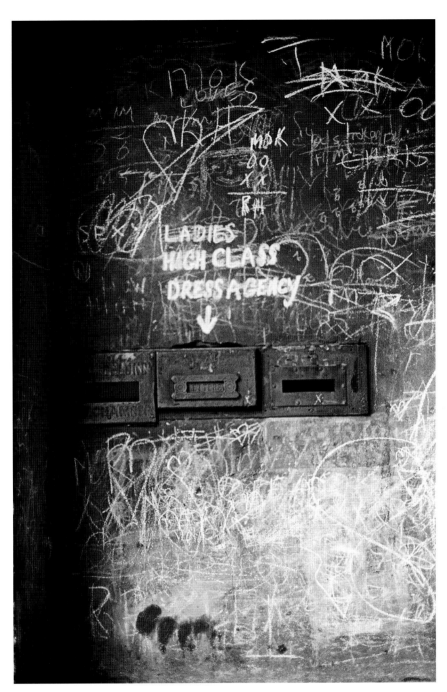

Erich Hartmann. Near Merrion Square. Dublin, 1964

Erich Hartmann. Graffiti near Abbey Theatre. Dublin, 1964

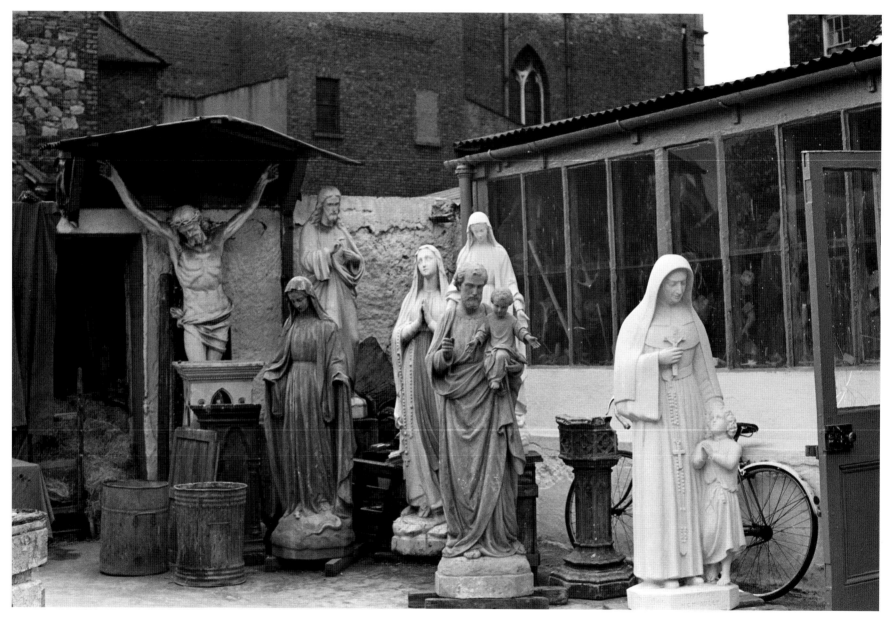

Erich Hartmann. Religious statues in manufacturer's yard. Dublin, 1964

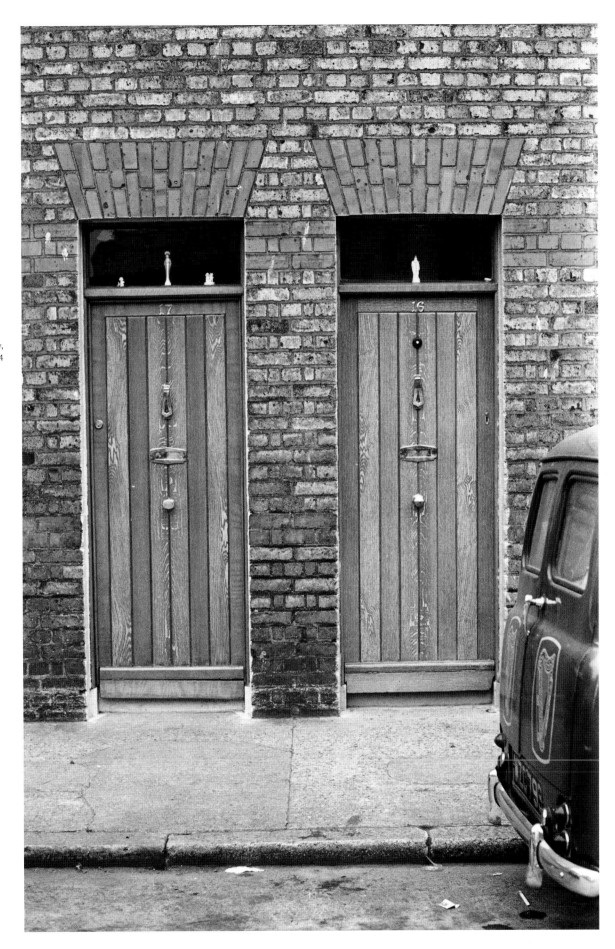

Erich Hartmann. Doorways along the River Liffey, Ormond and Arran Quays, Dublin, 1964

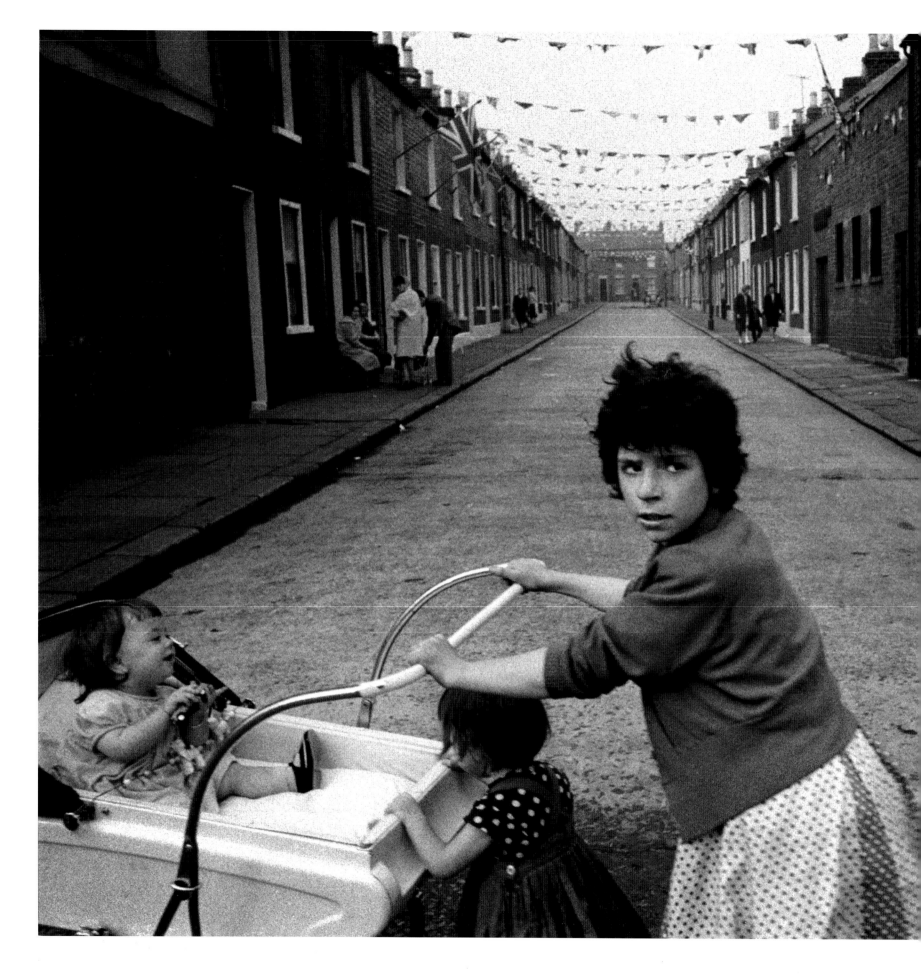

Philip Jones Griffiths. Ulster, 1965

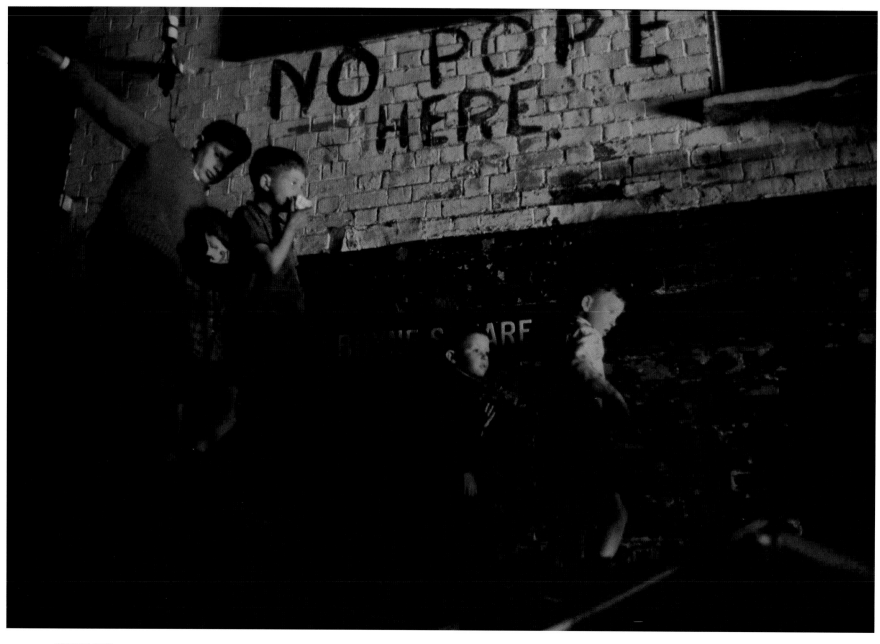

this page and opposite
Philip Jones Griffiths. Belfast, 1965

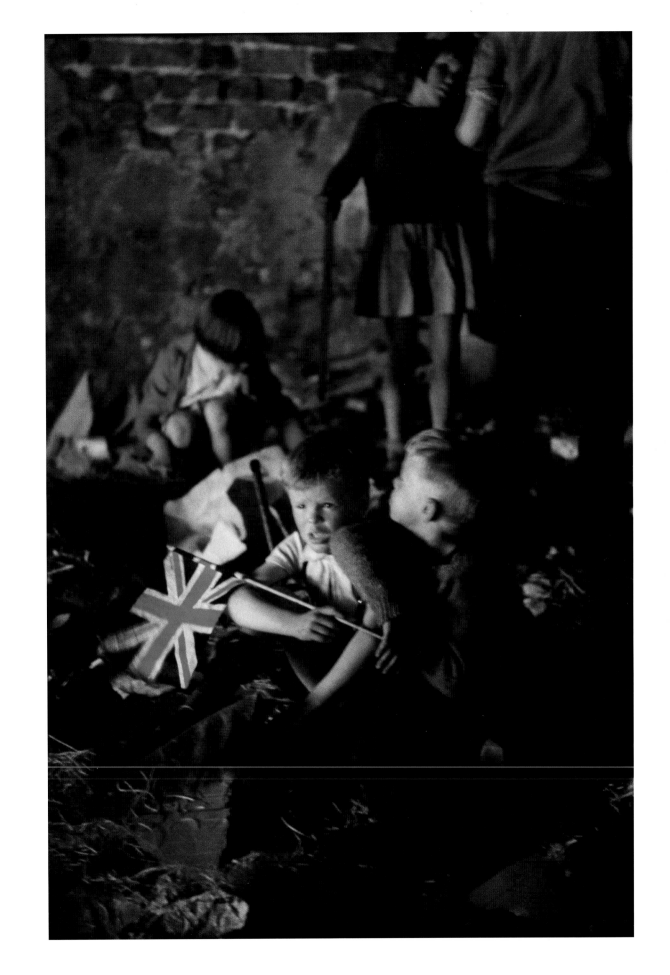

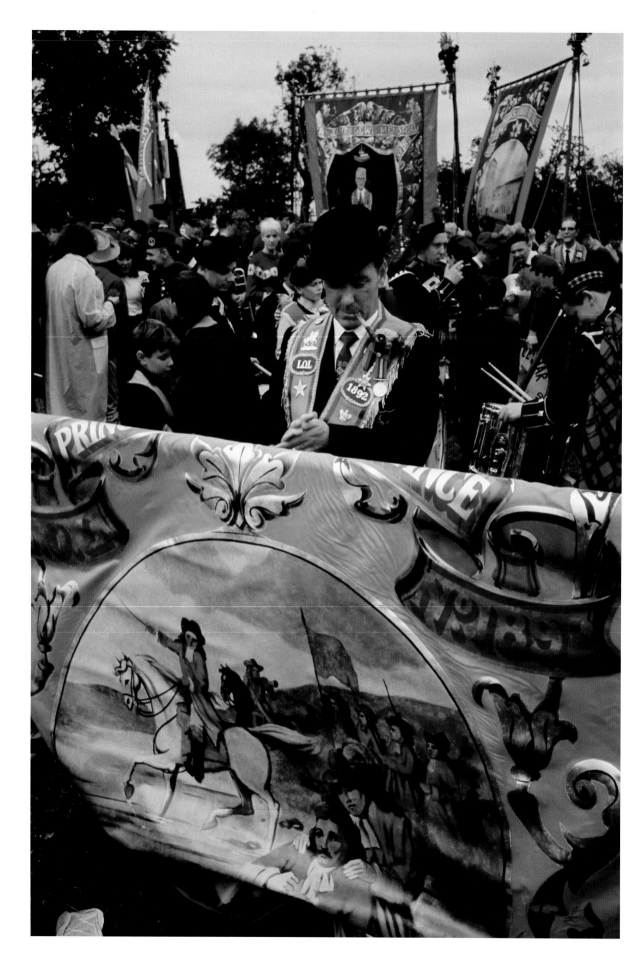

this page and opposite
Philip Jones Griffiths.
Battle of the Boyne celebration,
Drogheda, County Louth, 1965

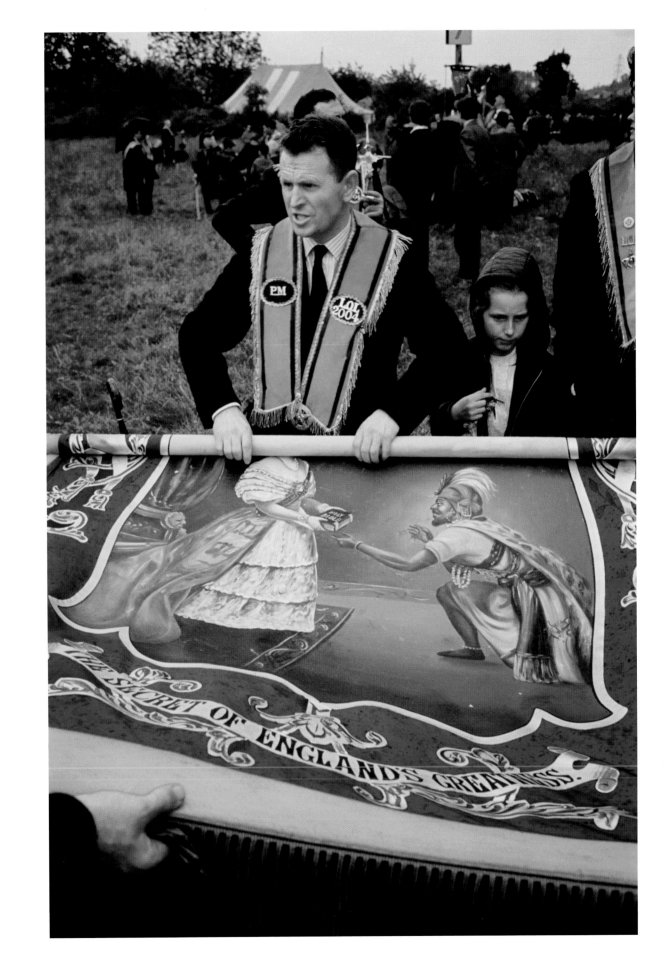

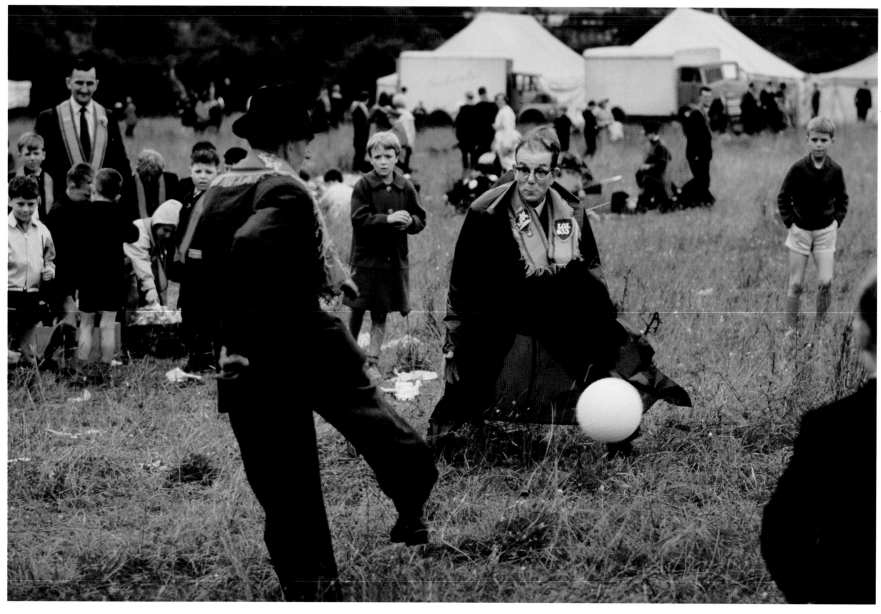

Philip Jones Griffiths. Battle of the Boyne celebration, Drogheda, County Louth, 1965

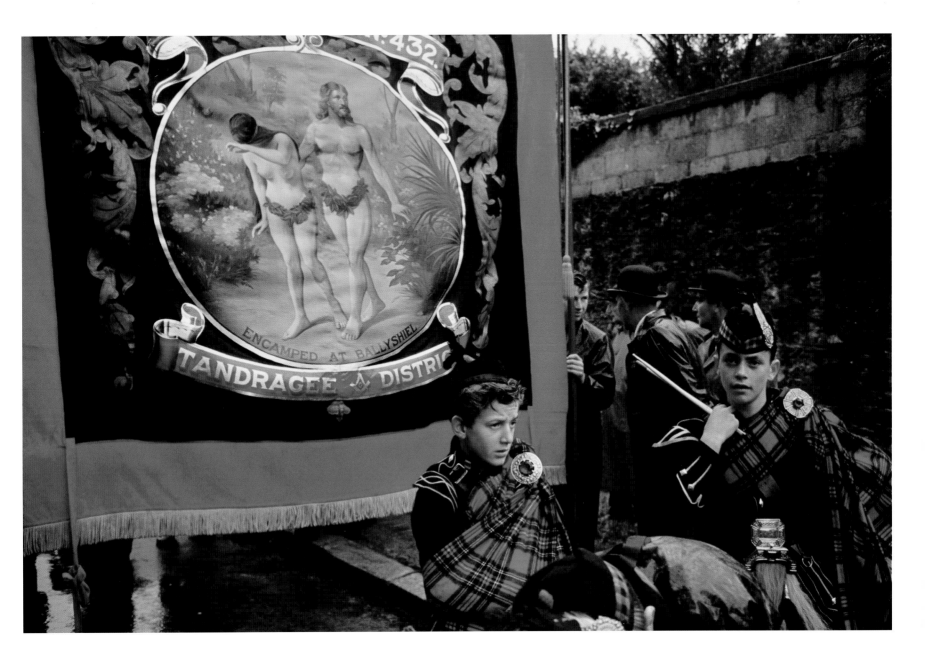

'70s

Josef Koudelka

Raymond Depardon

Abbas

Ian Berry

Bruno Barbey

Philip Jones Griffiths

Leonard Freed

Chris Steele-Perkins

Martin Parr

Hiroji Kubota

David Hurn

Thomas Hoepker

Eve Arnold

Dennis Stock

Marc Riboud

Peter Marlow

The '70s: Eamonn McCann

Time tends to impose order on the past. We look back on early days and think we discern the outline of all that came after. Knowing now how things happened, we assume this is the way it had to be.

But the trajectory wasn't pre-set. The chaos we felt around us was for real, and rich in possibilities other than those which came to pass.

The well composed, neatly cropped picture doesn't always say the truth. The snatched shot is sometimes more telling.

For half a century until the brink of the '70s, everything about Northern Ireland seemed static. Then came democracy on the streets and the rushing of crowds. It's hard to recall now the heady sense of change. It was tailor-made for self-indulgence. Since nobody knew for sure where we were headed, we could argue for any direction without seeming daft. Turning the world upside down seemed as sensible a proposal as it still is.

The civil rights movement had ushered the North into the '70s. We'd modelled ourselves a lot on the US, Malcolm X and Martin Luther King, saw ourselves as part of something huge happening everywhere. The thought had liberated us already from the restraints of our own history. Part of the world, ma. You could see it in the jaunty gait and Hendrix T-shirts of a chorus of cat-callers confronting baffled soldiers, sense it in nonchalant children who reckoned every battlefield a playground for boundless adventure.

There's a story told, and it may be true, of a ten-year-old girl hurtling down Rossville Street, stones in hand to take on the British Army, shouting, 'I've waited fifty years for this!'

The Provisional IRA emerged in 1970, breaking from the Movement which the more urgent street-fighters reckoned too ready to compromise. In the same year, John Hume updated constitutional Nationalism in founding the Social Democratic and Labour Party. Street-corner wits swiftly dubbed it the Stoop Down Low Party, which stuck.

By the beginning of '71, the gloves were off and the guns were out. By August, there were hundreds interned without trial. Rising rage swamped all thought of global perspectives, canny strategy or ideological cool. On a bright Sunday afternoon in January '72, paratroopers gunned down 27 in Derry, 14 dead, 13 wounded, who'd marched unarmed for an end to internment. And that was

that for civil rights. Anger in Dublin ignited the British Embassy. In late-night pubs, 'We Shall Overcome' gave way to 'The Boys of the Old Brigade,' the old certainties disdainfully reasserting themselves. The Brits sussed the one-party government game was up and abolished the fifty-year Unionist parliament at Stormont. On the streets of Belfast, IRA car-bombers reduced shoppers to offal and shreds.

The Brits went hugger-mugger with Loyalist assassins, to terrorize the Catholics into yielding up the 'Ra. Horror set in to re-paralyze politics.

It might be said that from the mid-'70s until next year (whenever) nothing significant shifted. The agreement negotiated amid the leafy ambience of Sunningdale, Kent, in late '73 between Dublin, London and all Northern forces of putative moderation involved power-sharing in the North and an all-Ireland 'dimension'. Every initiative since has been, in the nice phrase of pithy Stoop deputy leader Seamus Mallon, 'Sunningdale for slow learners.'

Sunningdale was trashed by a Protestant strike in '74. Protestant workers were able to grind the North to a standstill because they held almost all the key jobs. Not for long, though.

One of the reasons the Catholics had taken fairly easily to revolt was that the economic balance was shifting. The Northern economy had expanded from World War Two until 1973. From then, it began to contract. This has widely been put down to political violence deterring investment: but it had more to do with oil prices, a weak UK economy and the unstoppable decline in shipbuilding and heavy engineering, the industries of the Protestant redoubt which had provided skilled jobs for generations and underpinned a sturdy culture of respect for good order. Fearful for their economic as well as constitutional future, and under siege from, as they saw it, Catholic hordes on the rampage, Protestant workers tore down the Sunningdale structures, then found they had nothing to erect in their place.

The North was scorched earth for the rest of the decade. Soldiers continued to crack heads and shoot to kill, teenagers joined the 'Ra or, according to community, counter-'Ra outfits which reckoned the Brits weren't hitting the Catholics hard enough. Steady streams from the ghettoes replenished the prison blocks, which by the end of the decade were smeared with caked shit as young men refused convict uniforms or meekly to serve their time, believing that the shooting or bombing they'd been

convicted of had been a political and not a criminal act. Resolve was stiffening towards hunger strike.

The Ireland of thatched cottages and comely maidens, to the extent that it ever existed, hadn't entirely disappeared. There was a preservation order on certain examples. It's what the Republic's tourism experts believed tourists still wanted. Along the west coast and south of the borderlands, it could seem at times and in certain lights that nothing had disturbed the tranquillity of ages. Flurries of fierce Nationalism, as after Bloody Sunday, tended to subside soon enough. Loyalist paramilitaries in collusion with British agents killed 35 in Dublin and Monaghan in bombings backing up the strike which brought Sunningdale down. Grief and anger glutted bereaved families, but didn't shudder the stability of the State. The South was different.

Nevertheless, the changes under way were at least as profound as any being played out in the hectic North, and presaged convergence.

The same economic forces undermining traditional manufacturing around Belfast were to generate new ways of living down South. Jack Lynch and Fianna Fáil had won a general election in 1969 and were working flat out, in partnership and parallel with Britain, for entry into the European Community. They joined as an attached couple on 1 January 1973, just as the imminently ill-fated Sunningdale arrangements were being meticulously assembled. There have been turbulent times in the relationship since. But both parties have wanted it to work, and the match has lasted.

By the end of the '70s, the Republic was receiving more than £400 million a year from the EEC, while contributing just under £40 million. Education was transformed to meet the needs of a young European economy. Between 1971 and 1981, the number of girls at secondary school more than doubled, numbers attending third level had grown by 180 per cent. The number of women at work grew by 34 per cent – married women, from a rock-bottom base of 24,000, by a giddy 435 per cent. The changes wormed away assiduously at the notion that Irish women should be content with sexual repression under the stern domination of an all-male Church.

The Irish Women's Liberation Movement, partly inspired by the civil rights upsurge in the North, was founded in 1970. Six years later, the Contraception Action Programme began defying the law by selling condoms and accoutrements. Business was especially brisk at music festivals which drew vibrant assemblies of guiltless youngsters attracted by occasions of pleasurable sin. In 1979 Minister for Health Charles Haughey, at the time conducting an unfeasibly active adulterous affair, introduced a Bill making contraceptives legally available, strictly to married couples only and 'for bona fide family planning purposes'. It was a start. In the same year, Pope John Paul II pleaded with a gathering of rock festival proportions in Limerick to make Ireland a 'beacon of pro-life values'. But he was too late.

What remains most sharply in the mind from the early days of the decade isn't dismay at atrocity but the thrill of the sense of the birth of mass power. To an extent that had never been experienced before and hasn't been repeated since, the people were active participants in significant events, not spectators at the political show. The crowd on the street was the lead actor, not an amalgam of extras to be summoned when Leadership thought demos appropriate. Every voice against oppression was given a hearing. History wasn't an appeal court we had recourse to for validation but something we were conscious of being in the process of making. This was the most democratic place and period in modern Irish history. It is by no means a coincidence that it was the time of most rapid progress, too. Effectively, in fifty years previously there had been three Stormont Prime Ministers, then three in three years and Stormont abolished when the last of them fell, and some in the South looking wonderingly on.

By the end of the decade, armed struggle had replaced mass action, narrowing the basis of struggle and, in the end, facilitating the comeback of old authority. North and South, the class which ruled in 1970, despite all, rules still. But people who have envisaged the world better, for even a moment, are never wholly content. The best we can say of the '70s is that they aren't over yet.

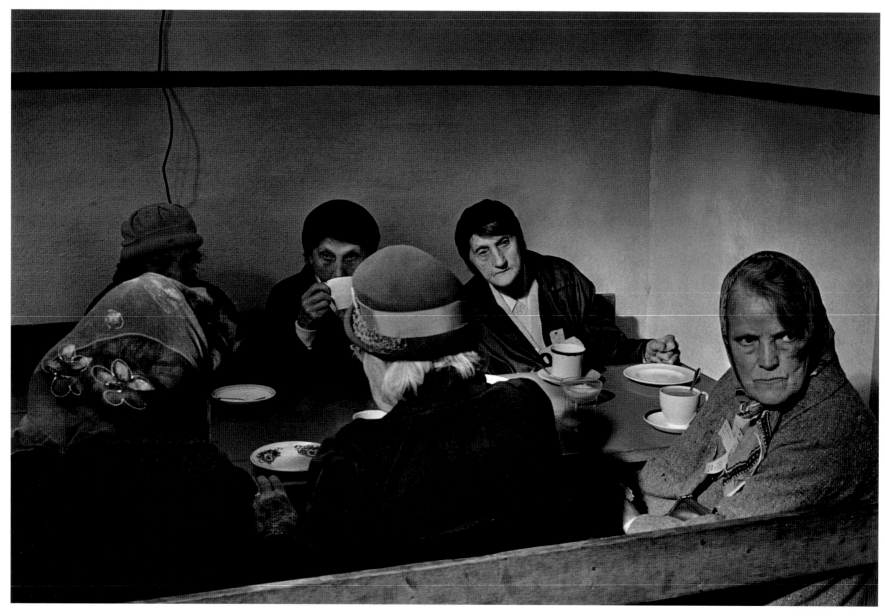

Josef Koudelka. 1971

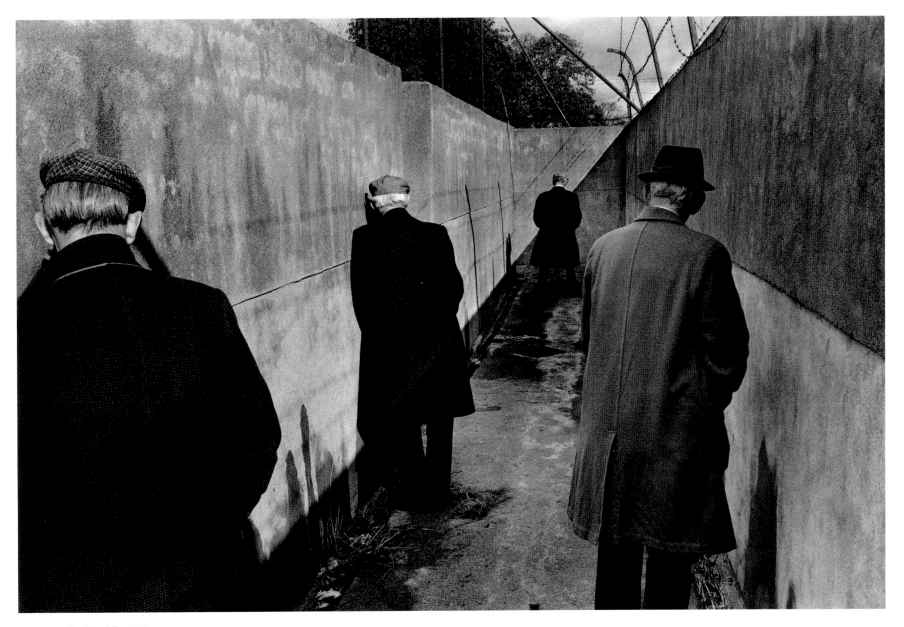

Josef Koudelka. 1976

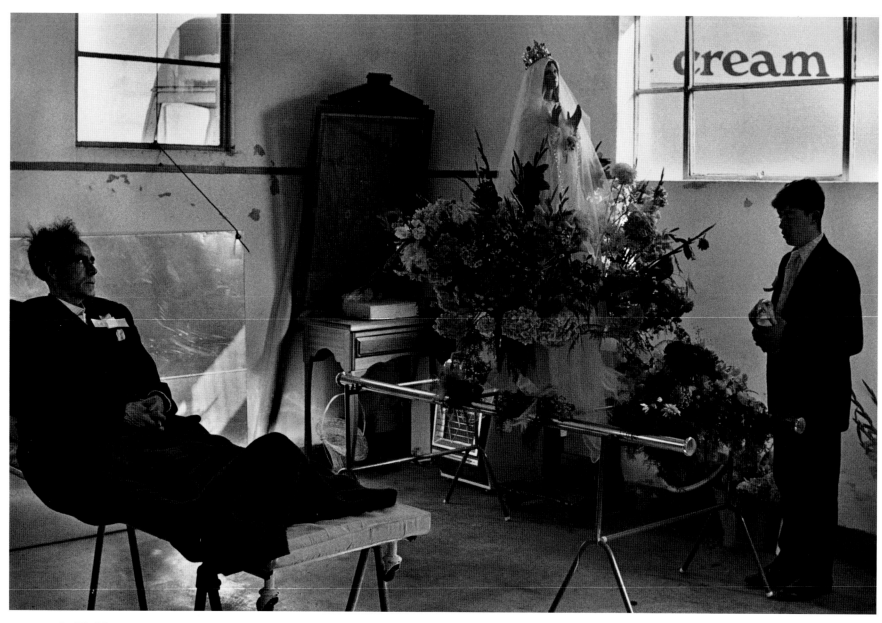

Josef Koudelka. 1971

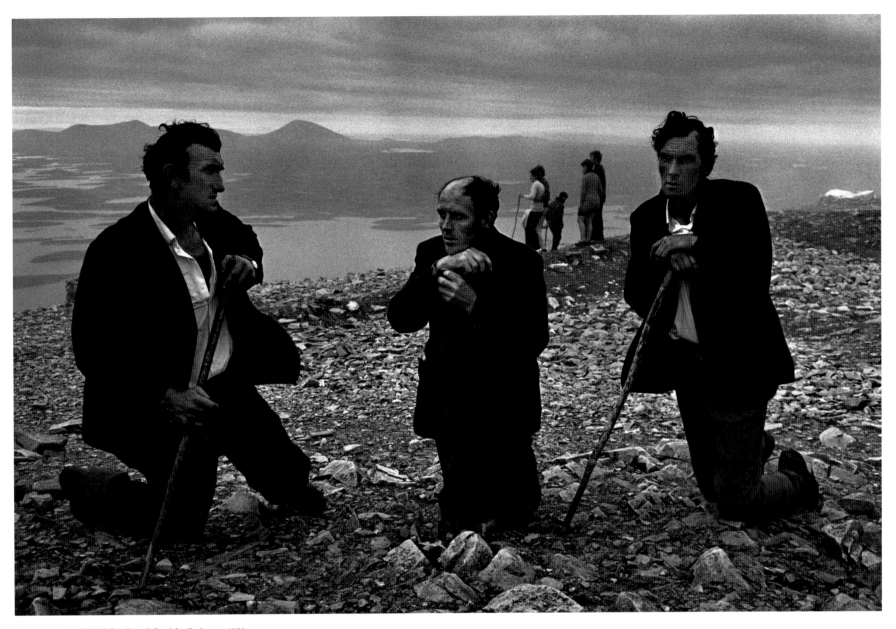

Josef Koudelka. Croagh Patrick pilgrimage, 1972

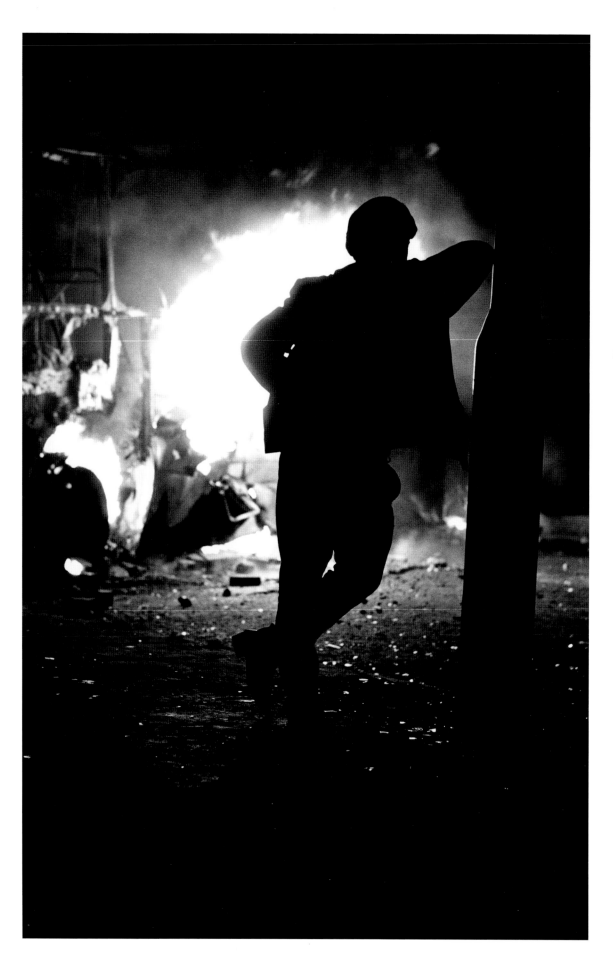

Raymond Depardon. Derry/Londonderry, 1971

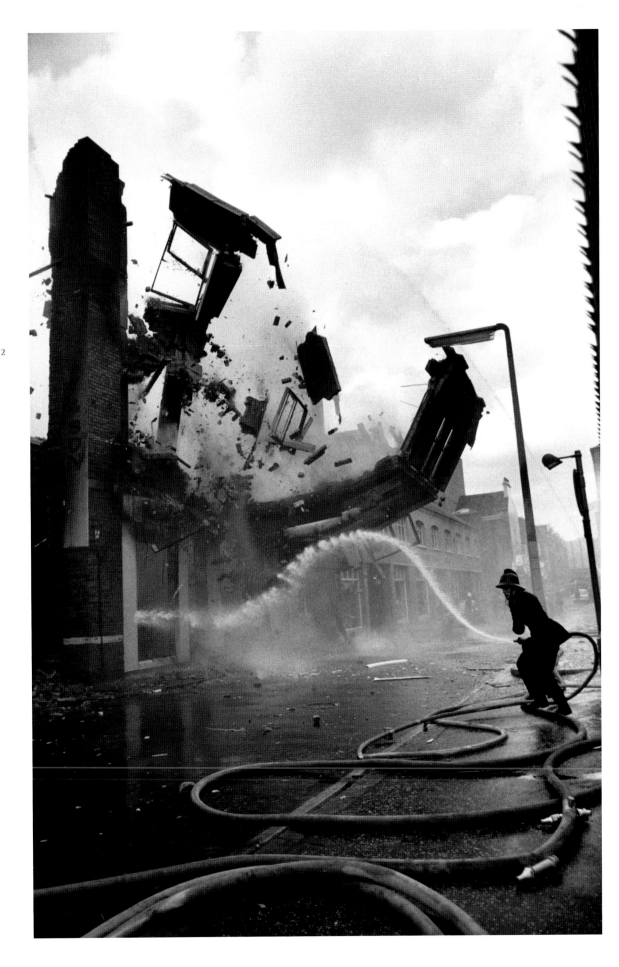

Abbas. Belfast, 1972

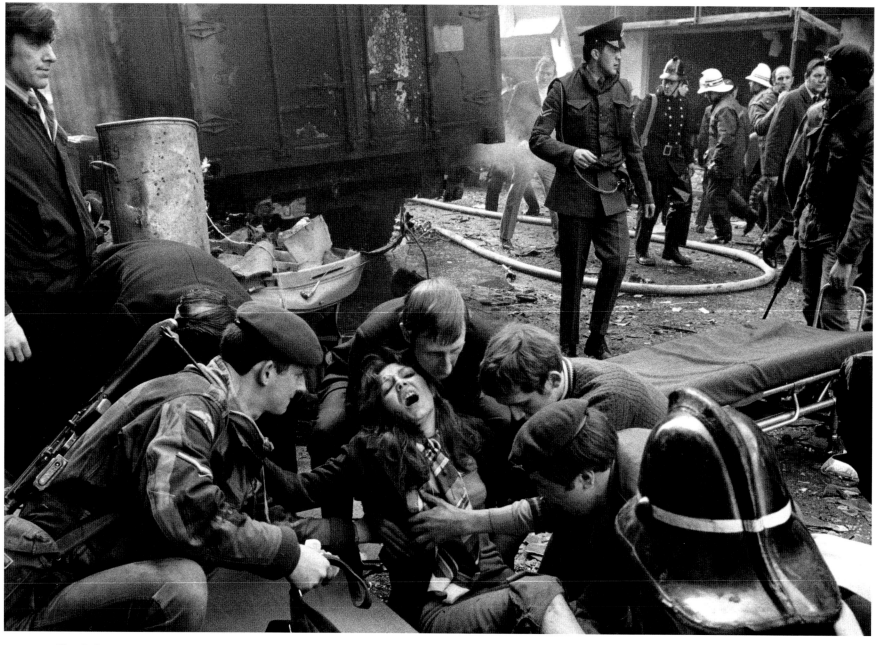

Abbas. Civilian wounded by an IRA bomb explosion in the city centre. Belfast, 1972

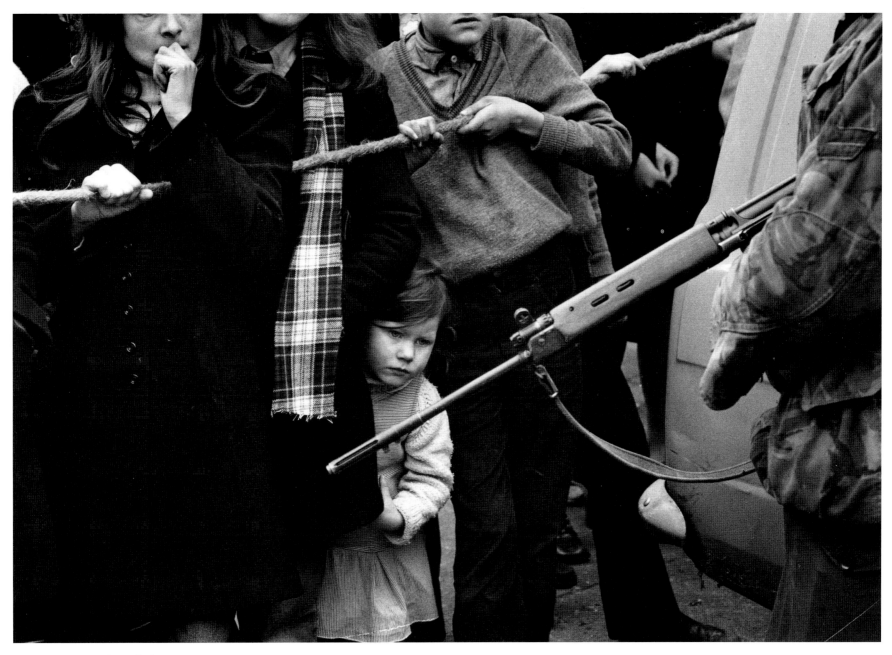

Abbas. Northern Ireland, 1972

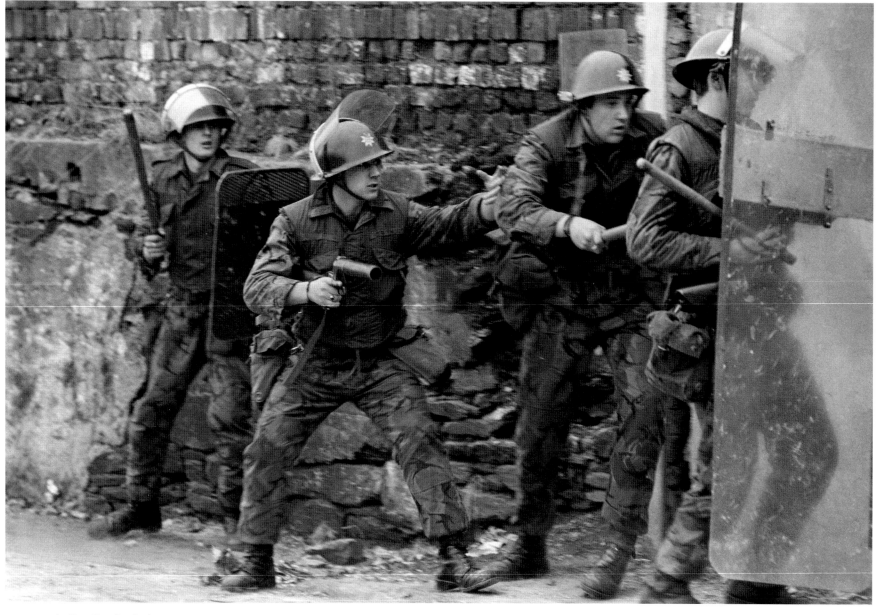

Ian Berry. Derry/Londonderry, 1971

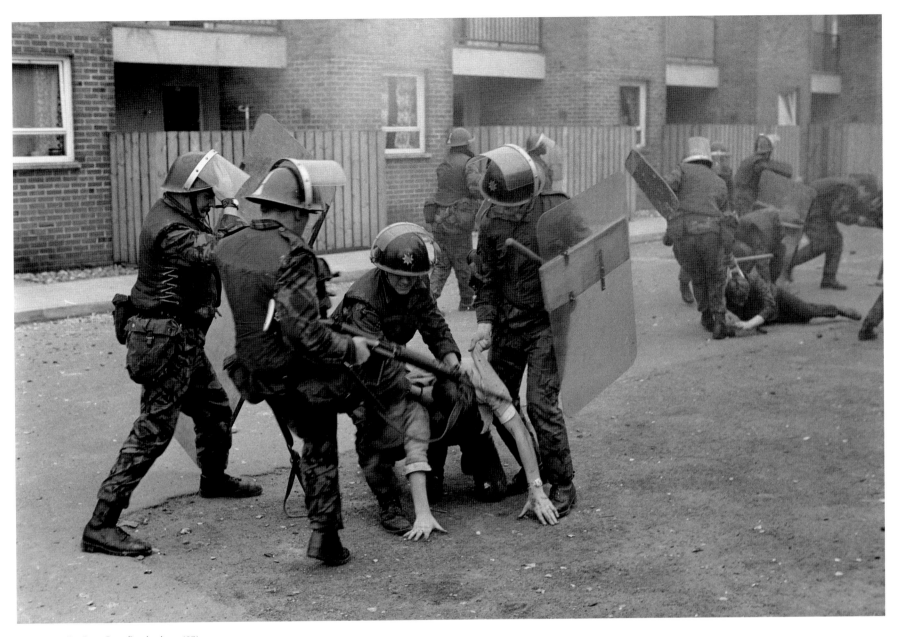

Ian Berry. Derry/Londonderry, 1971

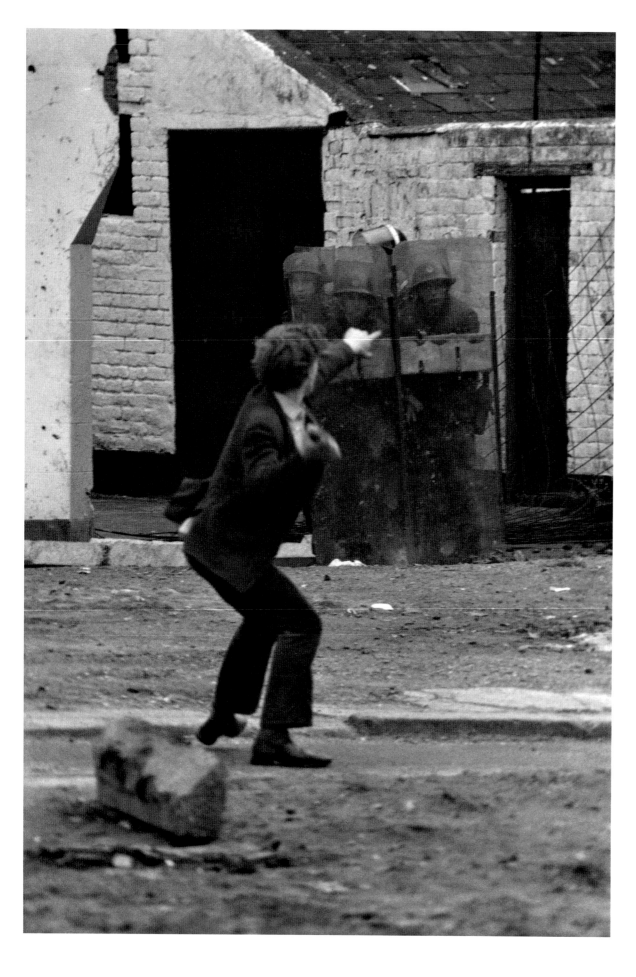

Ian Berry. Derry/Londonderry, 1971

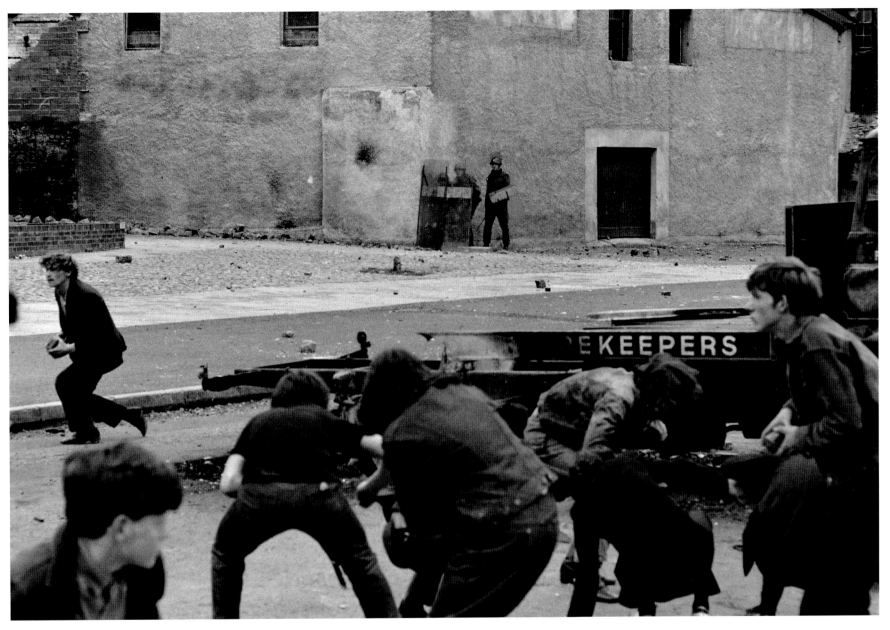

Ian Berry. Three isolated soldiers are stoned by IRA sympathizers. Derry/Londonderry, 1971

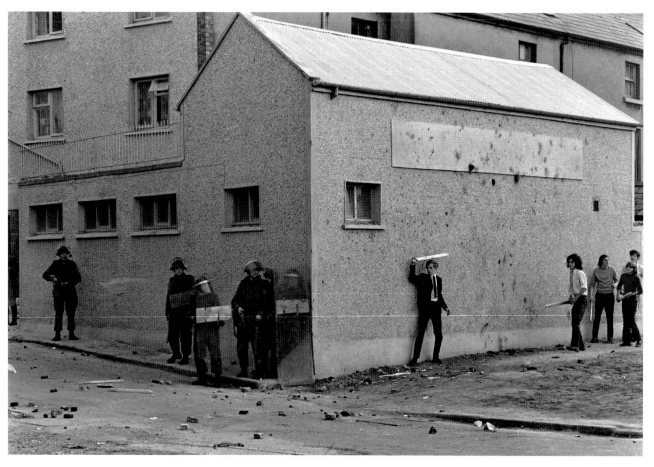
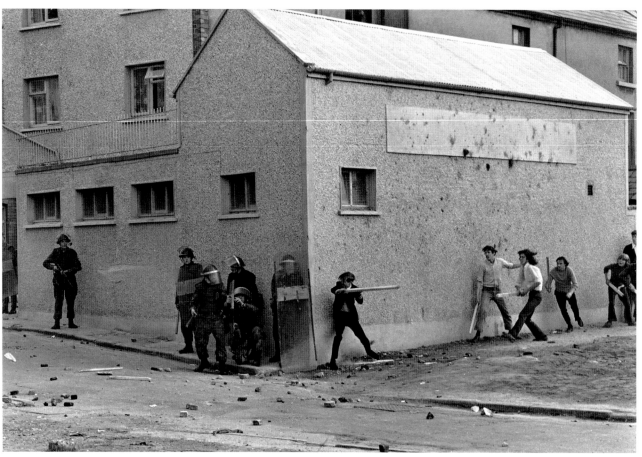

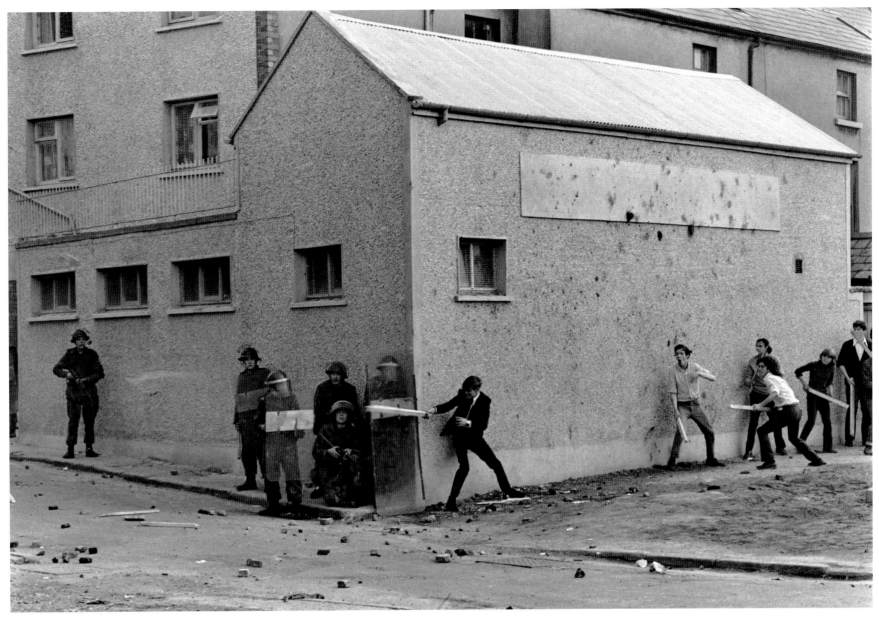

Bruno Barbey. Street-fighting against British soldiers. Derry/Londonderry, 1971

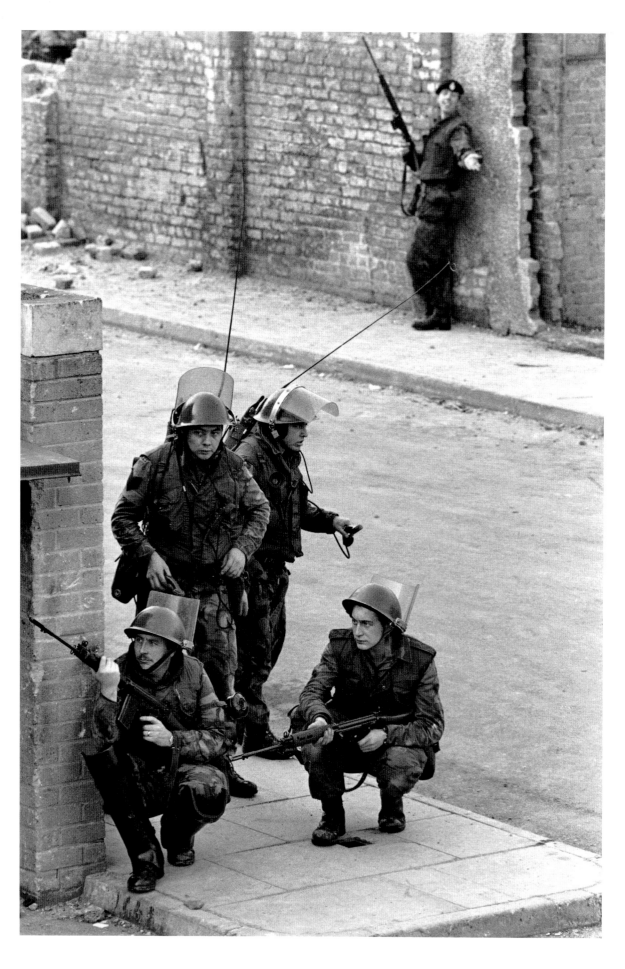

Bruno Barbey. British soldiers in a street fight with children. Derry/Londonderry, 1971

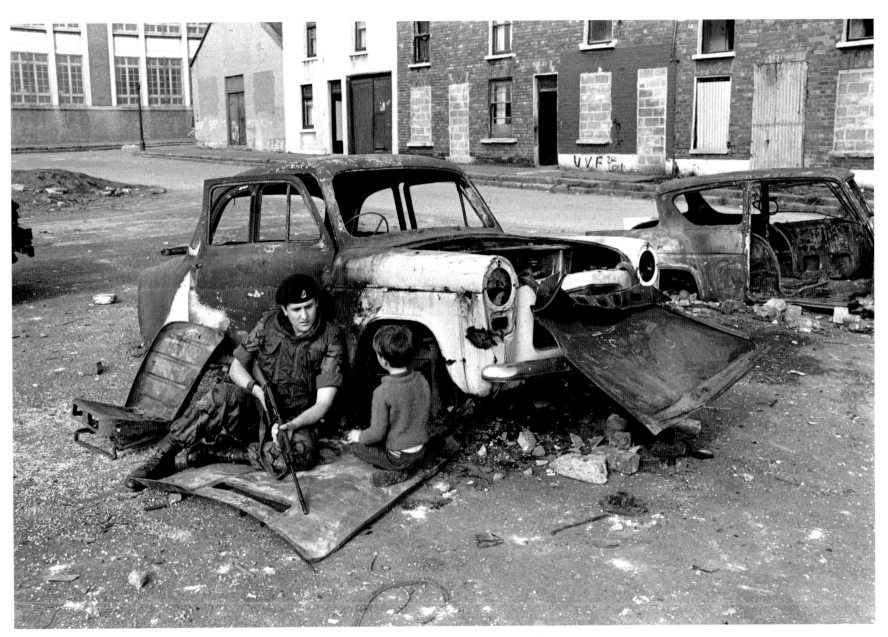

Bruno Barbey. A British soldier speaking with young boy. Usually children and soldiers are on opposite sides during street riots. Belfast, 1971

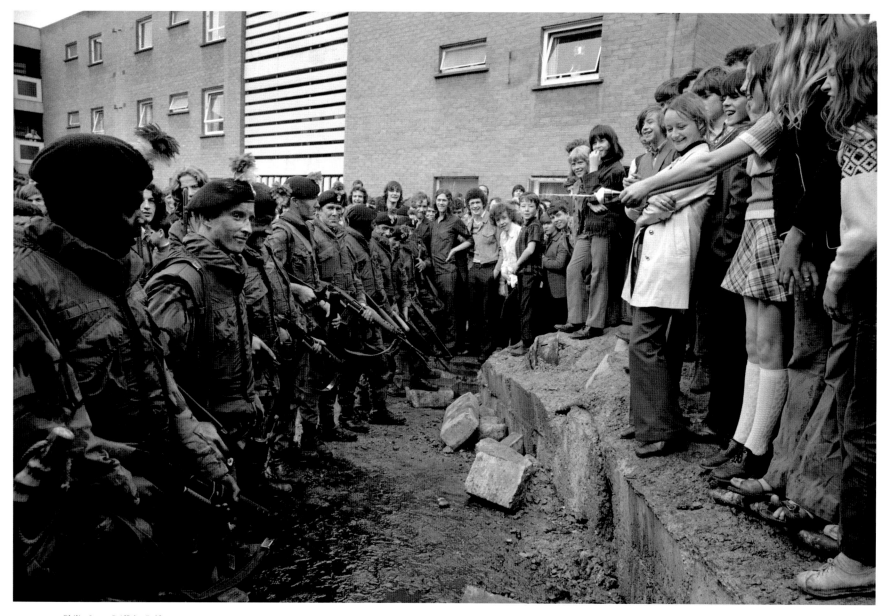

Philip Jones Griffiths. Belfast, 1972

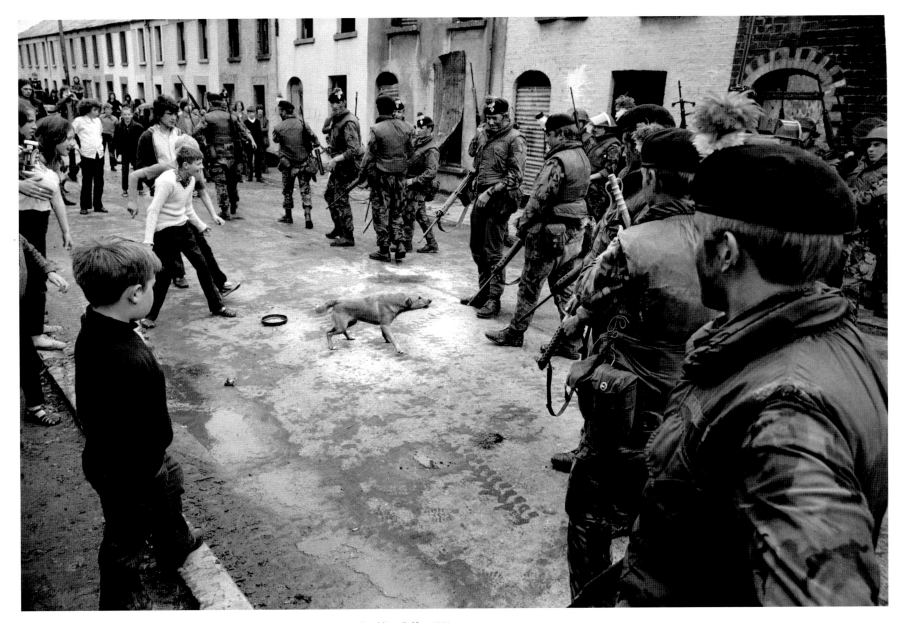

Philip Jones Griffiths. Some owners trained their dogs to be aggressive towards soldiers. Belfast, 1972

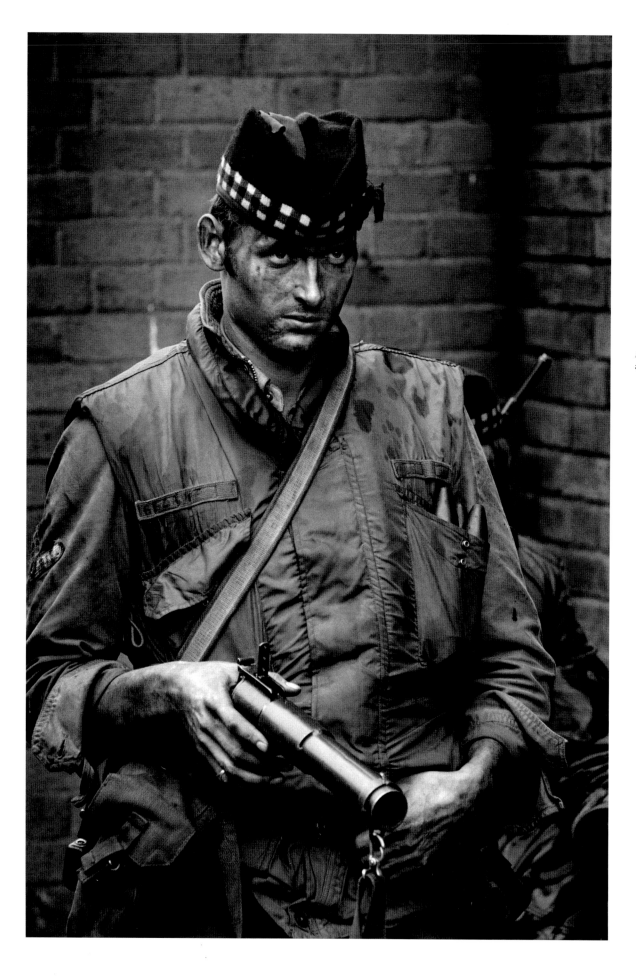

Philip Jones Griffiths. British soldier facing a hostile crowd of youngsters. Belfast, 1972

Philip Jones Griffiths. Belfast, 1973

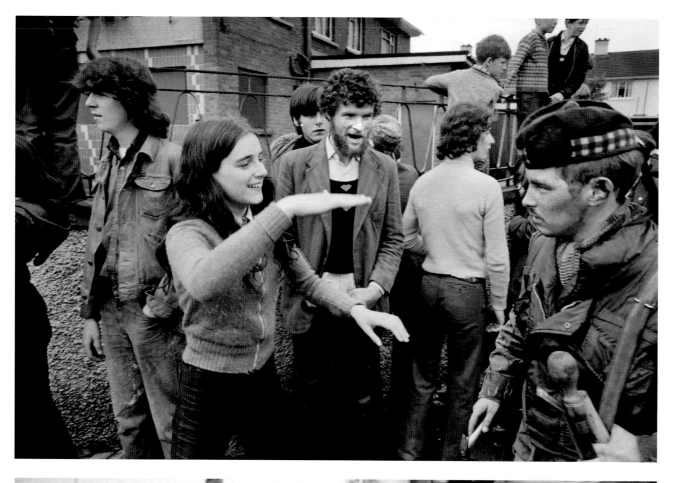

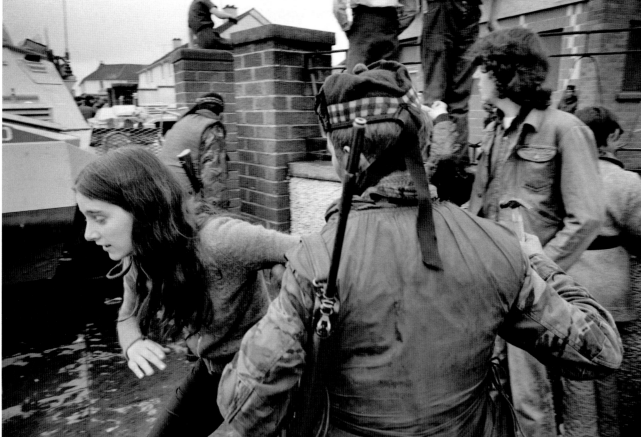

Philip Jones Griffiths. Catholic girl mocks a British soldier (above). He retaliates with a hammer (below). Derry/Londonderry, 1972

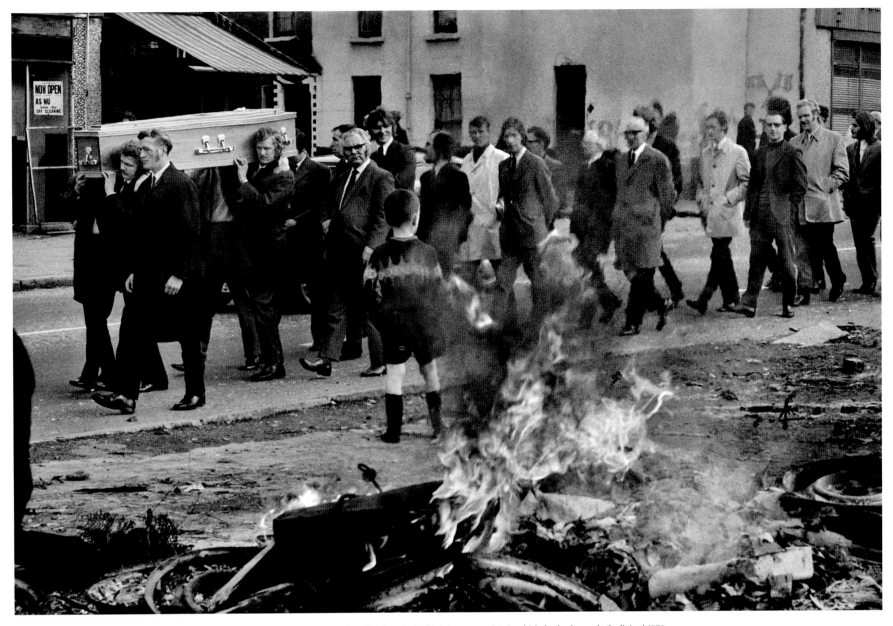

Philip Jones Griffiths. Funeral procession. As an Irish poet put it, 'The tragedy of Northern Ireland is it is now a society in which the dead console the living.' 1972

Philip Jones Griffiths. Soldier behind shield. Northern Ireland, 1973

Leonard Freed. Derry/Londonderry, 1971

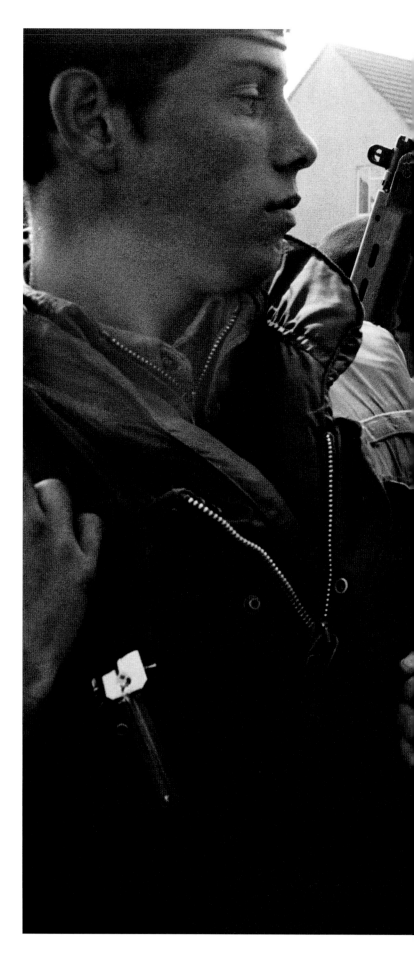

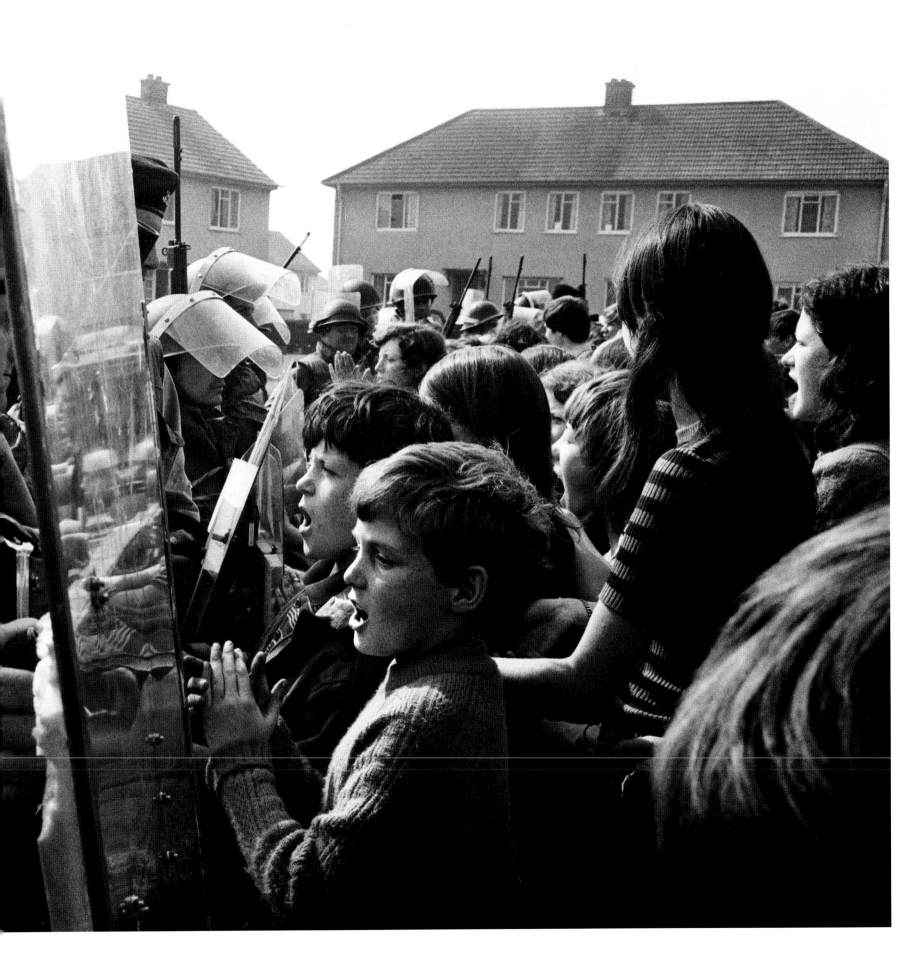

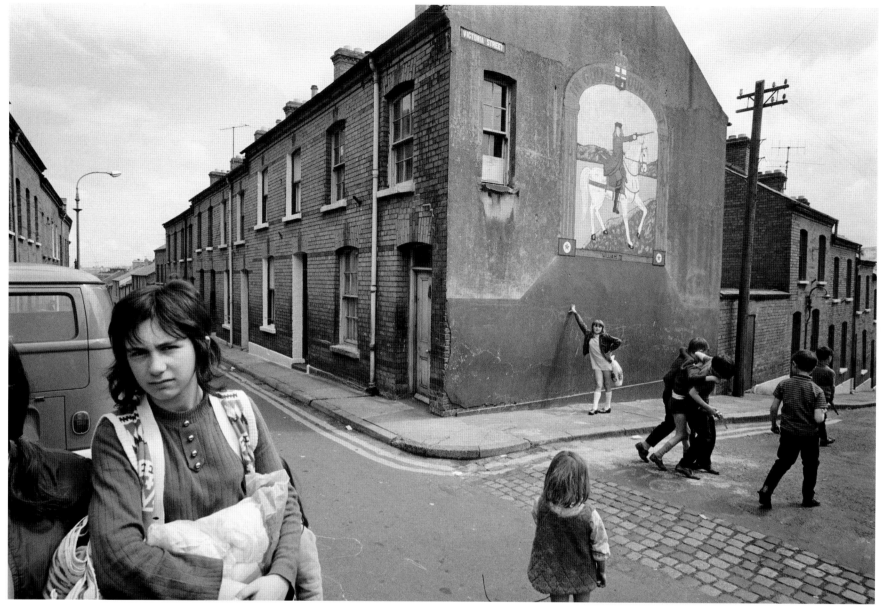

Leonard Freed. Derry/Londonderry, 1971

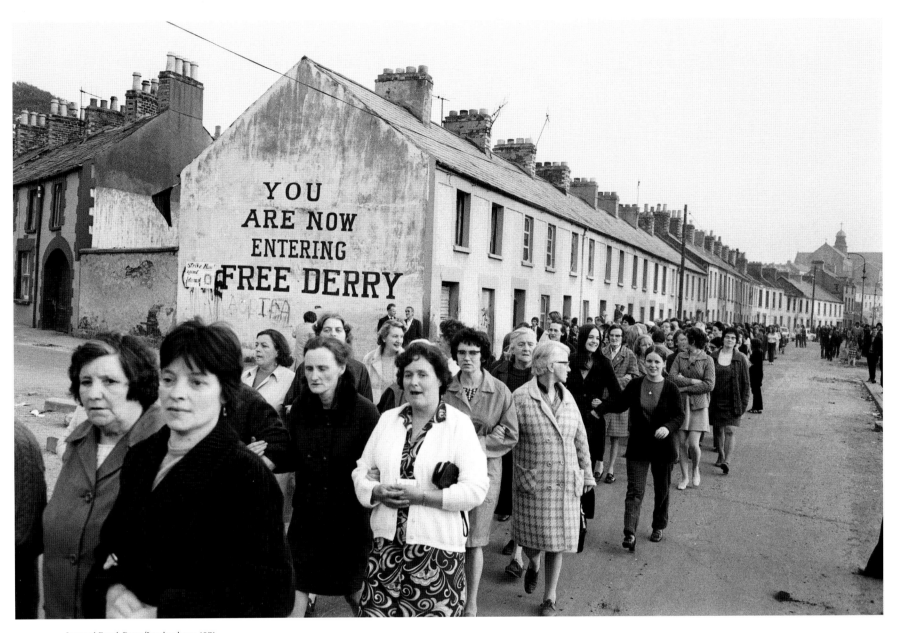

Leonard Freed. Derry/Londonderry, 1971

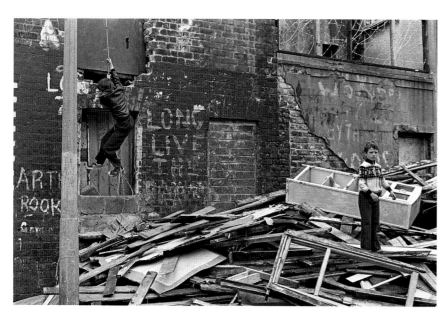

Chris Steele-Perkins. Kids playing in abandoned housing off Falls Road, West Belfast, 1978

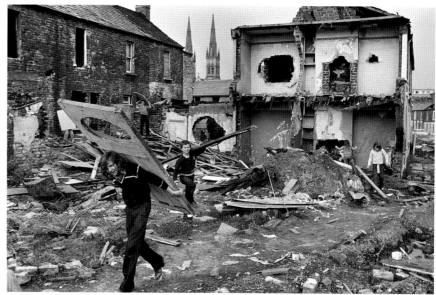

Chris Steele-Perkins. Collecting scrap from old houses, West Belfast, 1978

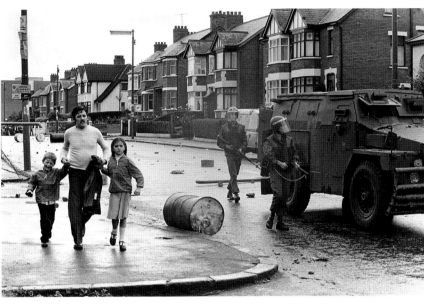

Chris Steele-Perkins. Street scene in Catholic West Belfast, 1979

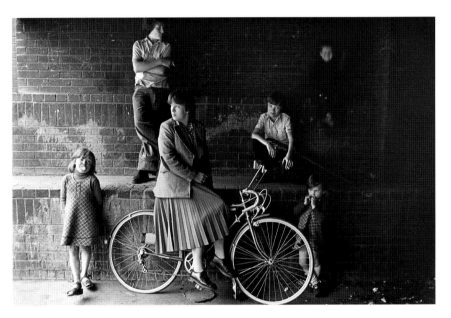

Chris Steele-Perkins. Group of kids in Divis Flats, West Belfast, 1978

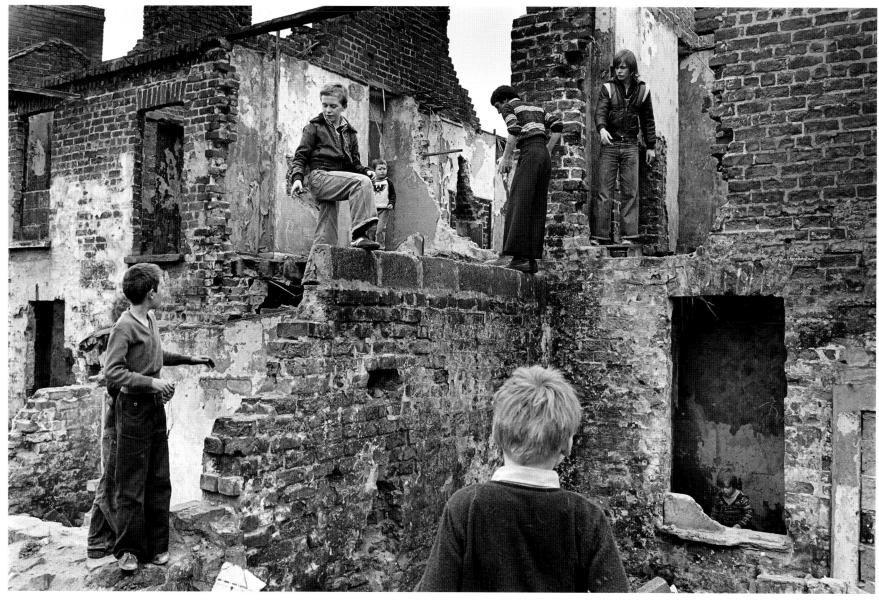

Chris Steele-Perkins. Playing in abandoned buildings near Divis Flats, West Belfast, 1978

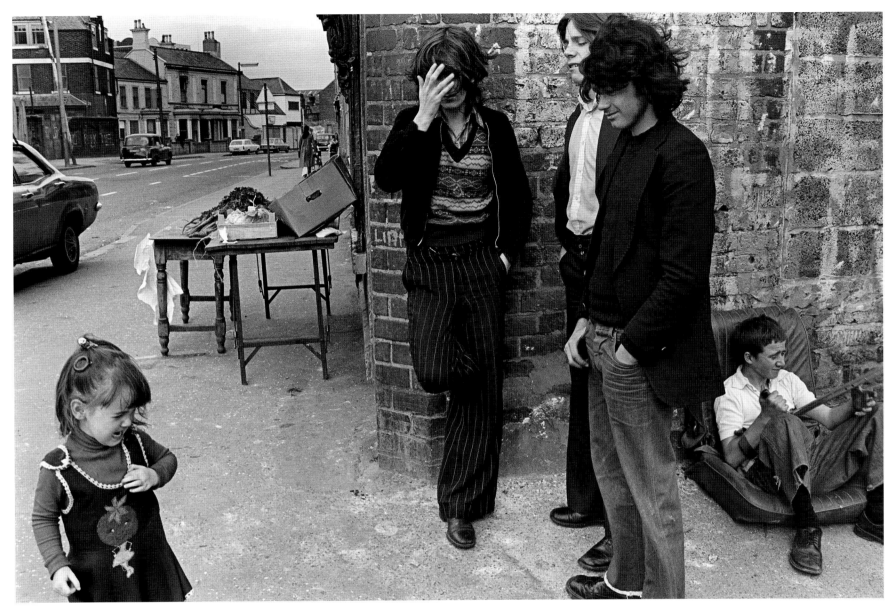

Chris Steele-Perkins. Street corner, West Belfast, 1978

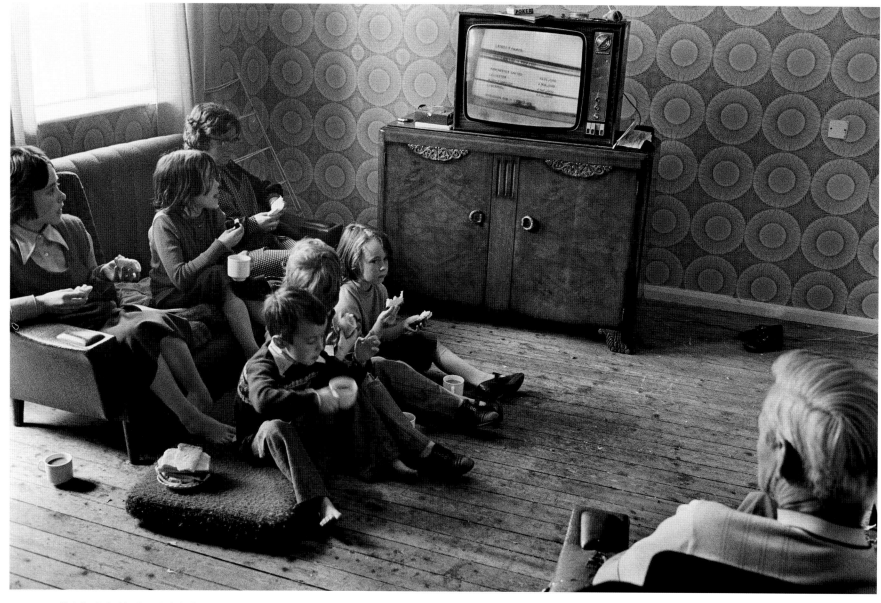

Chris Steele-Perkins. Poor Catholic family eating lunch, West Belfast, 1978

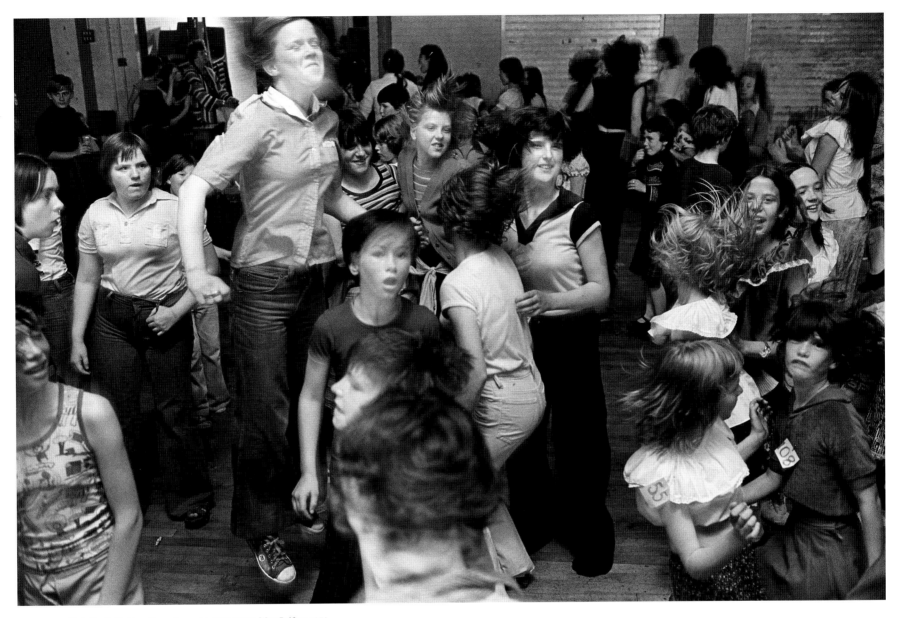

Chris Steele-Perkins. Disco at a community centre. West Belfast, 1978

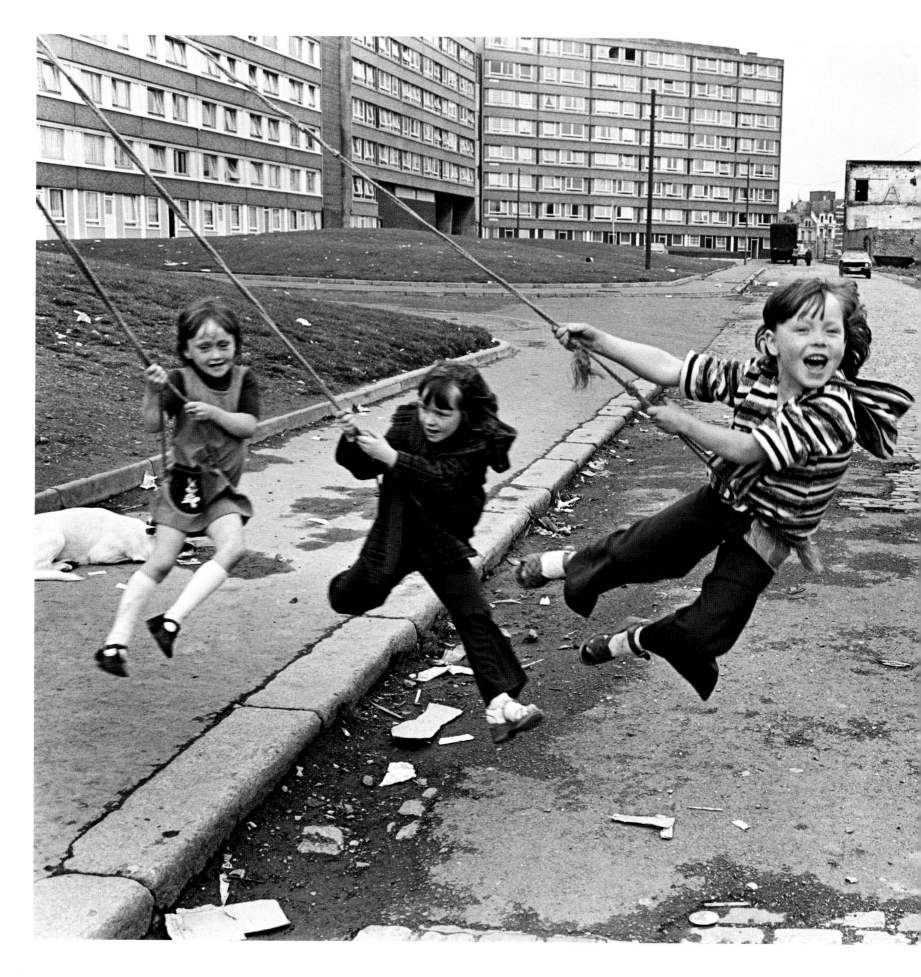

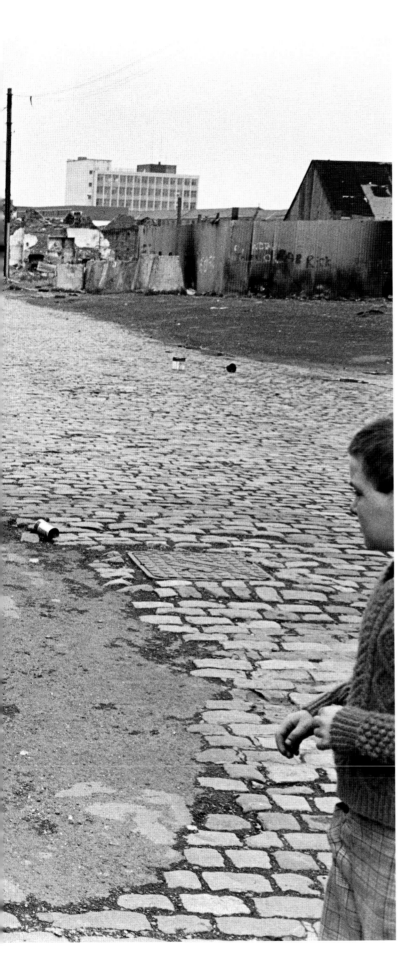

Chris Steele-Perkins. Outside Divis Flats, West Belfast, 1978

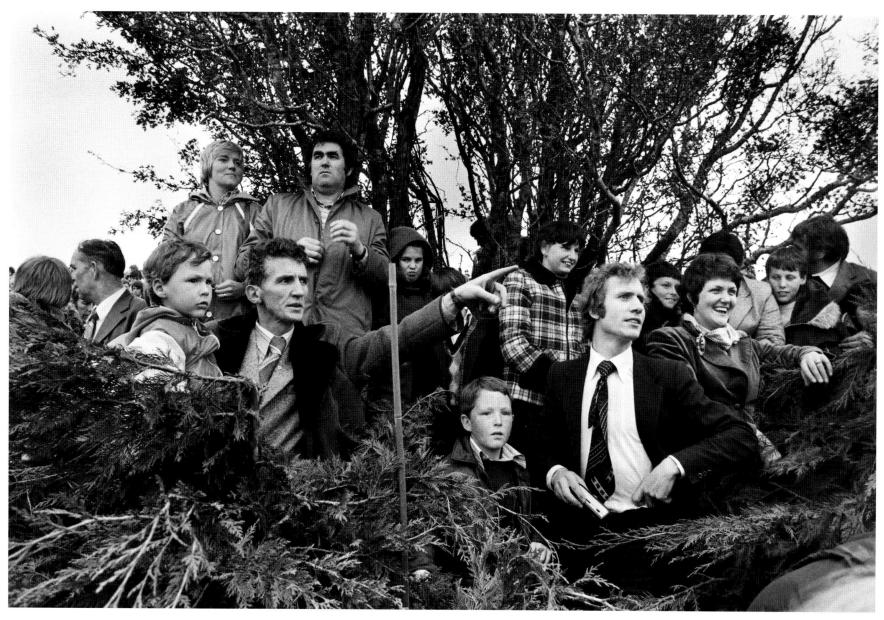

Martin Parr. Pope arrives at Knock, 1979

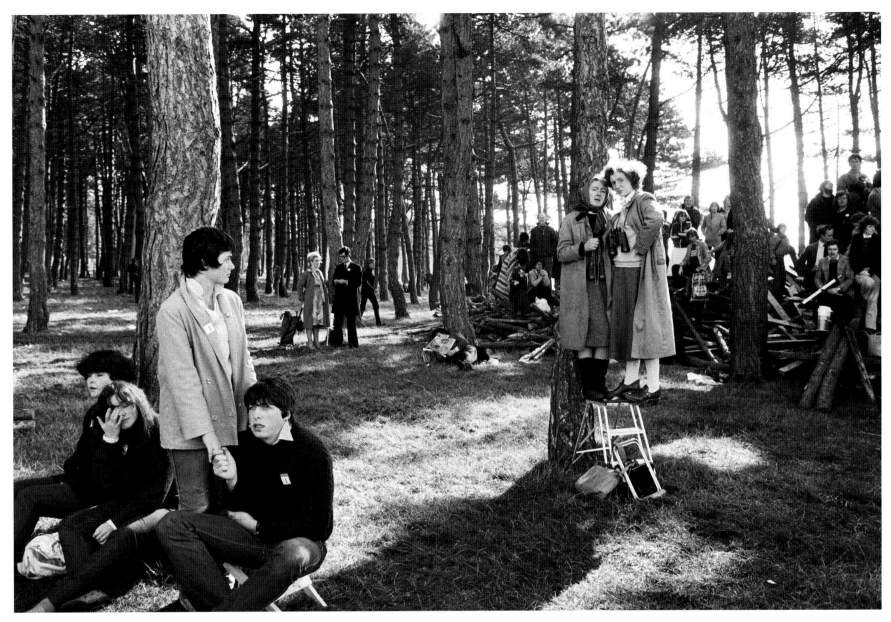

Martin Parr. Pope arrives at Knock, 1979

Hiroji Kubota. Aran Islands, 1972

Hiroji Kubota. Aran Islands, 1972

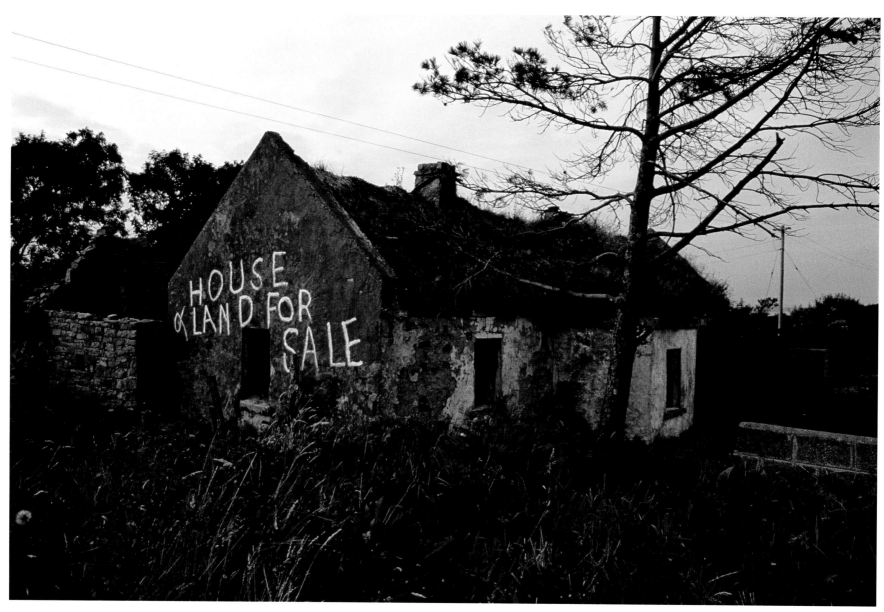

David Hurn. House for sale, southwest Ireland, c. 1970

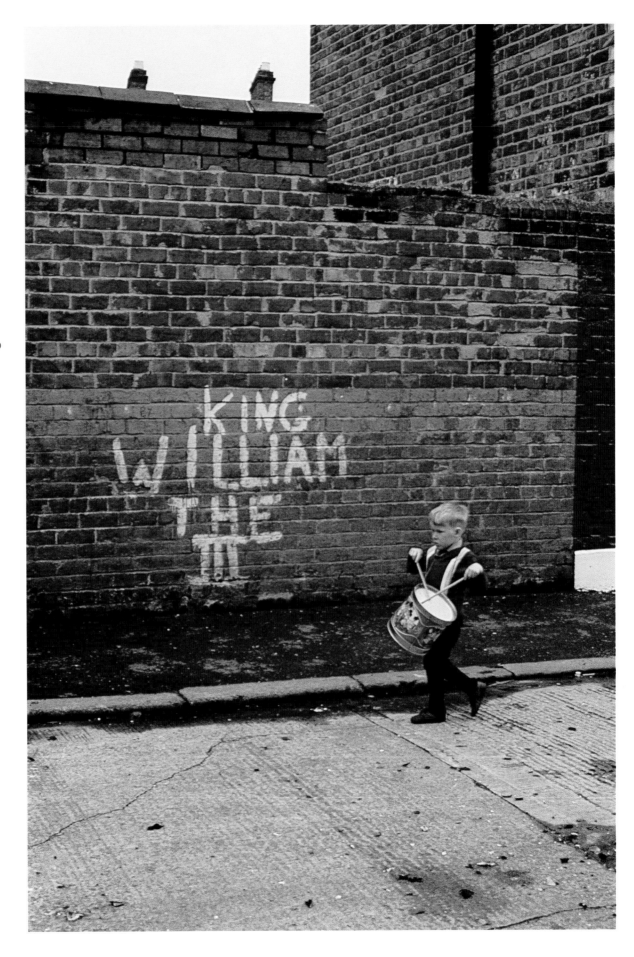

David Hurn. Protestant area of Belfast, c. 1970

David Hurn. Southwest Ireland, c. 1970

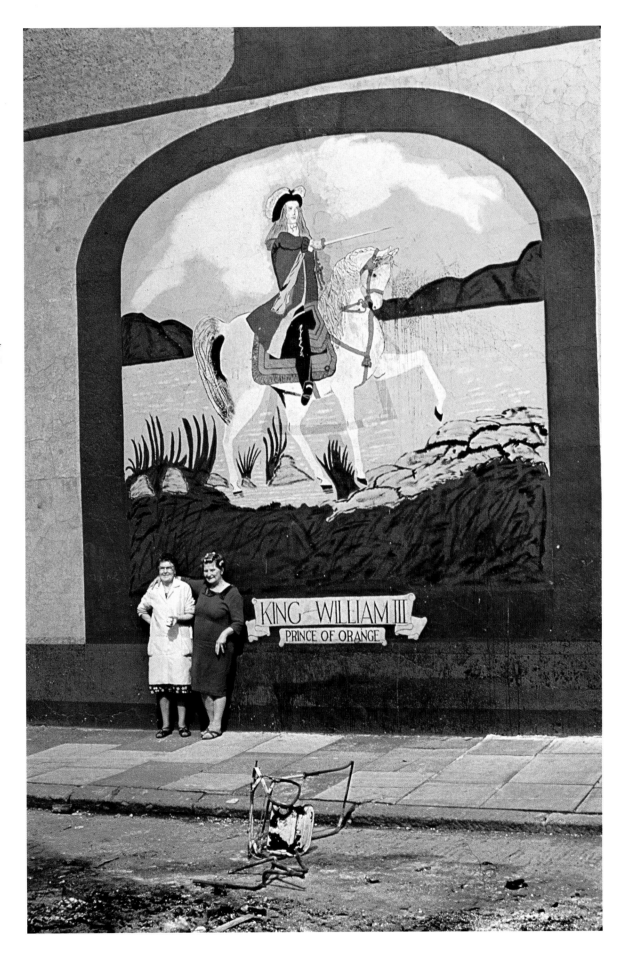

David Hurn. Wall painting in honour of William Prince of Orange. Protestant area, Belfast, 1972

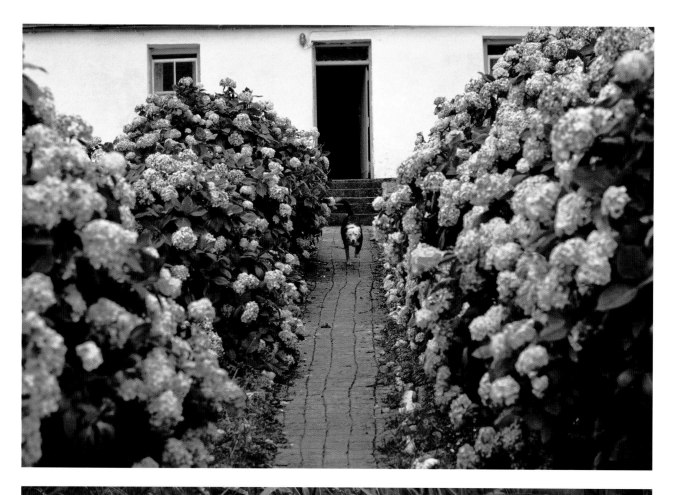

Thomas Hoepker. Near Clifden, Connemara, 1972

Thomas Hoepker. Remnants of grave decorations in a cemetery, Connemara, 1972

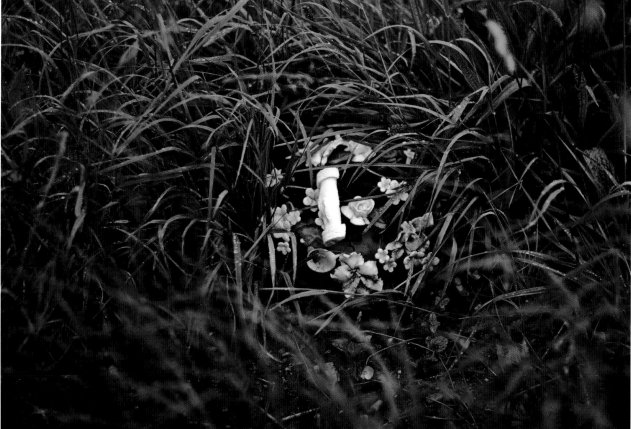

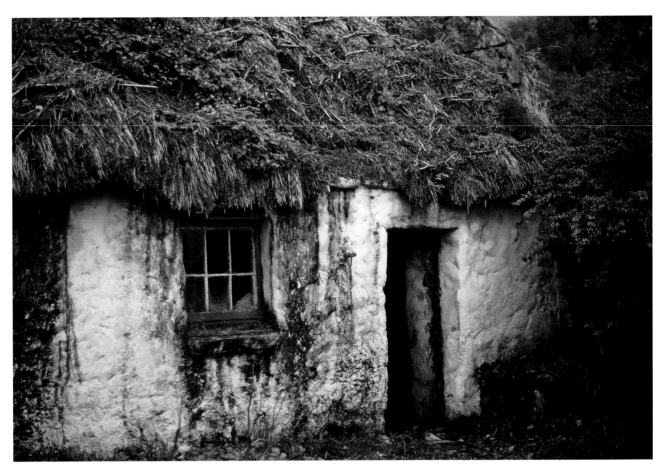

Thomas Hoepker. Abandoned cottage in Connemara, 1972

Thomas Hoepker. Plastic grave decorations in a cemetery, Connemara, 1972

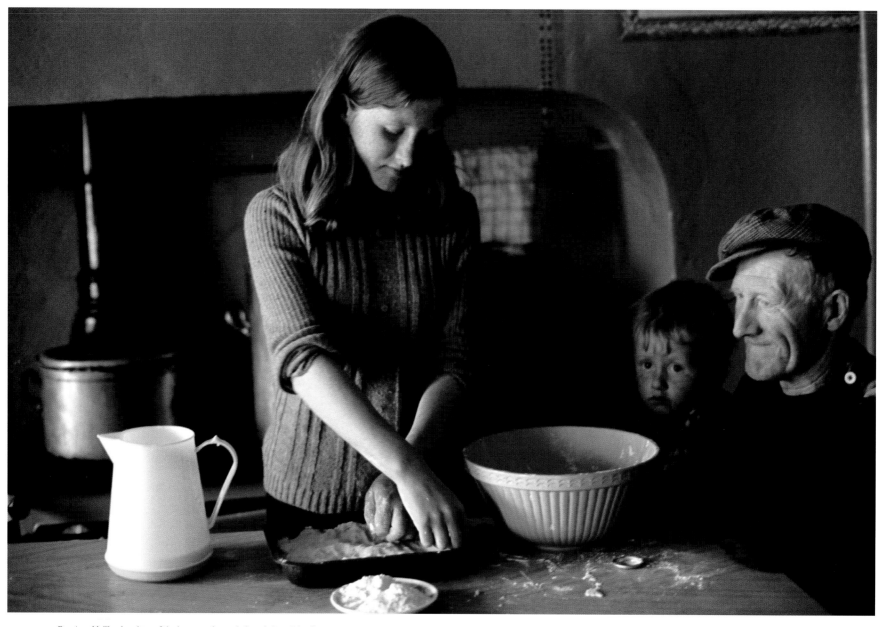

Eve Arnold. The daughter of the house makes soda bread. Aran Islands, 1974

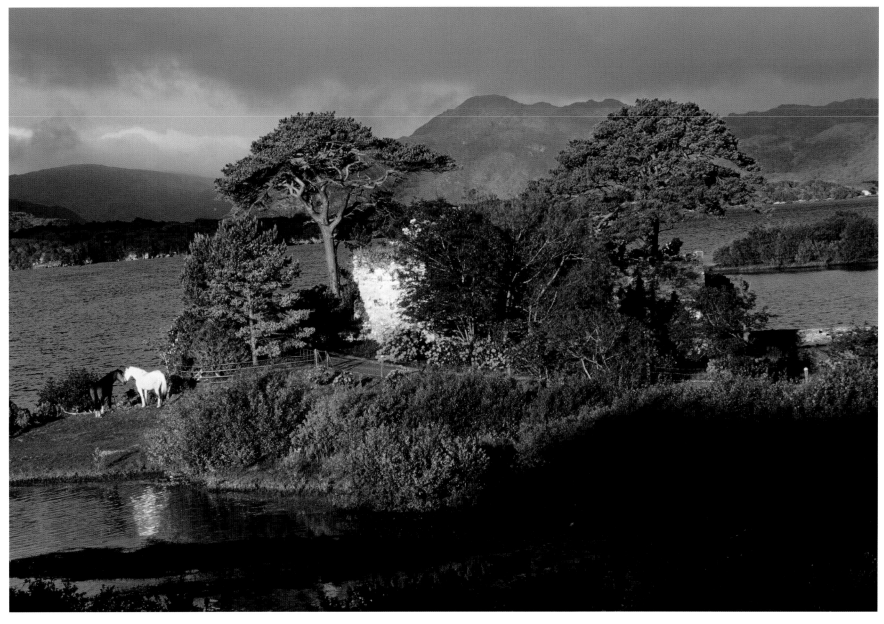

Eve Arnold. Killarney, 1974

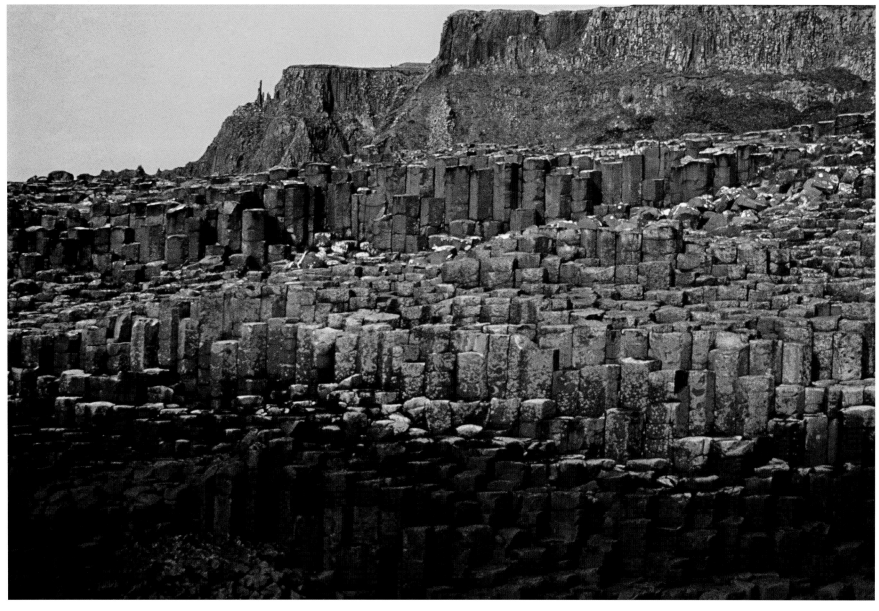

Dennis Stock. Giant's Causeway, east of Portrush, northern coast of County Antrim, 1977

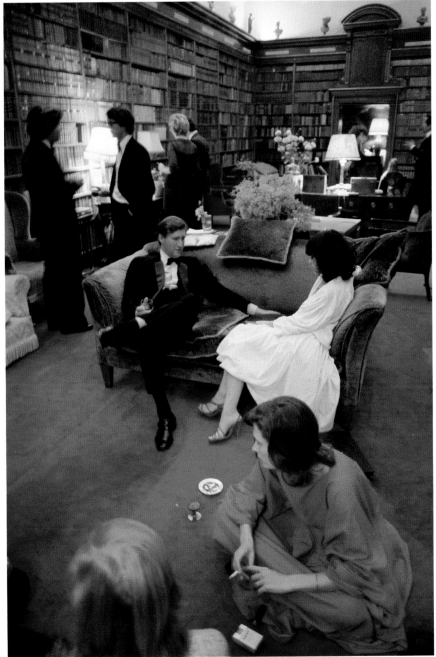

Marc Riboud. County Down, 1978

Marc Riboud. County Wicklow, 1978

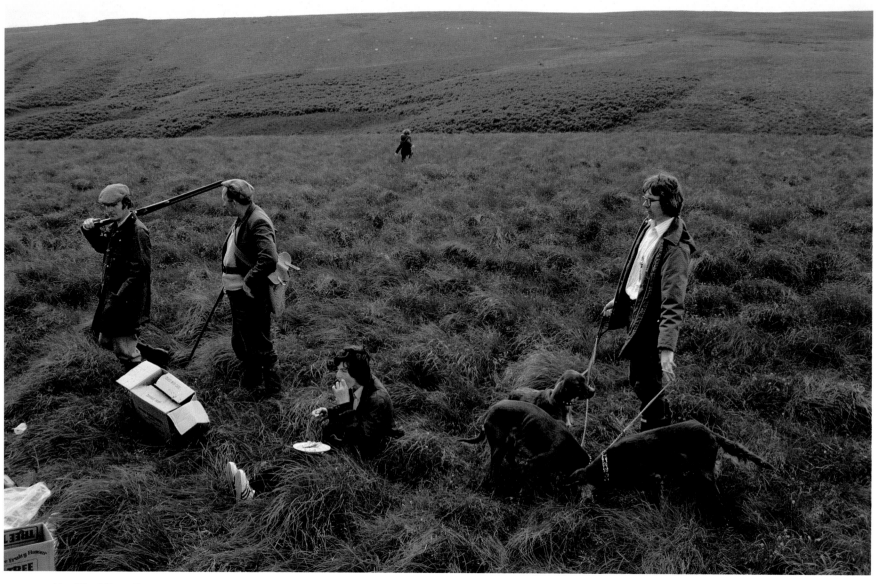

Marc Riboud. County Down, 1978

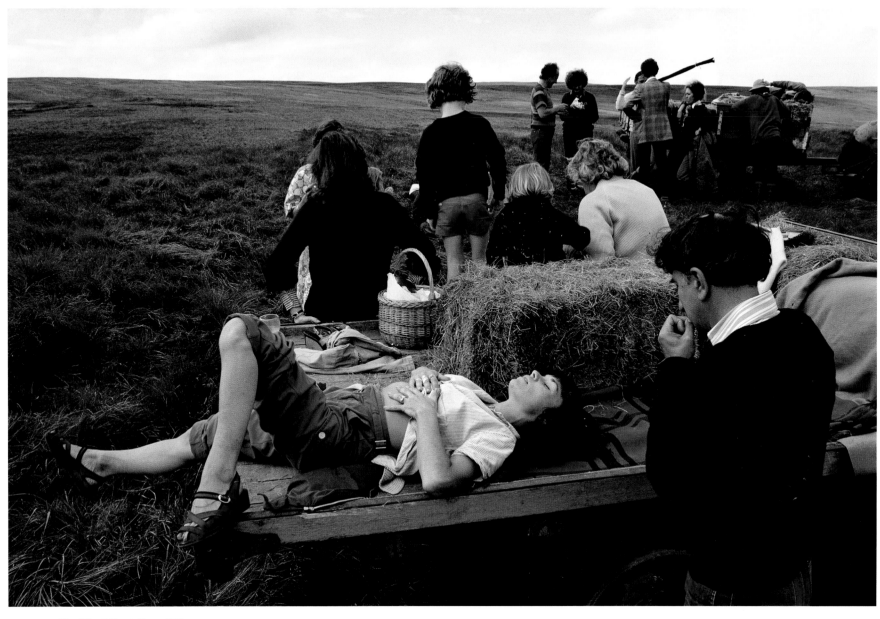

Marc Riboud. County Down, 1978

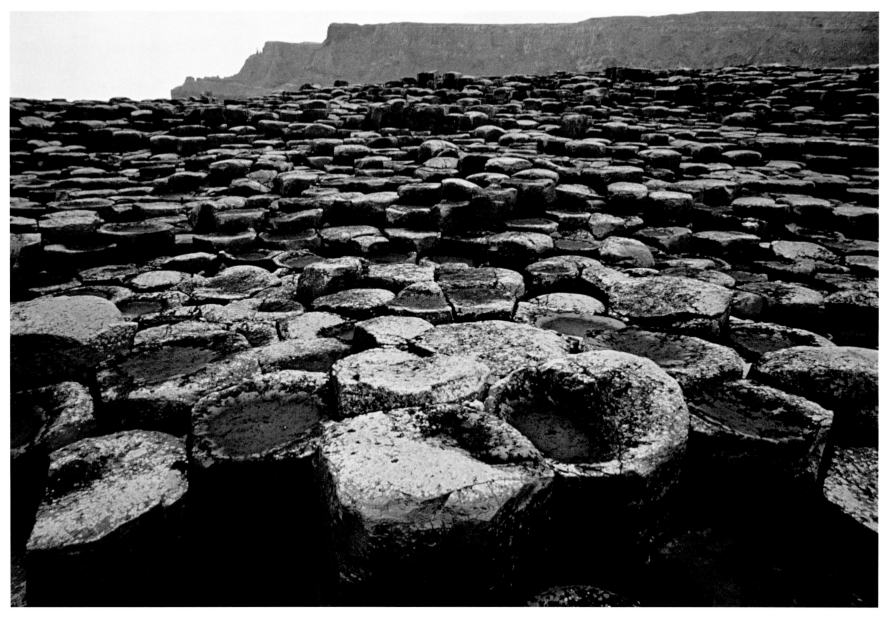

Dennis Stock. Giant's Causeway, east of Portrush, northern coast of County Antrim, 1977

Marc Riboud. County Wicklow, 1978

Marc Riboud. County Wicklow, 1978

Marc Riboud. County Wicklow, 1978

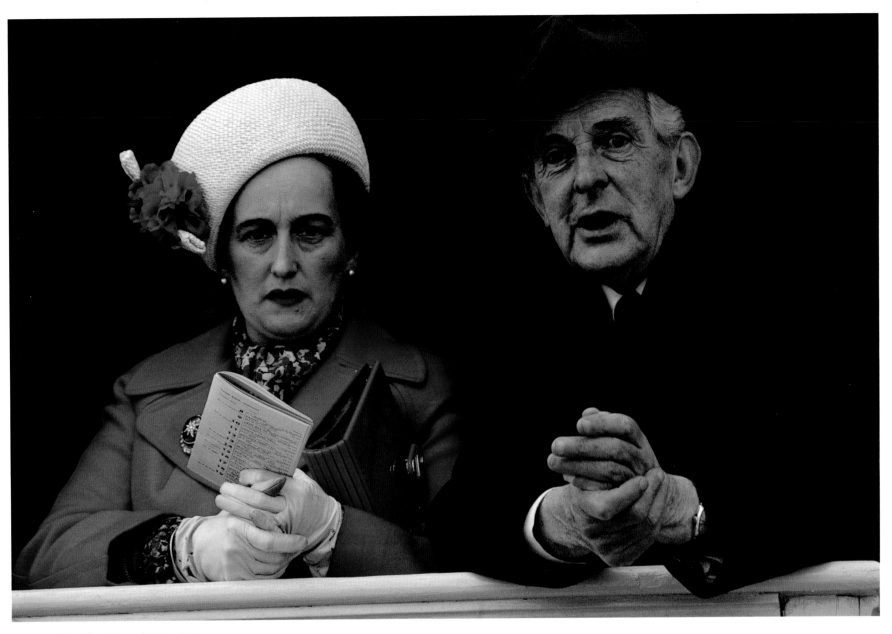

Marc Riboud. County Wicklow, 1978

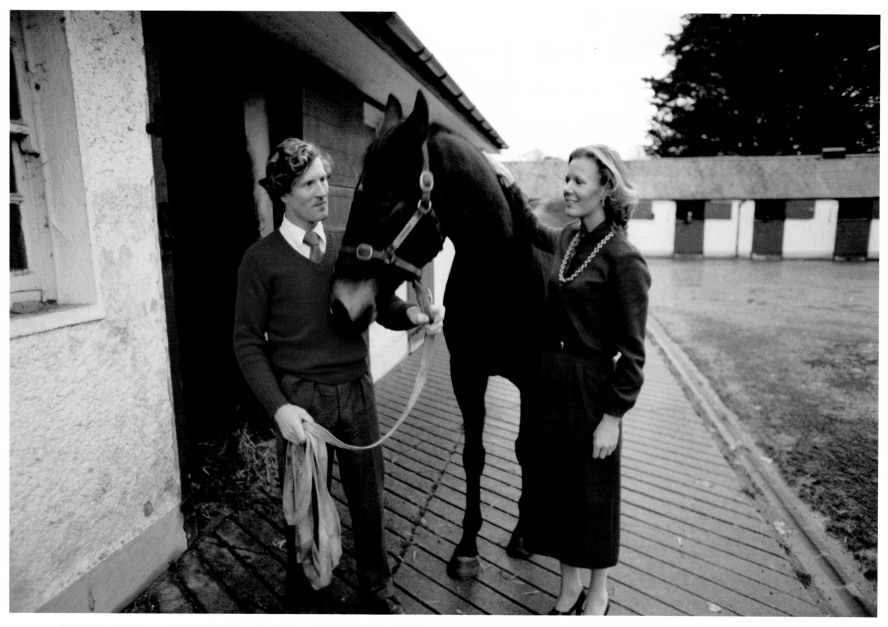

Peter Marlow. Joe McGowan with his wife. Her horse Davy Lad won the 1977 Cheltenham Gold Cup. 1979

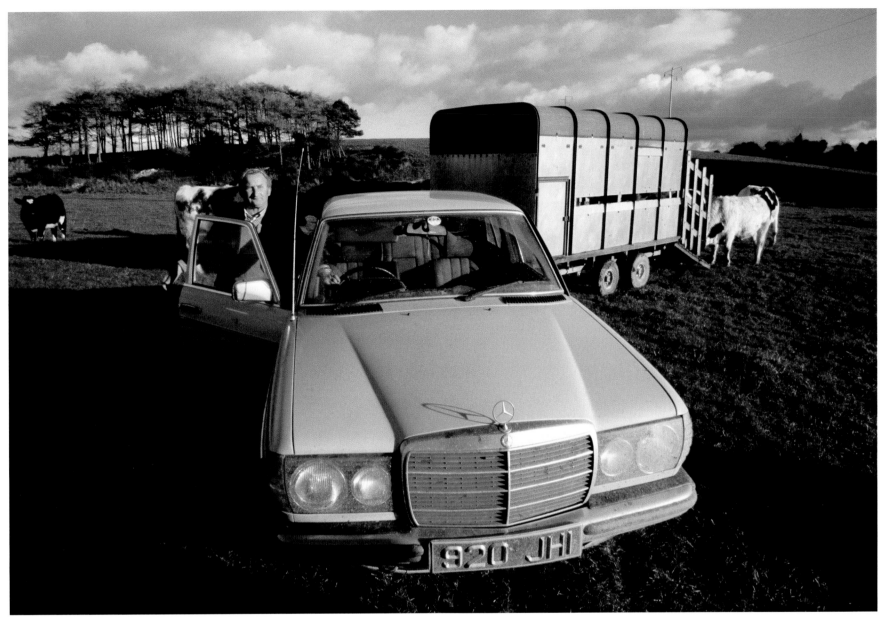

Peter Marlow. Paddy Devereaux. He uses his Mercedes as a farm runabout. Tipperary, 1979

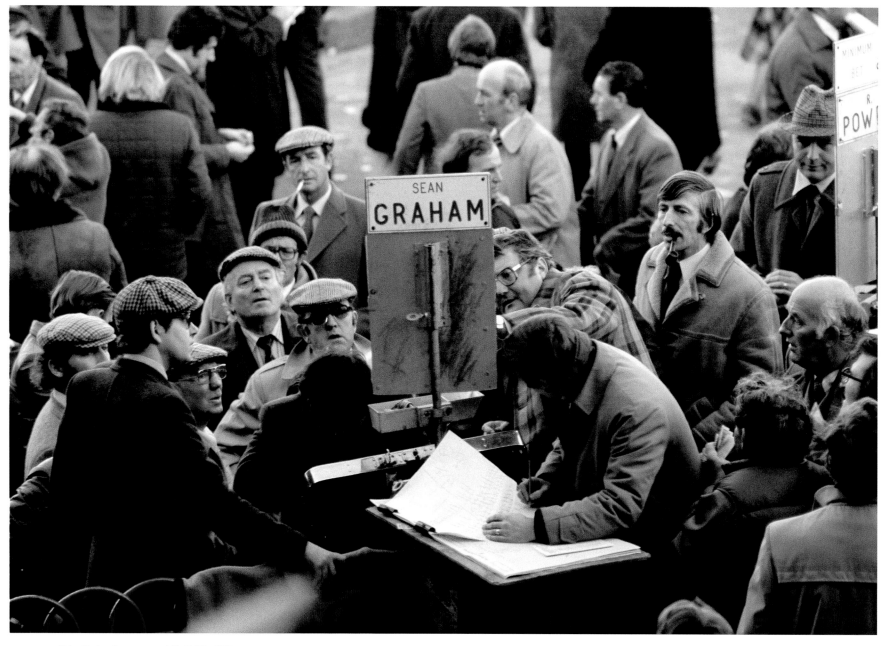

Peter Marlow. Racecourse outside Dublin, 1979

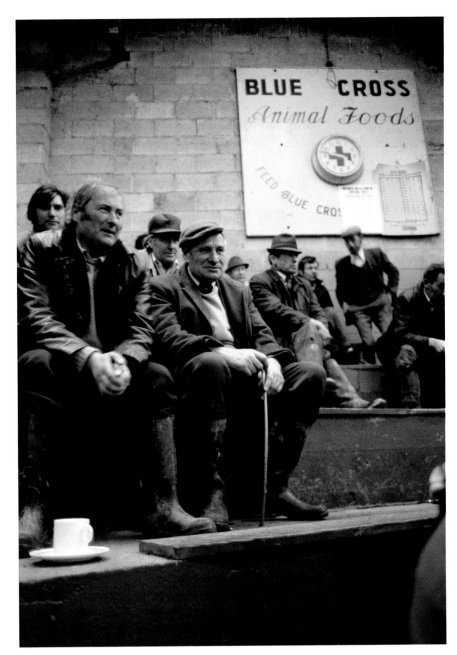

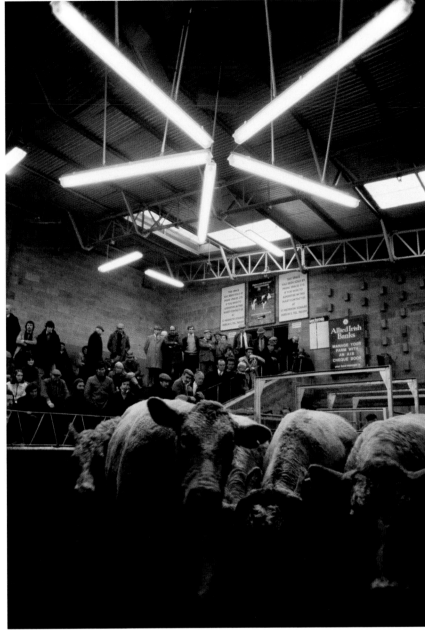

Peter Marlow. Farmers at a livestock market, County Kildare, 1979

'80s

David Hurn

Ian Berry

Chris Steele-Perkins

Stuart Franklin

Donovan Wylie

Martin Parr

Peter Marlow

Harry Gruyaert

Paul Fusco

For two weeks at the beginning of 1985, at one of the most painfully revelatory events of the decade in Ireland, the attention of the public was riveted on the mysterious Tom Flynn. A public inquiry (commonly called the Kerry Babies Inquiry) was in progress. Its ostensible purpose was to discover how a young woman in County Kerry could have confessed under police interrogation to murdering at birth a baby that was not in fact hers. It seemed, on the face of it, that the young woman, Joanne Hayes, and members of her extended family had been coerced into signing confessions to murder. Joanne Hayes had indeed given birth in May 1984 to a baby that had died, but this could not have been the baby found washed up on the seashore a fortnight earlier. The inquiry was therefore meant to be an investigation into possible police brutality. Yet, as it progressed, it became a magnet for the strange and the surreal. The formal legal report of the inquiry, itself an eccentric document, quoted with approval from James Thurber: 'We live, man and worm, in an age when almost everything can mean almost anything.'

Tom Flynn entered the story because the police wished to prove the bizarre theory that Joanne Hayes had in fact conceived twins by two different fathers at the same time. At the inquiry, they seized on their discovery of a name written in blue biro on Joanne Hayes's mattress: Tom Flynn. This, they suggested, was the phantom lover, the father of the other baby. Tom Flynn briefly became a national figure, famous for his mysterious absence. Who was he? Why had he disappeared? Eventually, the man who owned the furniture shop where the bed had been bought solved the puzzle. Tom Flynn was a young fellow who had worked in the shop. He had nothing whatsoever to do with the case. And he was now where so many young Irish people of his generation were: elsewhere. He had emigrated to America. He did not know that he had become, for a fortnight, the Irish version of Kilroy, the man caught up in big events beyond his ken, the actor wandering into an absurdist play he has not rehearsed, the man who, unlike Kilroy, wasn't there. Yet the name he scrawled on the mattress to momentarily relieve the tedium of his dead-end job was one of the most eloquent pieces of Irish writing in the 1980s, expressing as it did the oddness of a nation that did not know its own identity.

In February 1985, while the Kerry Babies inquiry in Tralee, County Kerry, was hearing revelations of sex, infanticide and cruelty, a seven-year-old girl entered the little Catholic church of Saint Mary in the village of Asdee, about fifteen miles away. She knelt down to say a prayer before the two painted plaster statues of Jesus and the Blessed Virgin Mary which stood in an alcove at the back of the church. As she looked up at the statue of Jesus, lit by the glow of votive candles and the diffuse light from a small stained glass porthole, she saw Christ crook his finger and beckon her over to him. When she looked at the statue of the Blessed Virgin, Mary's mouth was open. She ran outside and told the other children who were on their lunch break from school. Gradually, in different groups, dozens of children gathered around the statues. Thirty-six of them later claimed that they, too, had seen the statues move. By the following Sunday, there were two thousand people in the village to see the statues. Soon, adults who had travelled for hundreds of miles to be there were recounting how, when they touched the Blessed Virgin's hand, the cold stone turned to warm flesh and held their fingers in a firm grasp. Soon, statues were moving in churches all over Kerry and the neighbouring county of Cork.

The Kerry Babies and the moving statues were closely related phenomena. The first carried with it the sense that everything was breaking down, that the official culture of conservative Catholic Ireland was falling apart. People were having sex and babies outside marriage, and a buried past in which women who misbehaved were hidden and silenced was coming to the surface. The authorities, like the police in the Kerry Babies case, were insisting on improbable explanations and looking for someone to blame. The moving statues turned this sense of disturbance into an apocalyptic hope that everything would be all right, that prayers would be answered, God would intervene, and things would go back to the way people thought they had been.

The sense of collapse was everywhere, and it manifested itself in a curious invasion of the public, political world by the private imagery of the body and its functions. As the public realm drifted out of control, the personal and the political intertwined in a sometimes grotesque and often tragic embrace. In Northern Ireland, the vicious sectarian conflict became stranger, wilder, more incomprehensible to outsiders, when IRA prisoners in the H-Blocks of Long Kesh prison used their own excrement as a weapon and smeared it on the walls of their cells. They then turned their own bodies into battlefields, as ten men slowly starved themselves to death. The images that dominated the island in 1981 and 1982 were the harrowing, pre-historic figures of unkempt men with long hair and long beards, each wearing nothing but the blanket that covered a naked, dwindling body. These spectres haunted Ireland like emanations from some collective nightmare.

In the Republic, meanwhile, the decade was a time of creeping catastrophe, when it felt as if the State was slowly ebbing away. The national debt rose to such high levels that every penny of the income tax paid by Irish workers went merely to pay the interest. Unemployment rose to over a quarter of a million from a labour force of 1.3 million. Another quarter of a million, out of a population of just 3.5 million, left the country during the decade. Most of them were young: the most exciting place in Dublin in the late 1980s was the American Embassy where bright young men and women were queuing for Green Cards. As a result, the population of what had thought of itself as the fastest-growing nation in Europe, actually declined in the 1980s, so that in 1989 it was no higher than it had been in 1889, after four decades of famine, strife and mass emigration. Stable government became almost impossible: in 1981 and 1982 alone, there were three general elections in the Republic.

As the body politic wasted away, the body itself became a strange obsession. The most divisive and passionately fought public debate was that between an entrenched Catholic majority and a growing secular liberal minority over a referendum to insert into the Constitution a clause prohibiting abortion forever. Catholic conservatives saw the move as a way of shoring up the old values and preventing further change. In fact the debate itself was evidence that something very strange was happening. Wombs, eggs, sperms, periods, embryos, ectopic pregnancies and ovaries became the terms of political debate. And this chimed with the sense of a place that could not keep anything in. Just as money and jobs and people were draining away, privacies kept leaking out into the open.

In the Kerry Babies inquiry, the possibilities of fertilization, the mechanics of giving birth, the look of blood on the bedclothes, were examined in forensic detail and turned into newspaper headlines. From the streets and country lanes of Northern Ireland, intimate human blood flowed onto TV screens. A young girl, Anne Lovett, died giving birth to a stillborn child in the village of Granard in County Longford. She kept her plight to herself and bore her child alone in a grotto beneath a statue of the Virgin. Her dead body became a symbol of all the secrets an outwardly conformist society had kept for decades. In another divisive referendum, also won by Catholic conservatives, the Republic debated whether or not to legalize divorce, and the confidential cruelties and pleasures of marriage were discussed in the way the current budget deficit or the unemployment figures might be disputed. At one point, a government minister, intending to utter one of the economic catch-phrases of the time, 'fiscal rectitude', said 'physical rectitude' instead. It was, in its own way, an eloquent slip.

Only in retrospect did it become clear that these odd fixations were the symptoms of a profound change. Though different in so many respects, Ireland in the 1980s shared a great deal with the Warsaw Pact countries in the same period. Each had an apparently stable ideological orthodoxy (Catholic nationalism in one case, Communism in the other) that seemed able to impose its will on dissidents. In each, reality was defined so as to exclude unacceptable facts. From each, those of the discontented who could get out went into exile. In each, economic failure was eating away at those certainties from the inside. In each, a wall would fall with what seemed a sudden, shocking rapidity and only then would people realize that its apparently formidable bulk had rested on shaky ground.

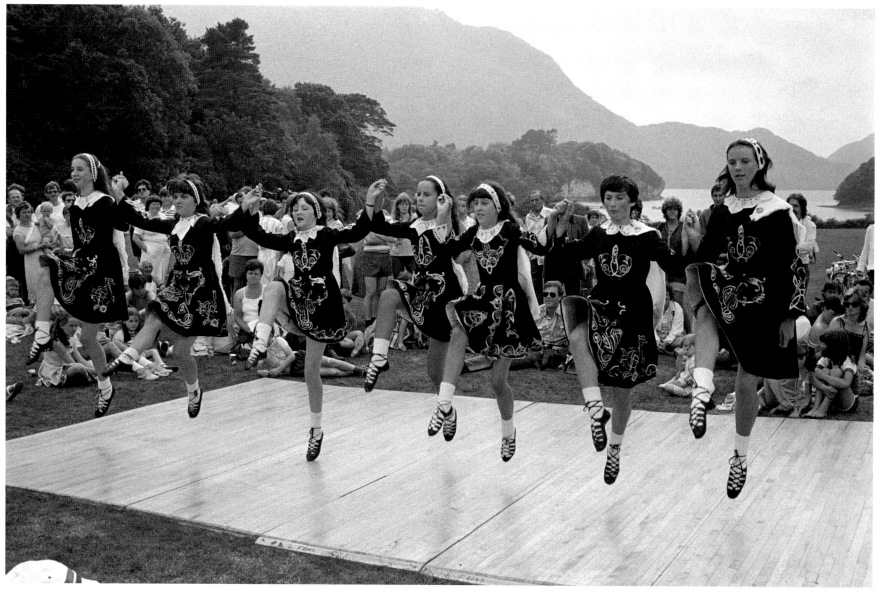

David Hurn. The tradition of Irish dancing is kept alive by numerous schools who frequently give demonstrations. Killarney, 1984

David Hurn. The local petrol station. Killarney, 1984

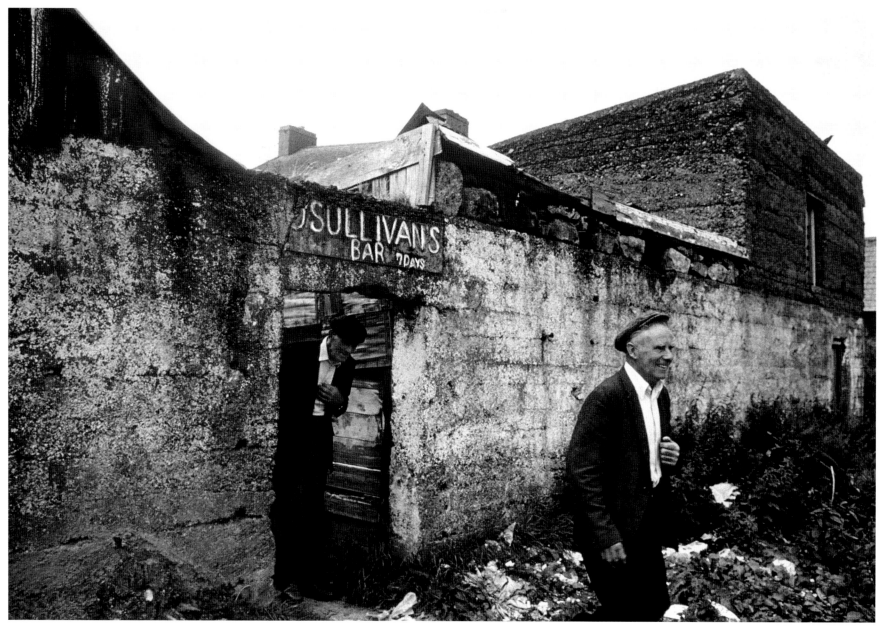

David Hurn. A hole in the wall bar in Killorglin. County Kerry, 1984

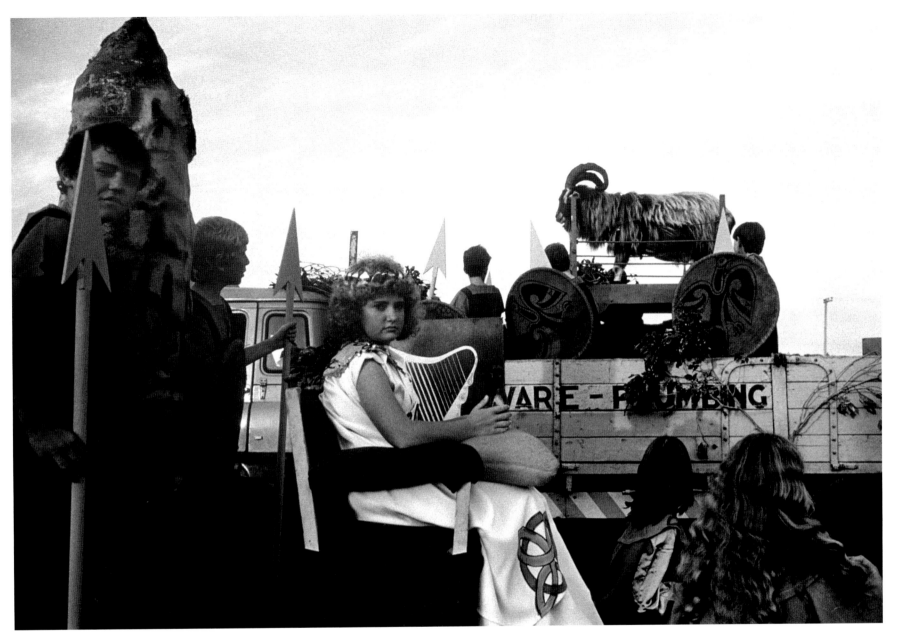

David Hurn. The Puck Fair, Killorglin, County Kerry, 1984

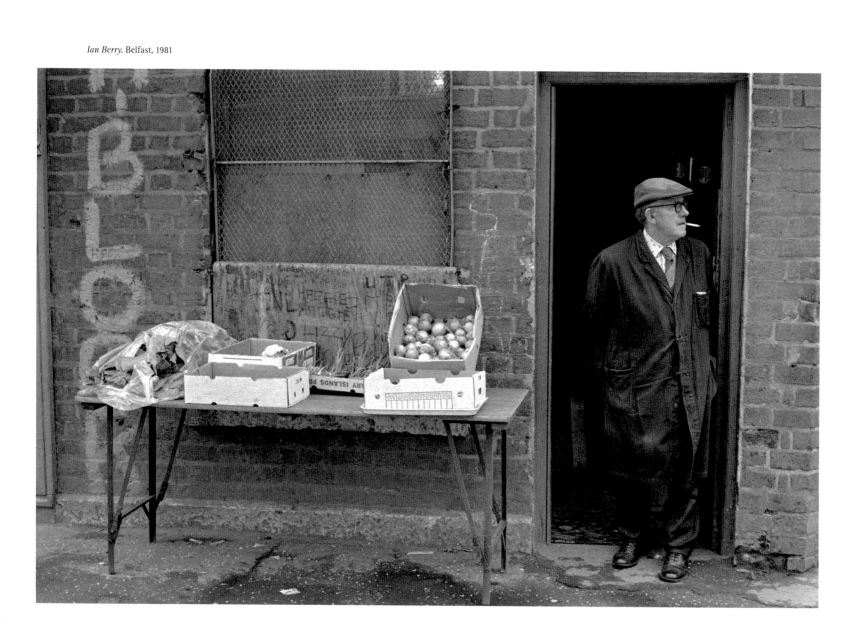

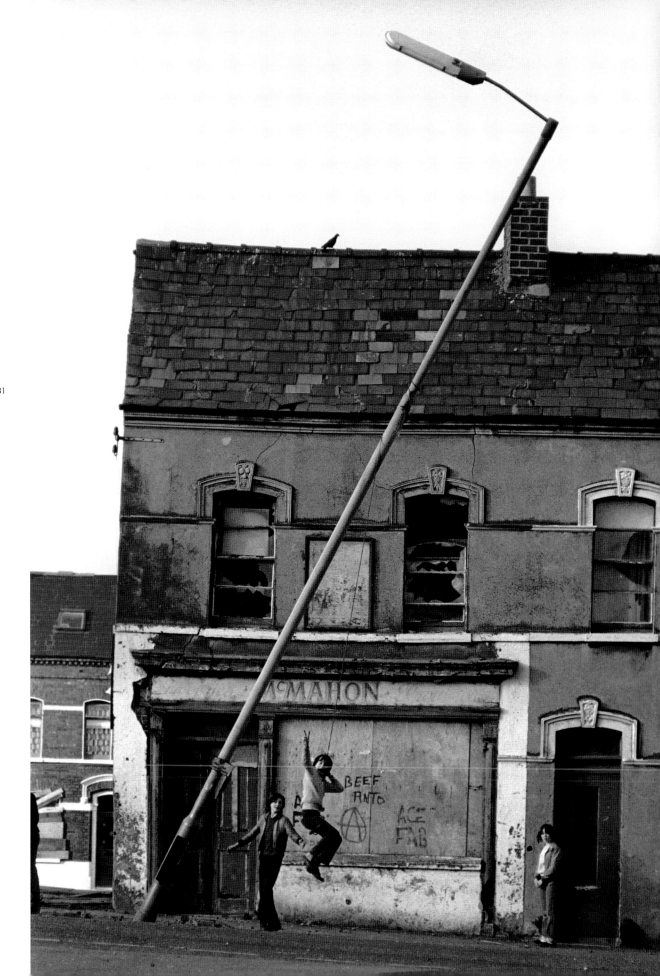

Ian Berry. Belfast, 1981

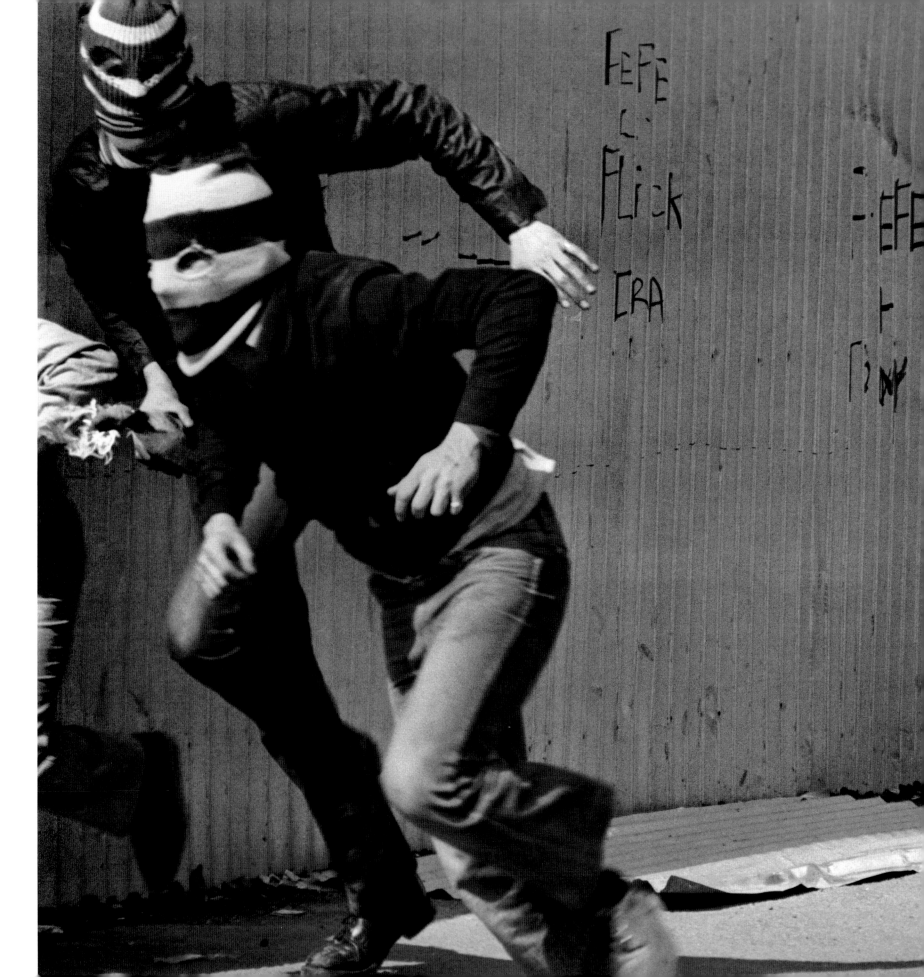

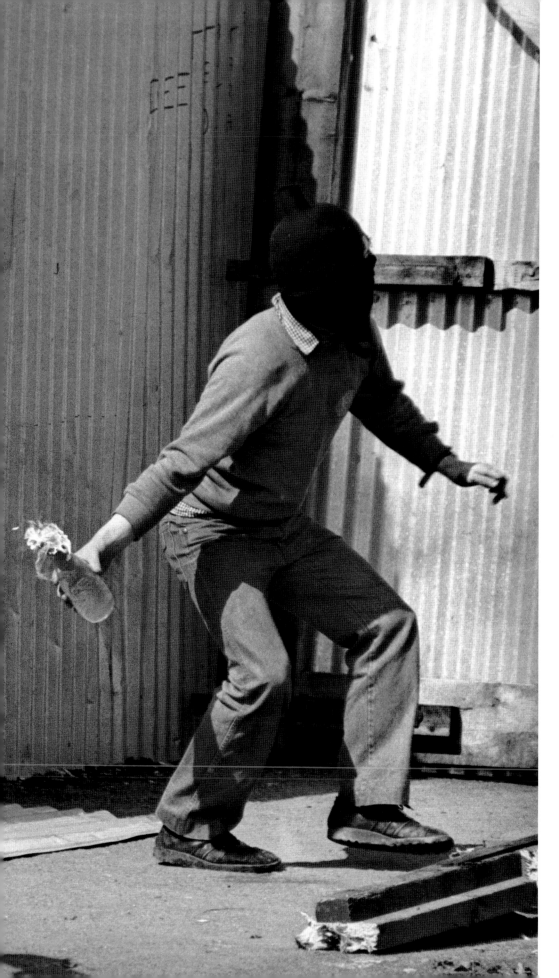

Ian Berry. Belfast, 1981

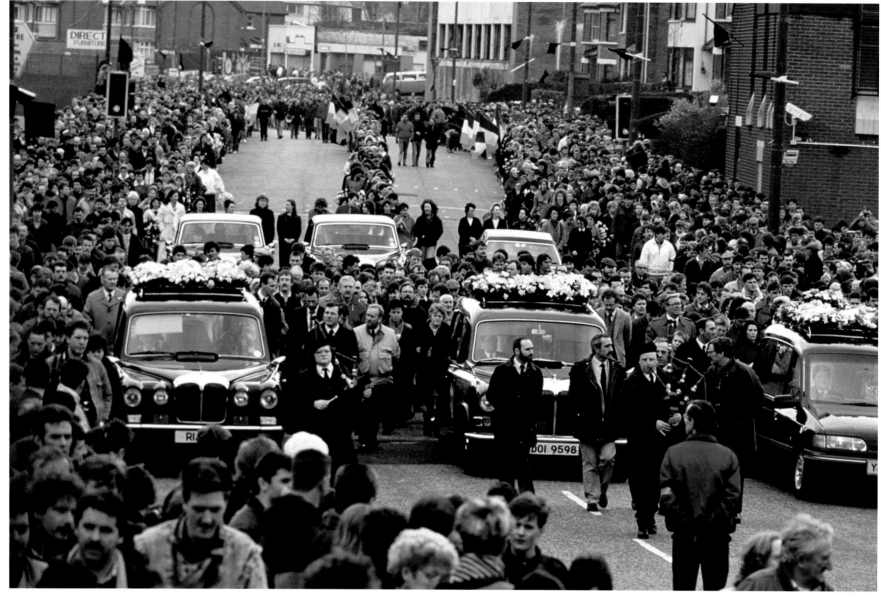

Chris Steele-Perkins. The Milltown Massacre. IRA funeral for three men killed in Gibraltar. West Belfast, 1988

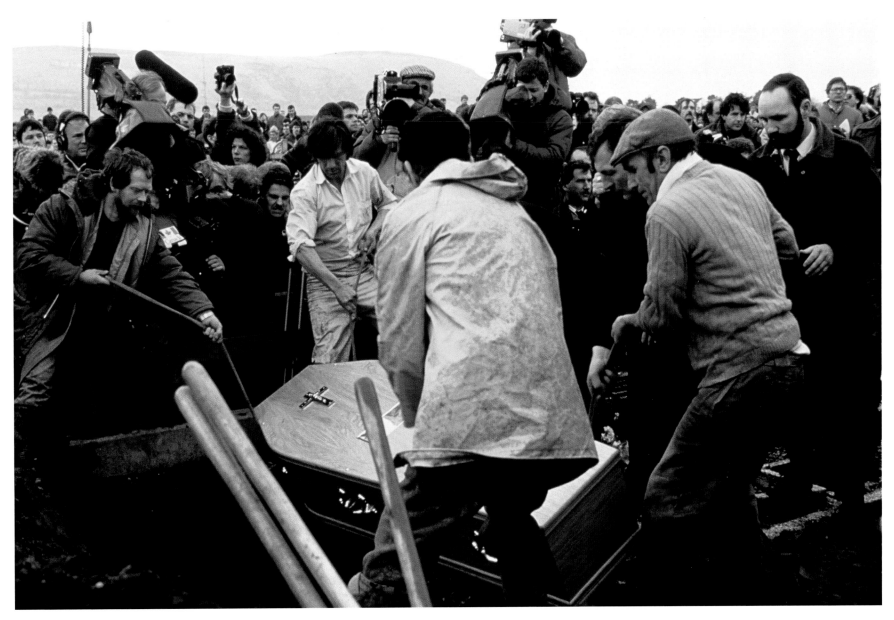

Chris Steele-Perkins. The Milltown Massacre. West Belfast, 1988

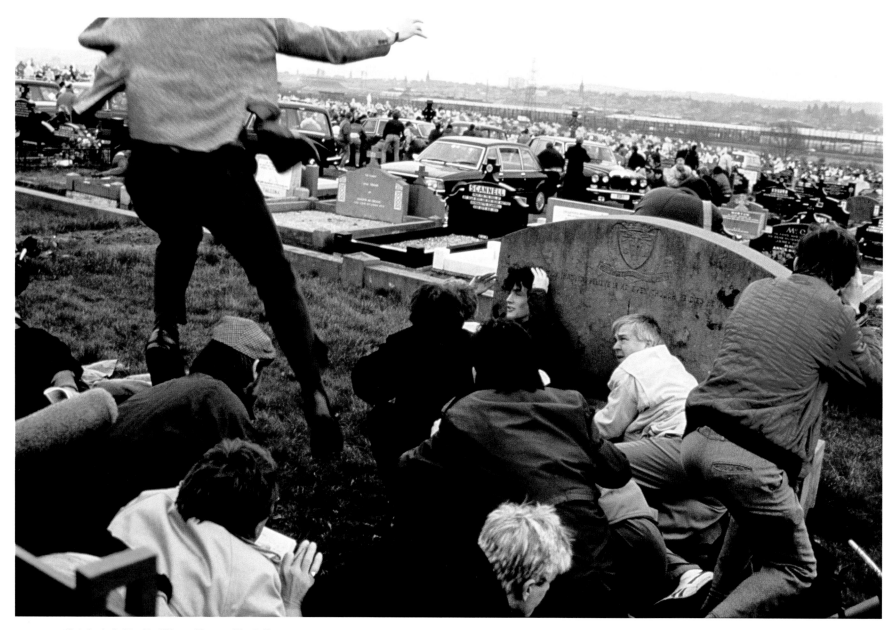

Chris Steele-Perkins. The Milltown Massacre. West Belfast, 1988

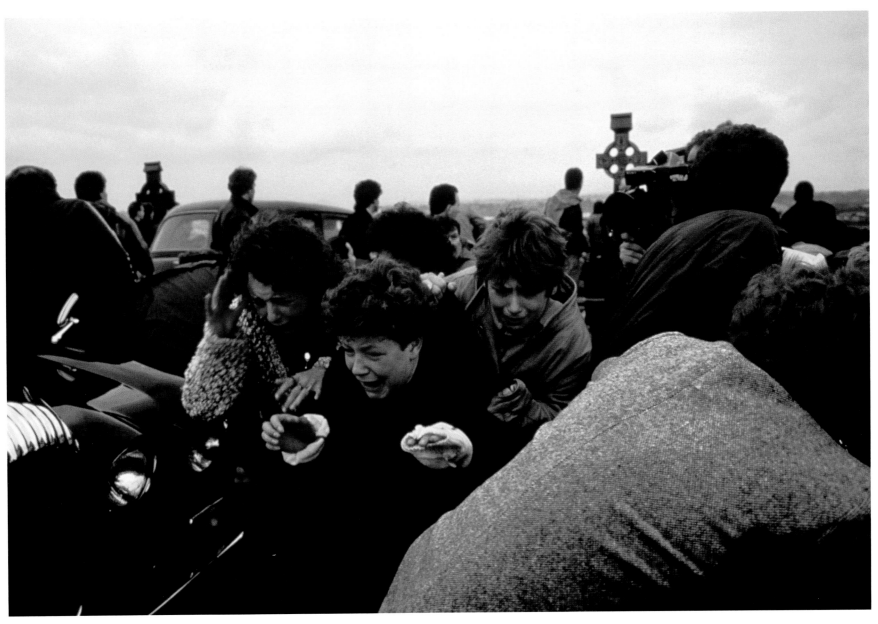

Chris Steele-Perkins. The Milltown Massacre. Mourners at a Republican funeral flee for cover as they are attacked by a Protestant gunman, Michael Stone. Three people were killed and more than 60 injured. Stone was captured and sentenced to life in prison. West Belfast, 1988

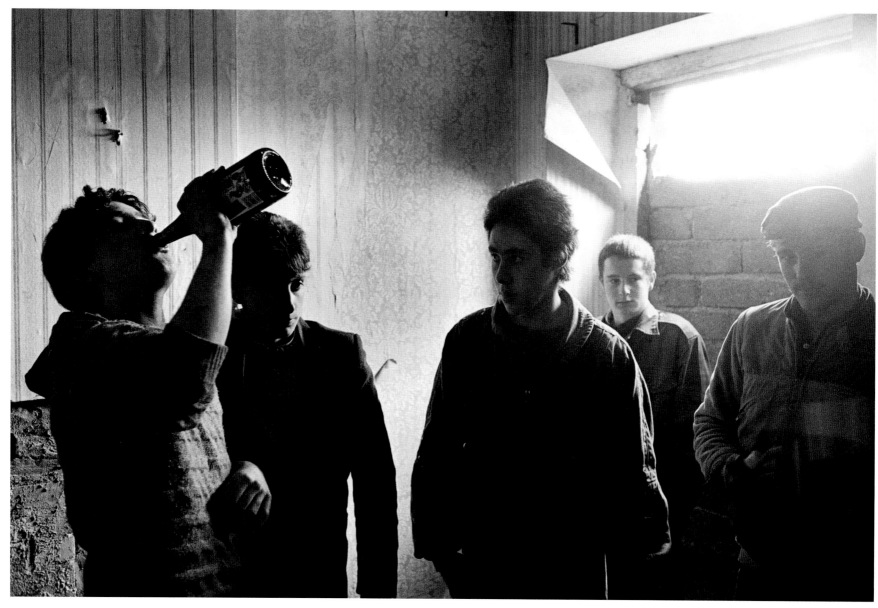

Stuart Franklin. Unemployed boys. Strabane, 1985

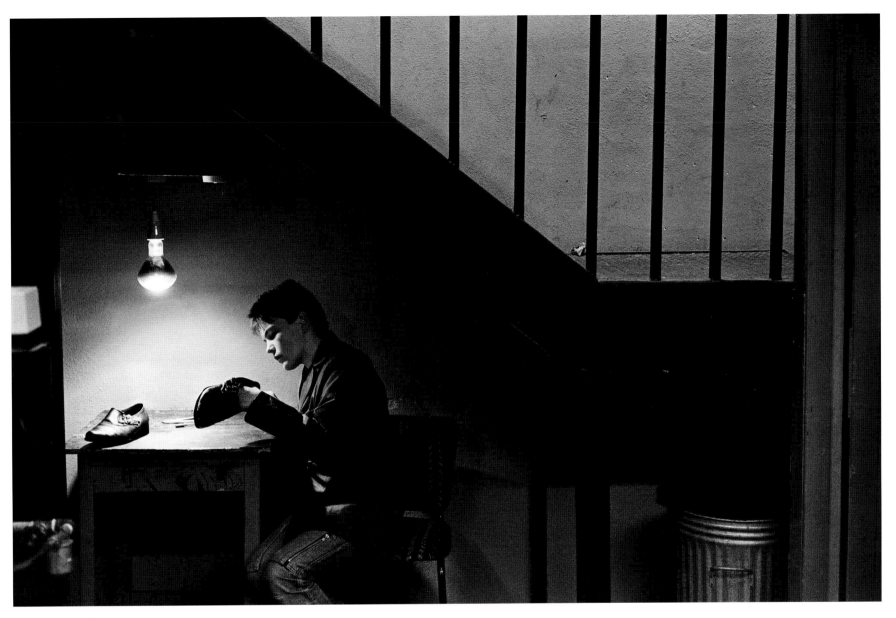

Stuart Franklin. Youth training scheme. Strabane, 1985

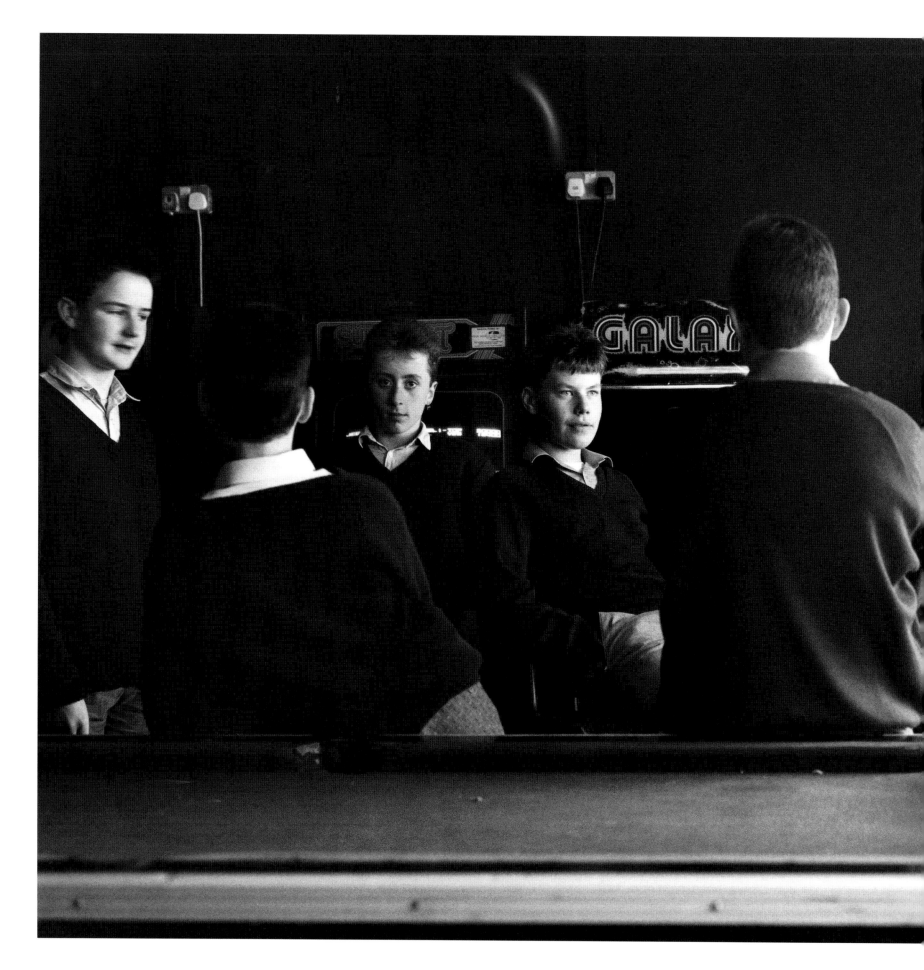

Donovan Wylie. After school, Manorhamilton. County Leitrim, 1988

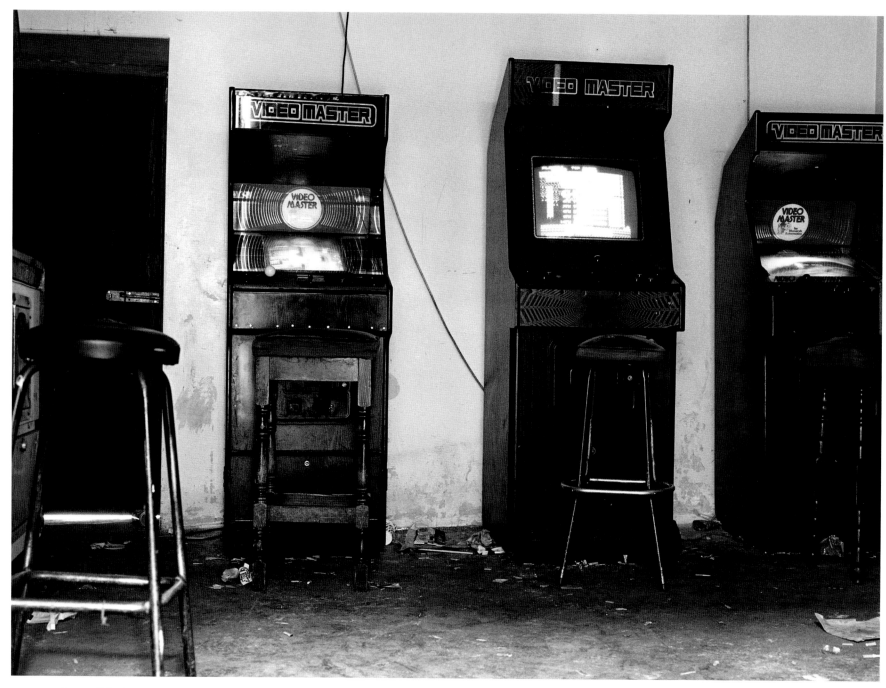

Donovan Wylie. Amusement arcade. County Offaly, 1988

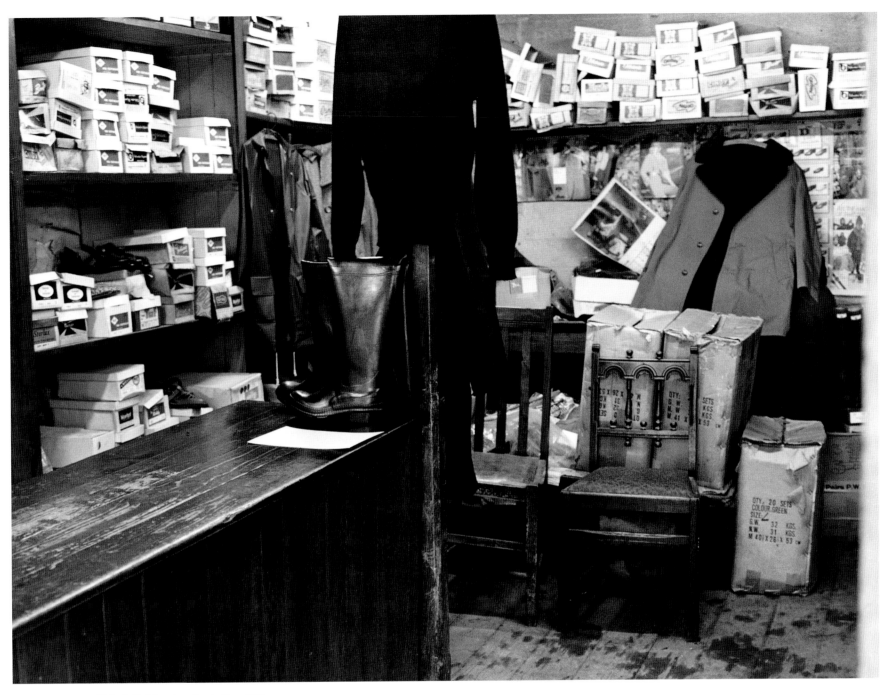

Donovan Wylie. Ladies' shoe shop. County Clare, 1988

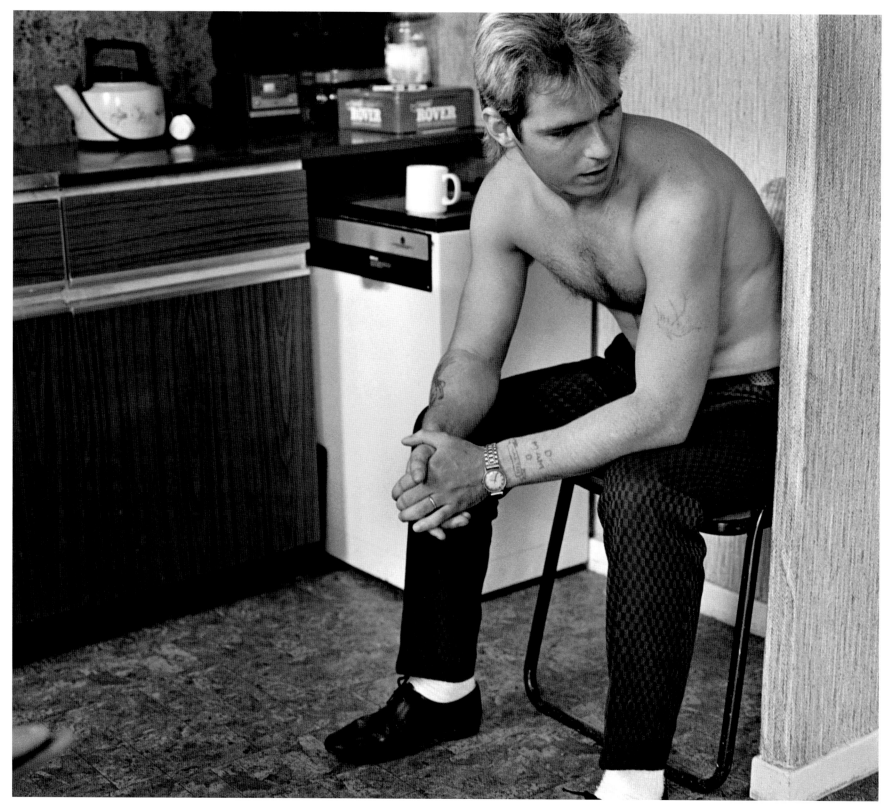

Donovan Wylie. Young unemployed man in kitchen. Athlone, County Westmeath, 1988

Donovan Wylie. 'Don't Be Cruel', Athlone, County Westmeath, 1988

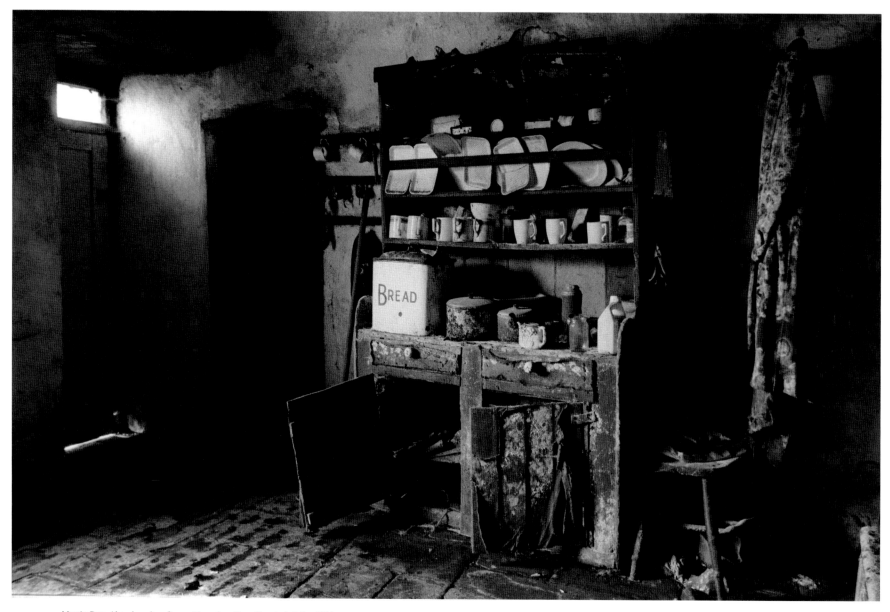

Martin Parr. Abandoned croft near Manorhamilton, County Leitrim, 1981

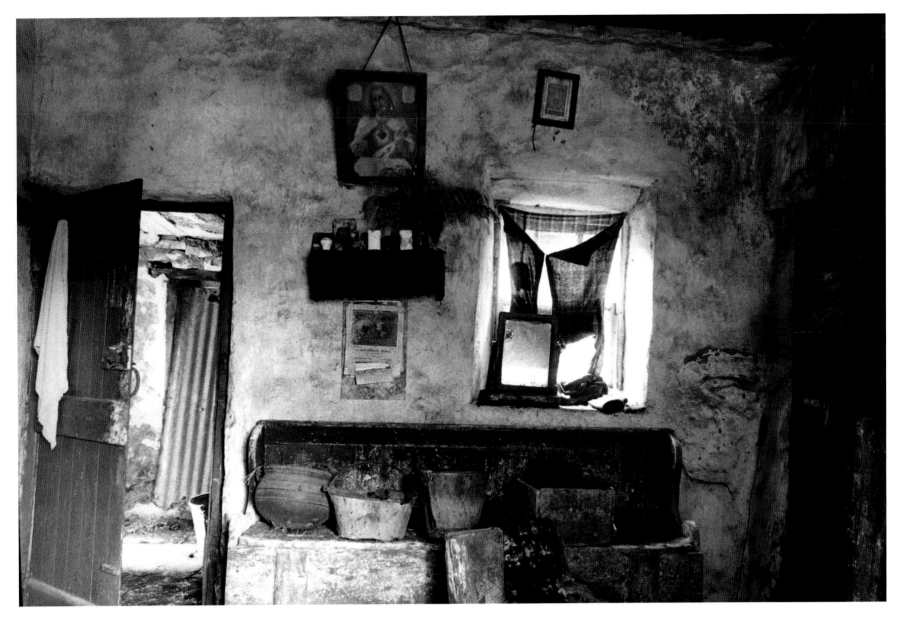

Martin Parr. Abandoned croft, 1981

Martin Parr. Athleague, County Roscommon, 1983

Martin Parr. Westport, County Mayo, 1983

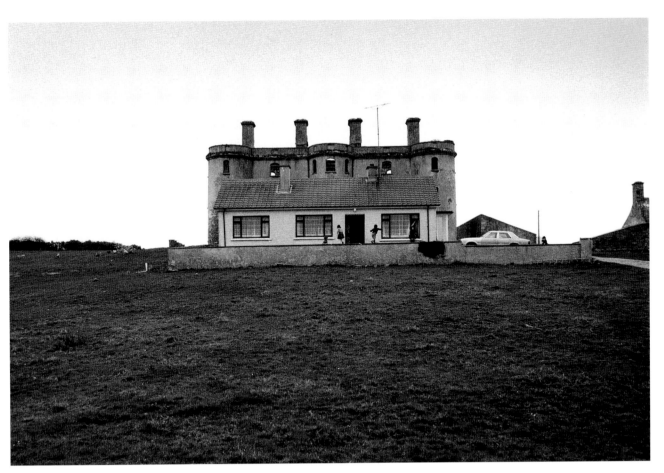

Martin Parr. County Donegal, 1983

Martin Parr. Thomastown, County Tipperary, 1983

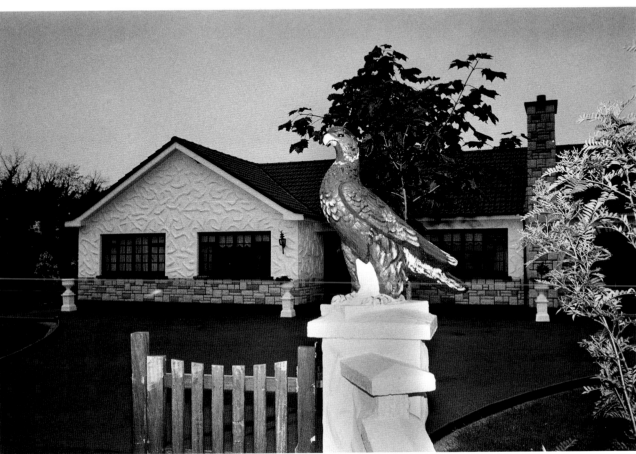

Martin Parr. Mayflower Ballroom, Drumshambo. County Leitrim, 1983

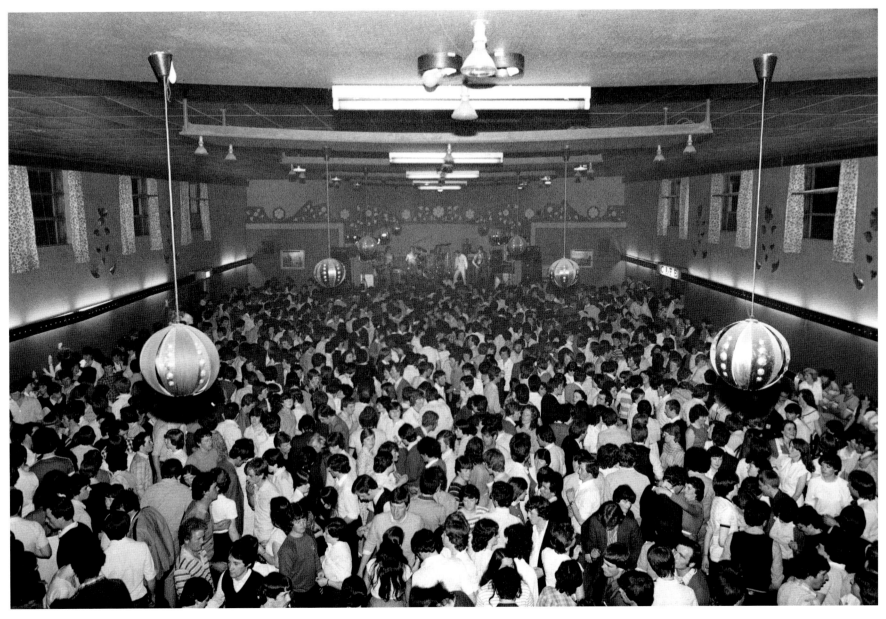

Martin Parr. Mayflower Ballroom, Drumshambo. County Leitrim, 1983

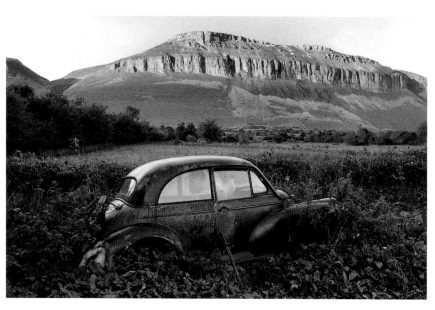

Martin Parr. Abandoned Morris Minor. Near Glencar Lake, County Leitrim, 1981

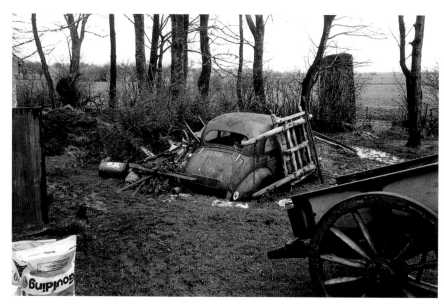

Martin Parr. Abandoned Morris Minor. Near Tulsk, County Roscommon, 1981

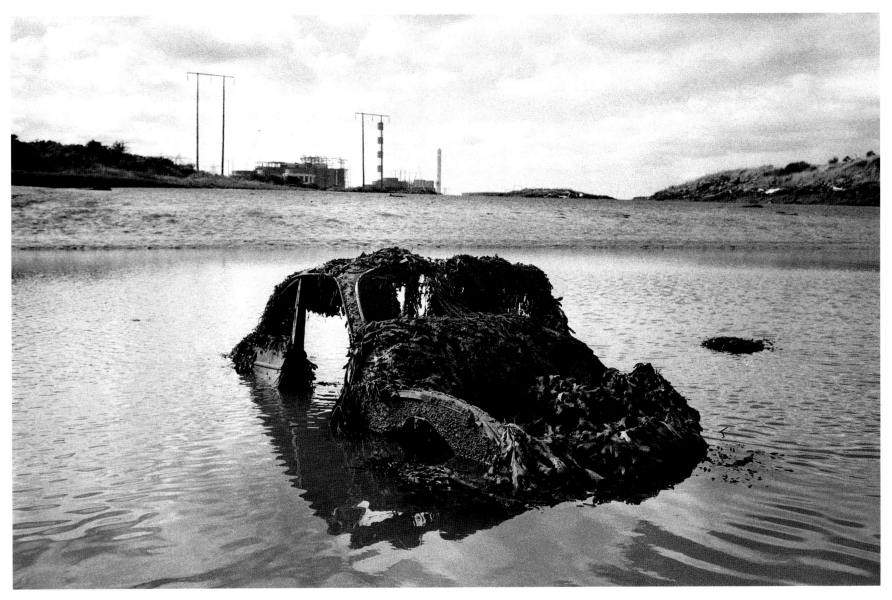

Martin Parr. Abandoned Morris Minor. Near Askeaton, County Limerick, 1981

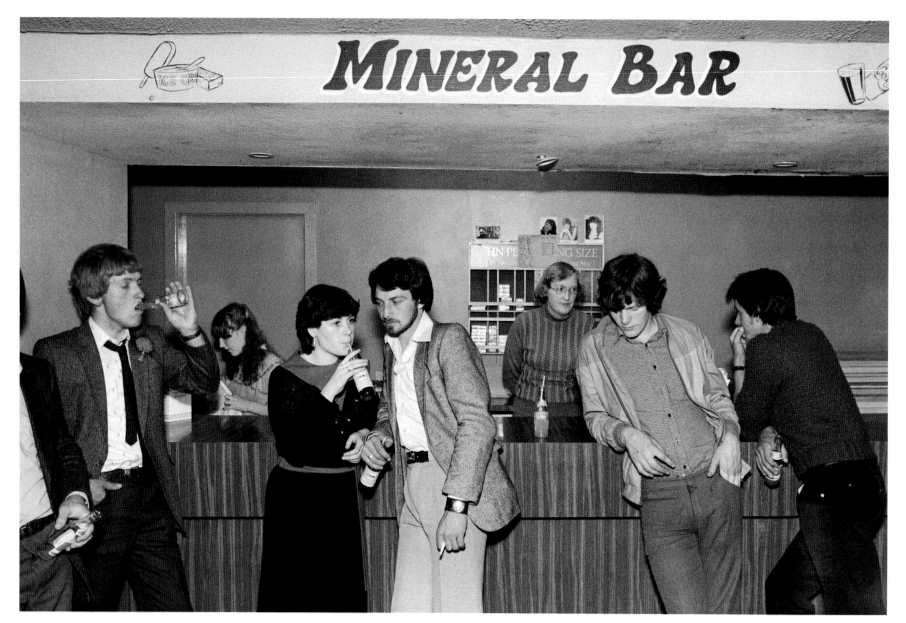

Martin Parr. Rainbow Centre, Glenfarme. County Leitrim, 1983

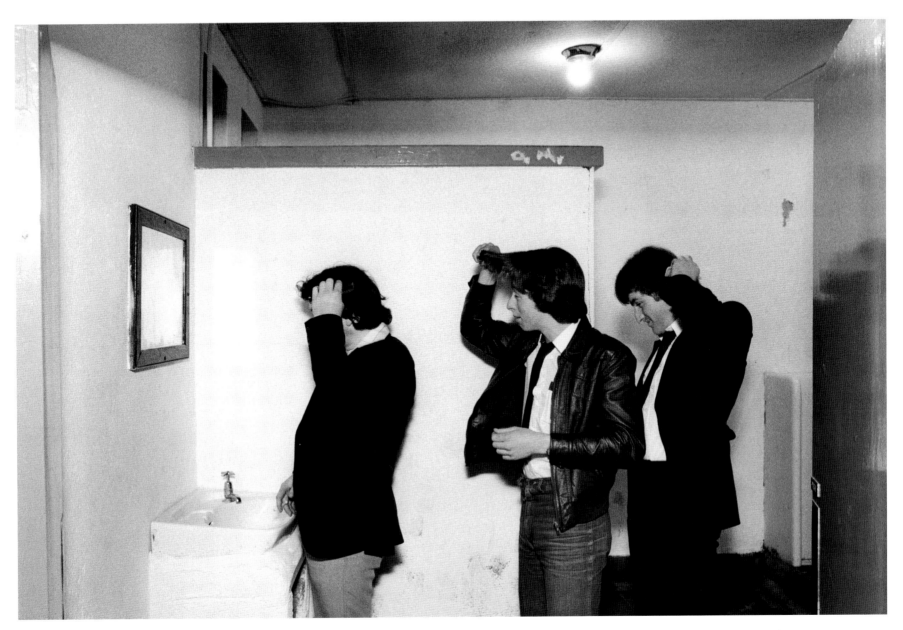

Martin Parr. Amethyst Ballroom, Elphin. County Roscommon, 1983

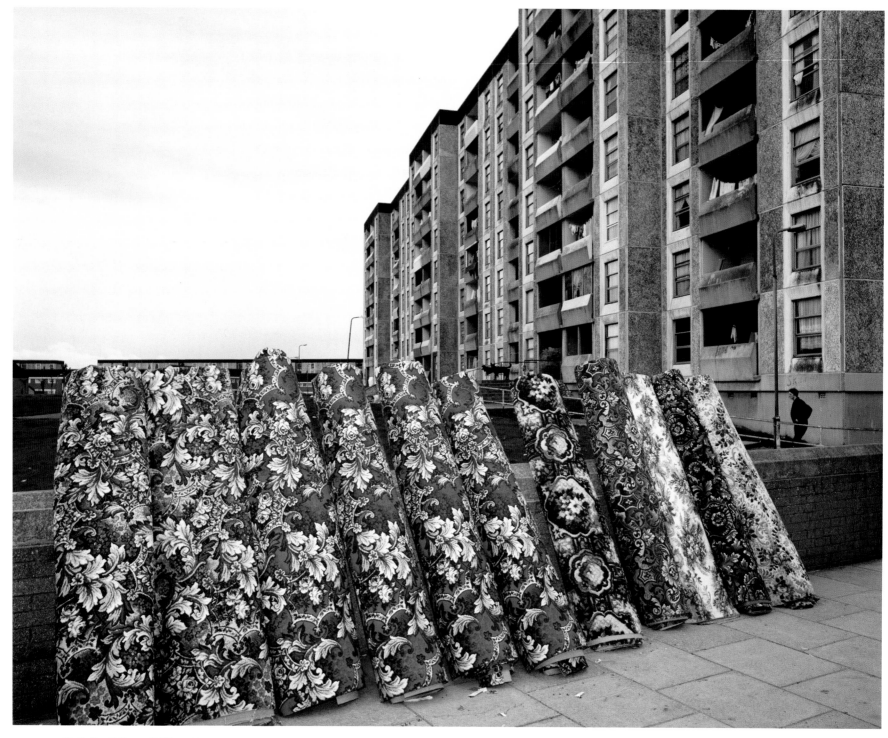

Martin Parr. Ballymun. Dublin, 1986

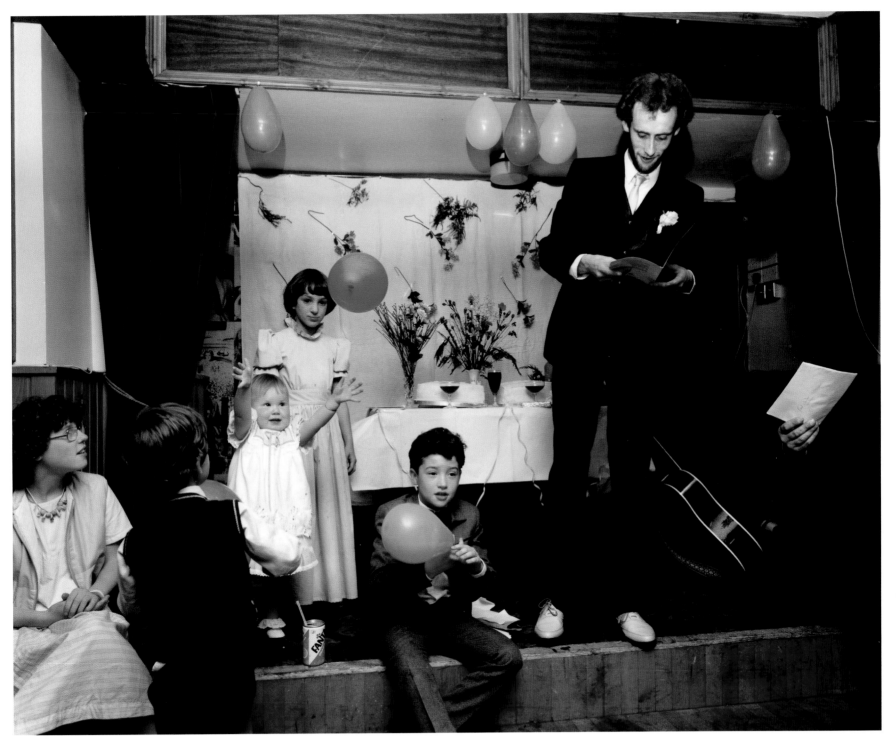

Martin Parr. Speeches at wedding reception. Mulhuddart, 1986

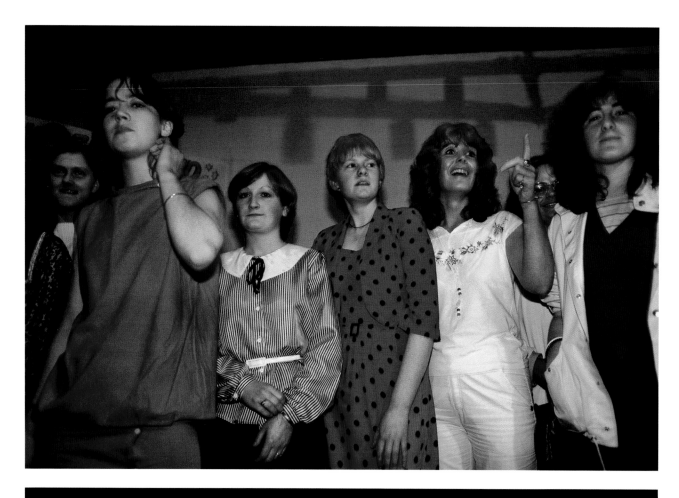

Peter Marlow. The competition for Miss Lisdoonvarna. Lisdoonvarna, County Clare, 1982

Peter Marlow. Disco at the Hydra Hotel, Lisdoonvarna. County Clare, 1982

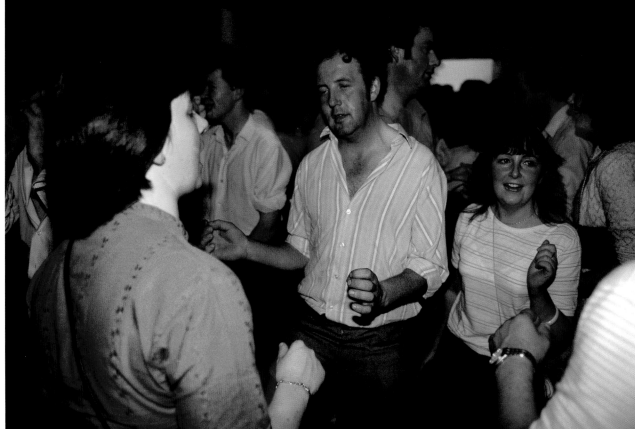

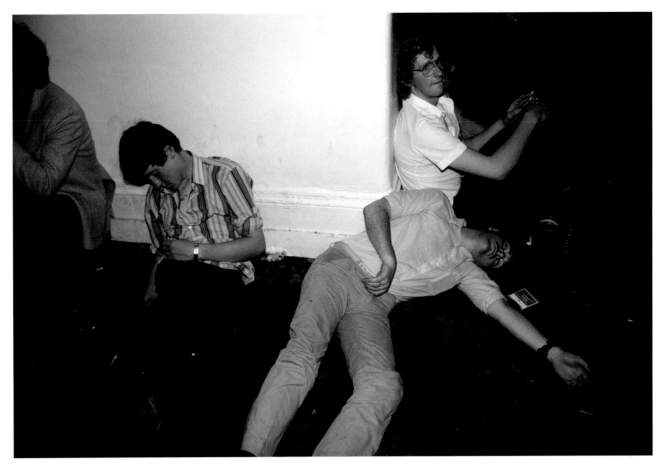

Peter Marlow. Lisdoonvarna. County Clare, 1982

Peter Marlow. Lisdoonvarna. County Clare, 1982

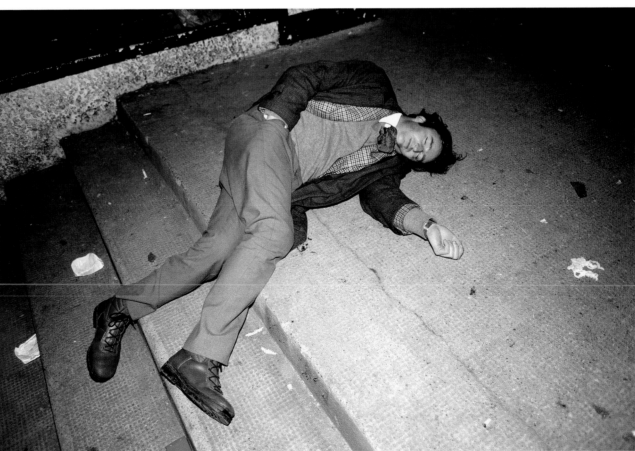

Harry Gruyaert. County Kerry, 1983

Harry Gruyaert. County Kerry, 1983

Harry Gruyaert. County Kerry, 1983

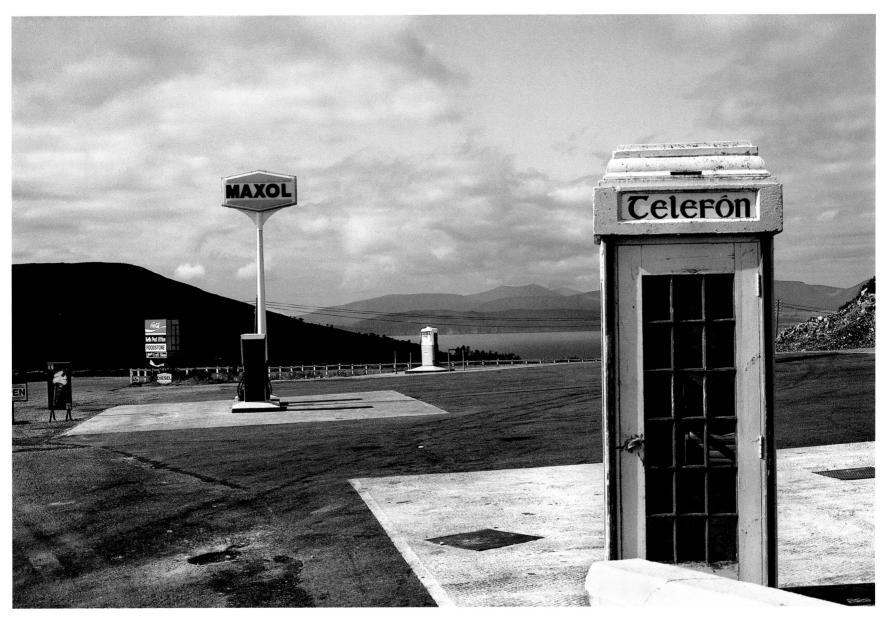

Harry Gruyaert. County Kerry, 1983

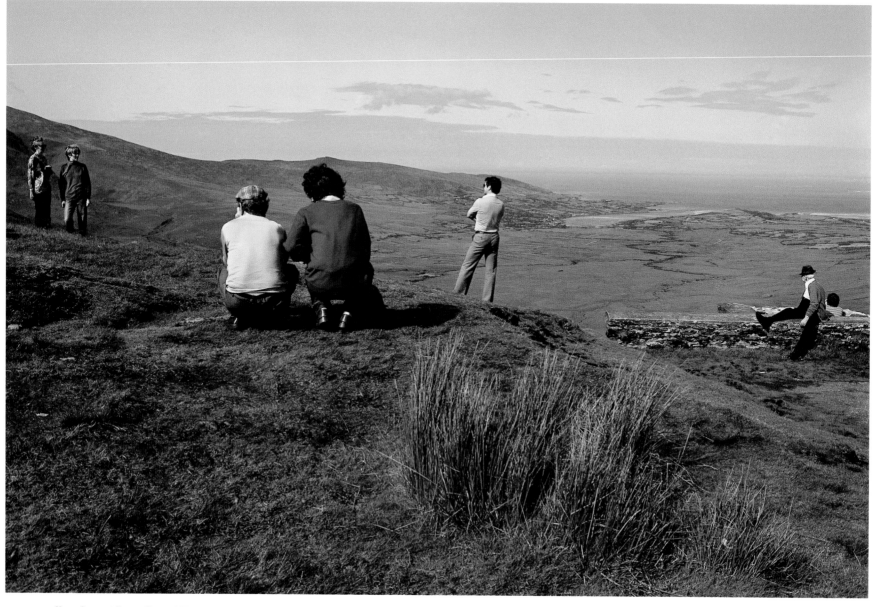

Harry Gruyaert. County Kerry, 1988

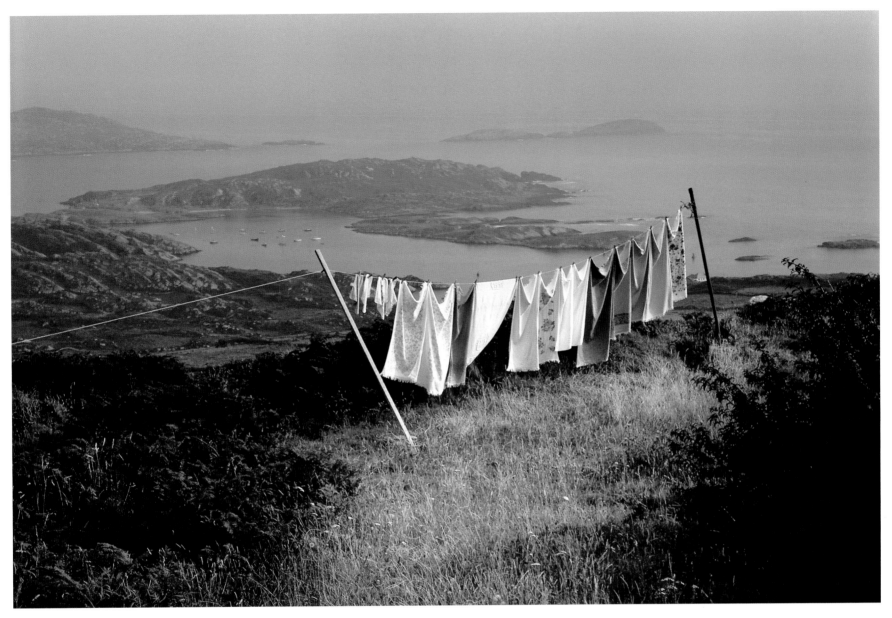

Harry Gruyaert. County Kerry, 1988

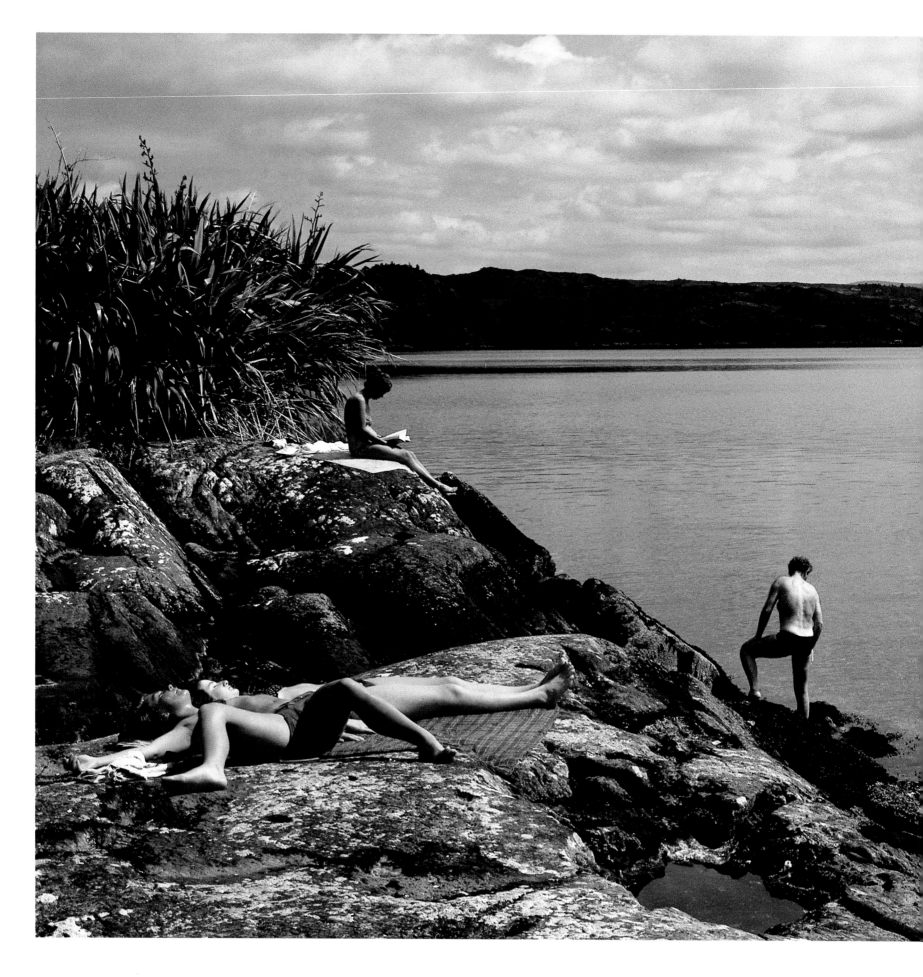

Harry Gruyaert. County Kerry, 1988

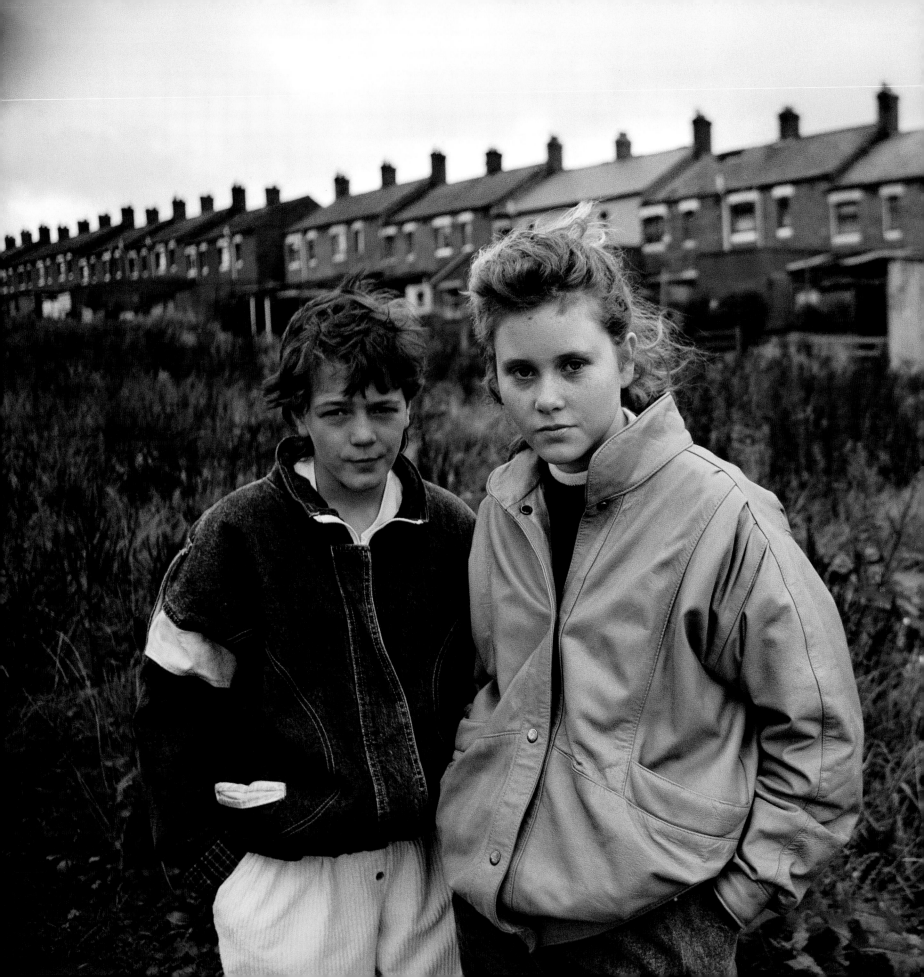

Paul Fusco. Belfast, c. 1980

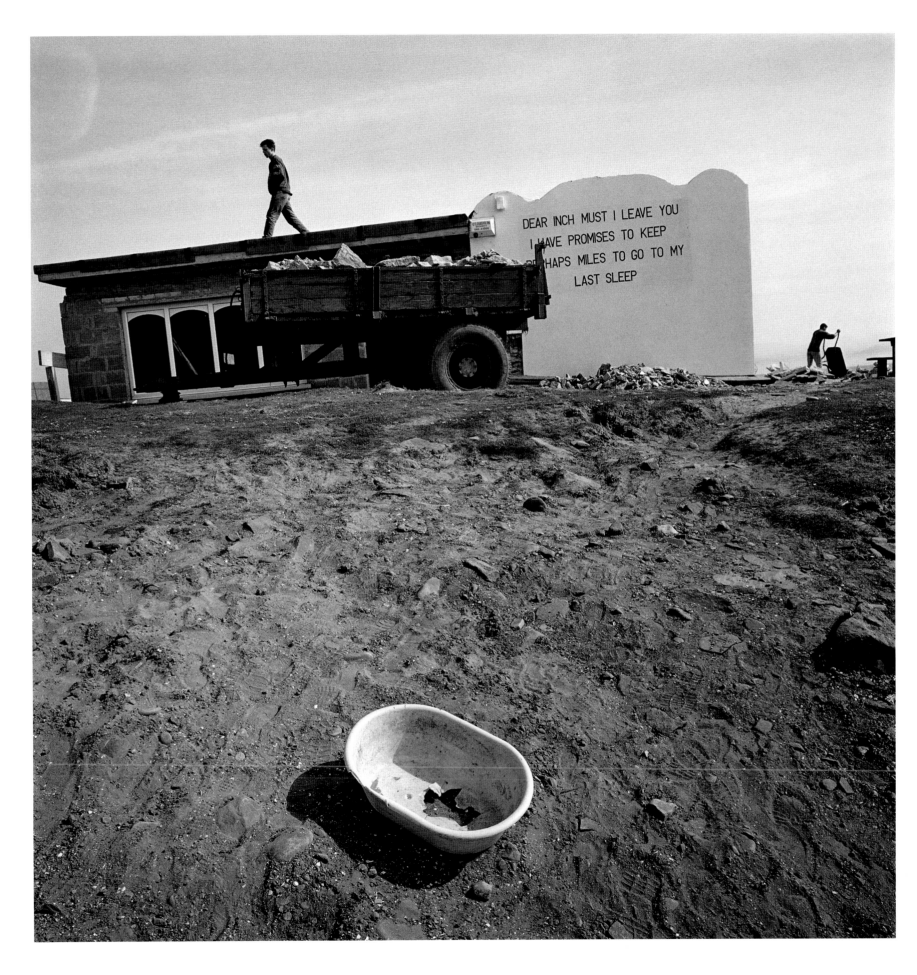

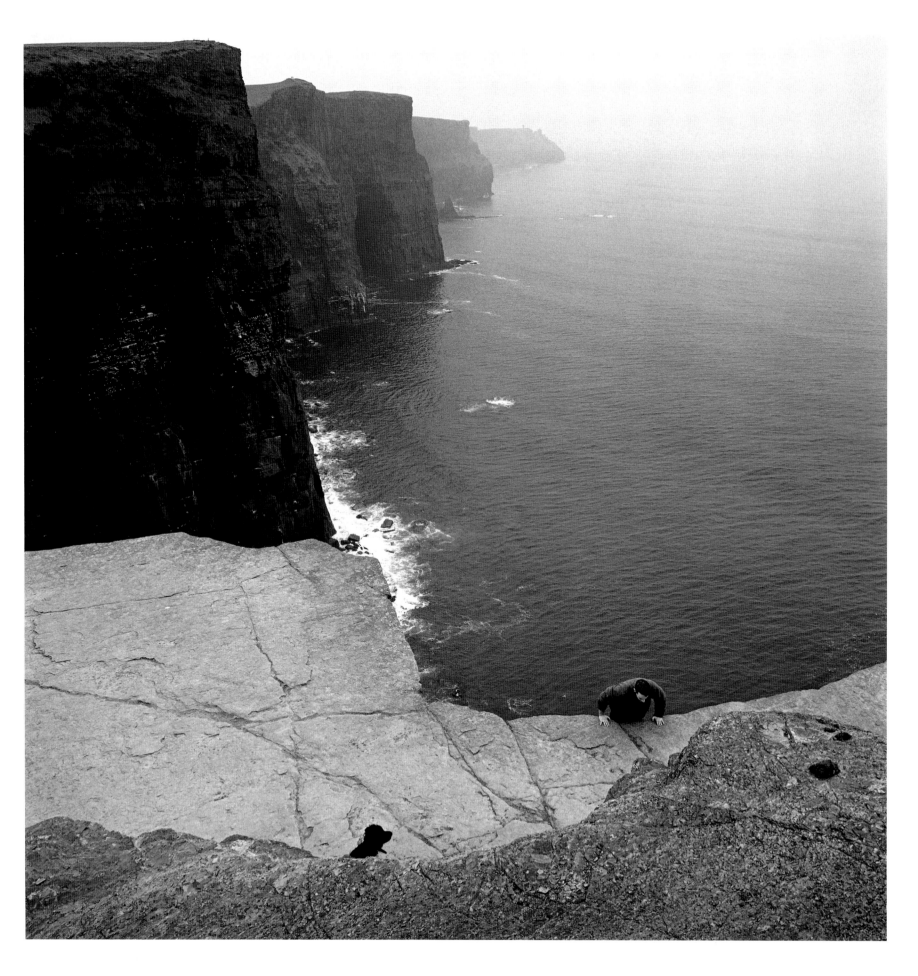

European cities, holidays in the Caribbean, golfing in South Africa, skiing holidays, shopping sprees in New York, mad drinking sprees in Dublin, designer labels, lower taxes, all became central parts of a culture which was once based on ideas of frugality, economic failure, obedience and low expectations.

But it was not clear whether this change in Ireland was serious or subtle. It was not a revolution or a revolt, more a reform. Fianna Fáil, at the end of the 1990s, still held most of the political power in the South; sectarian differences were still active in the North, where fearful inability on both sides to make compromises still impeded progress. The church in the South still owned and ran schools and hospitals. The outward show was all change, but the belief systems remained much the same. Things became more tolerant and open and prosperous in the South in the 1990s, more peaceful and hopeful in the North. The powerful monoliths and large historical problems were still in place by the end of the decade, but the power had been eroded and the problems had become less pressing. By the end of the decade it was, for most of us, an easier place in which to live.

right
Mark Power. Cliffs of Moher. County Clare, 1996

following pages:
left
Mark Power. Inch Strand. County Kerry, 1995

right
Mark Power. Caherdaniel, Shannon. County Kerry, 1995

'90s

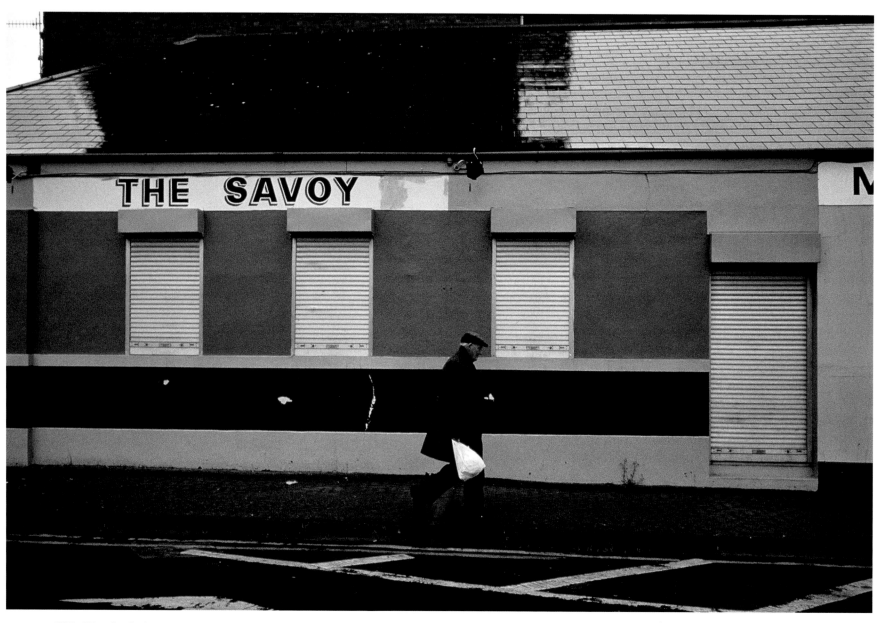

Eli Reed. Derry/Londonderry, 1991

Eli Reed. On an early Friday morning, Derry/Londonderry, 1991

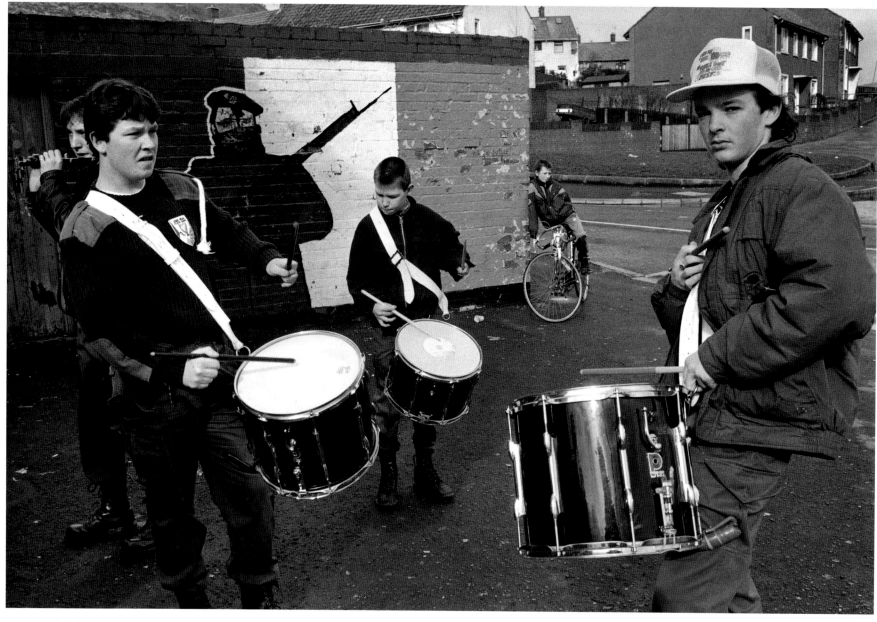

Patrick Zachmann. Ballymurphy, Republican district. Belfast, March 1991

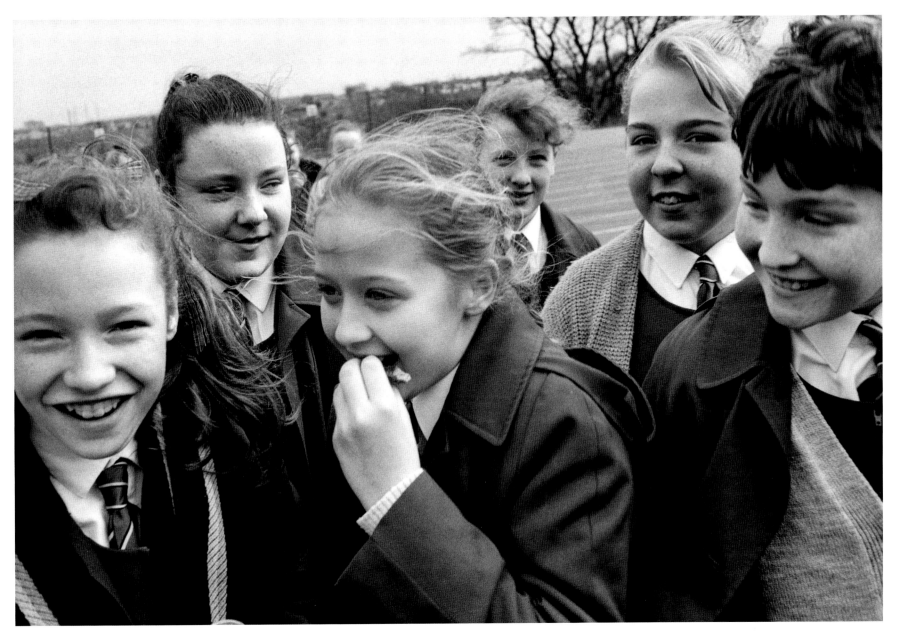

Patrick Zachmann. Thornhill, Catholic school. Derry/Londonderry, 1991

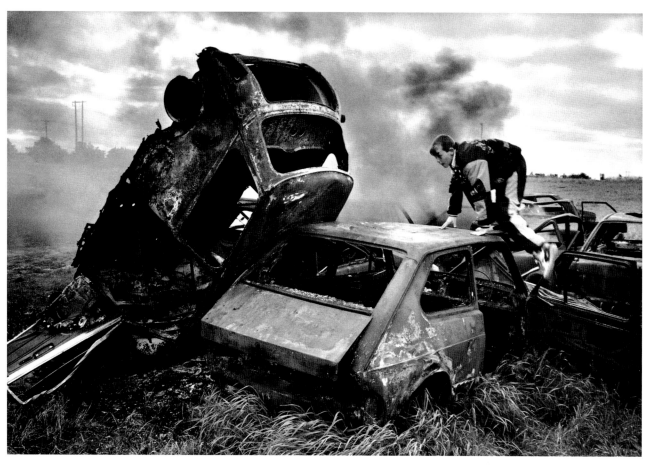

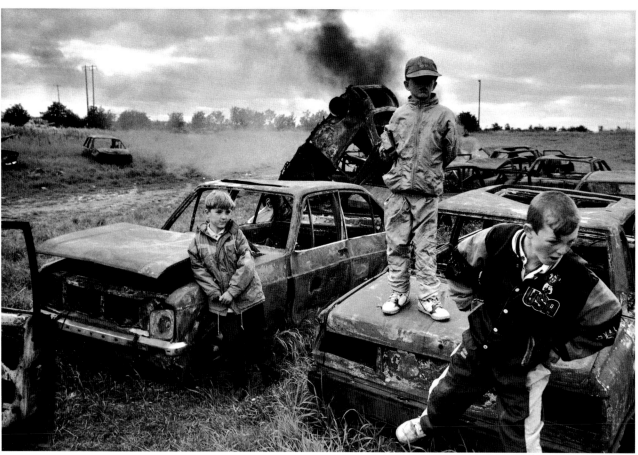

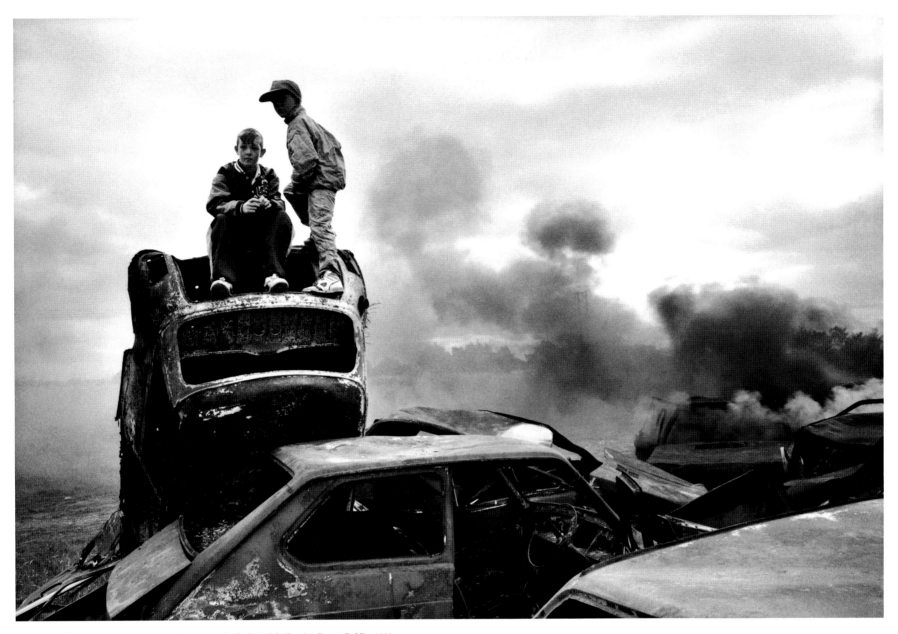

Martine Franck. A cemetery of stolen cars in the Darndale Housing Estate. Dublin, 1993

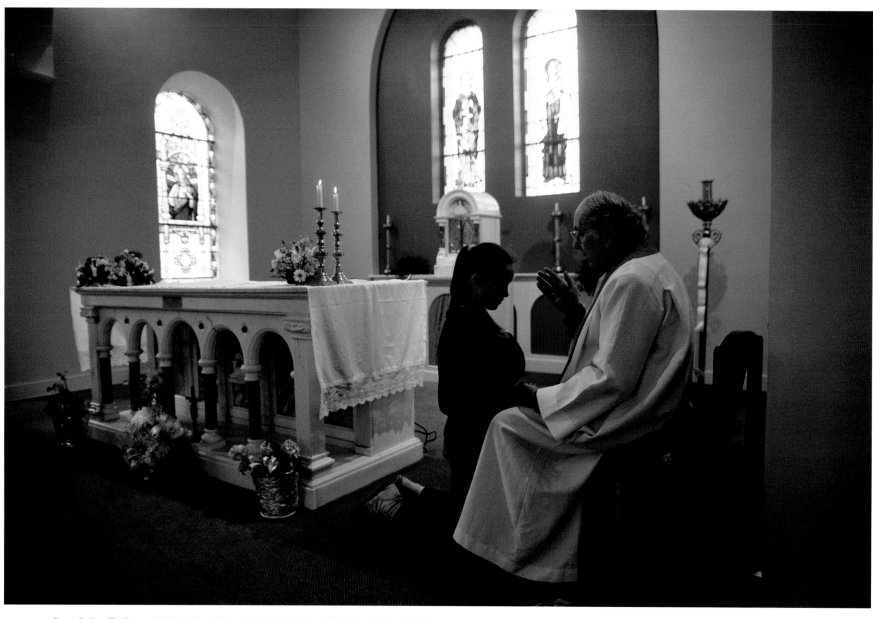

Bruno Barbey. The Reverend Robert E. Lee in his parish church Gill Treasa (Saint Teresa). Ros a' Mhil, County Galway, 1991

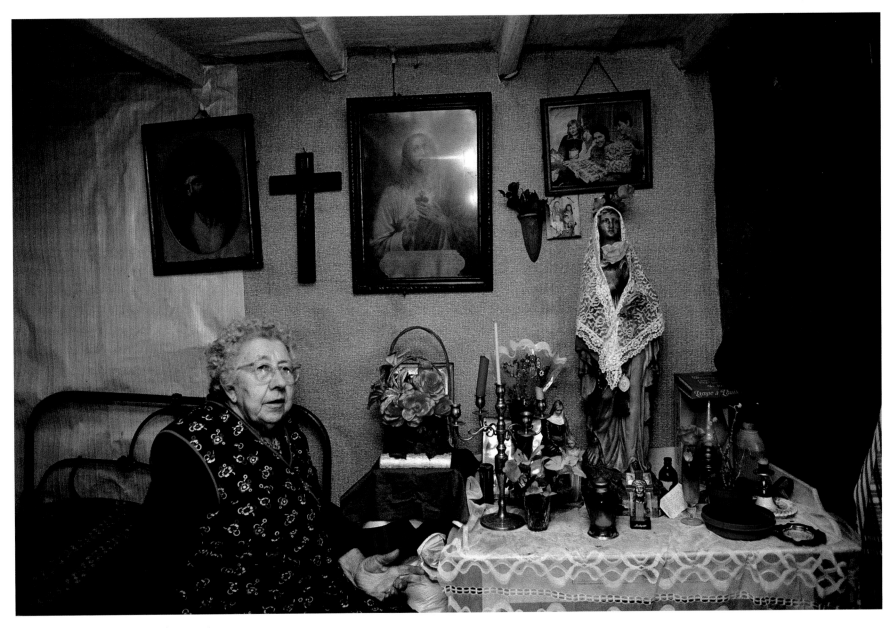

Bruno Barbey. The house of Mary Garrin, 1991

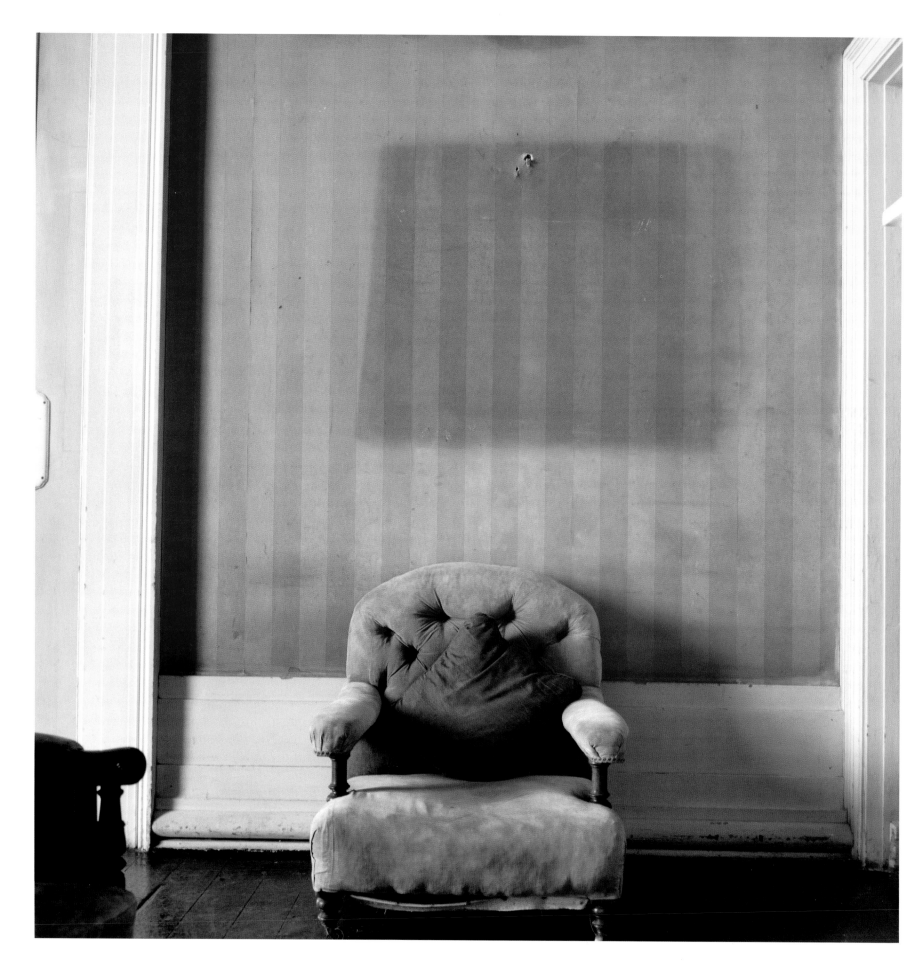

opposite page
Martin Parr. The site of the stolen painting. Lissadell, County Sligo, 1996

this page, top and bottom
Martin Parr. Lissadell, County Sligo, 1996

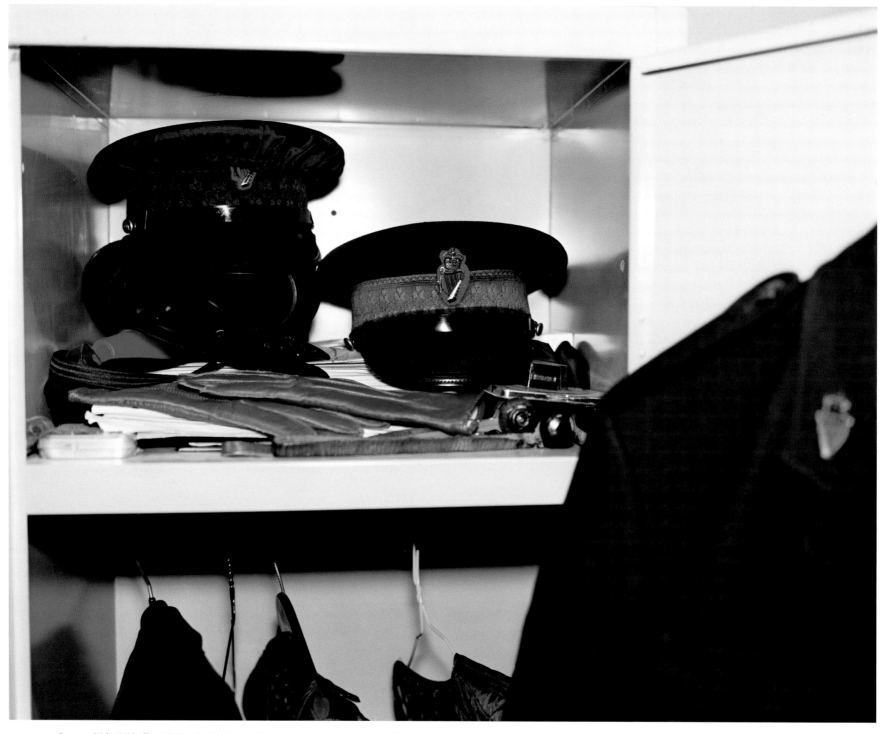

Donovan Wylie. RUC officers' locker. Enniskillen, County Fermanagh, Northern Ireland, 1998

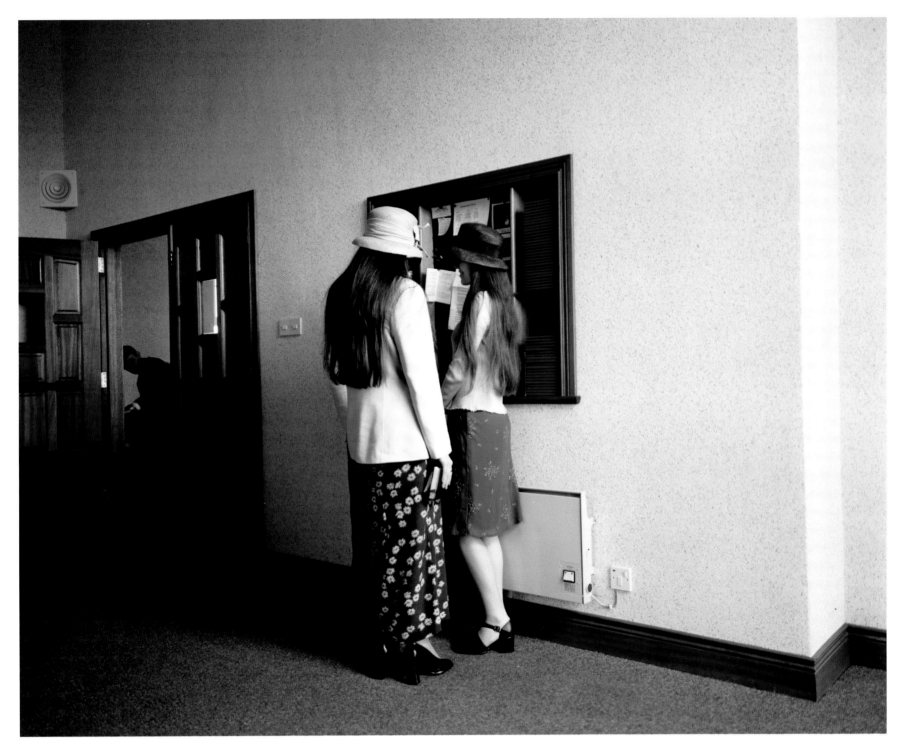

Donovan Wylie. Kingsmill Gospel Hall, Stewartstown, Northern Ireland, 1998

Donovan Wylie. Abandoned home, mid-Ulster, Northern Ireland, 1998

Donovan Wylie. Abandoned home, mid-Ulster, Northern Ireland, 1998

Donovan Wylie. Gospel Scripture, Kilsally, Northern Ireland, 1998

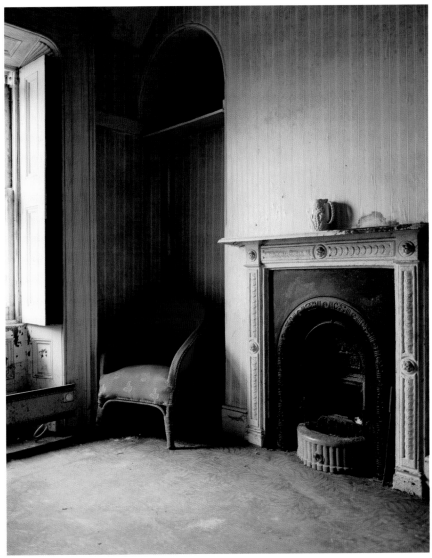

Donovan Wylie. Abandoned home, mid-Ulster, Northern Ireland, 1998

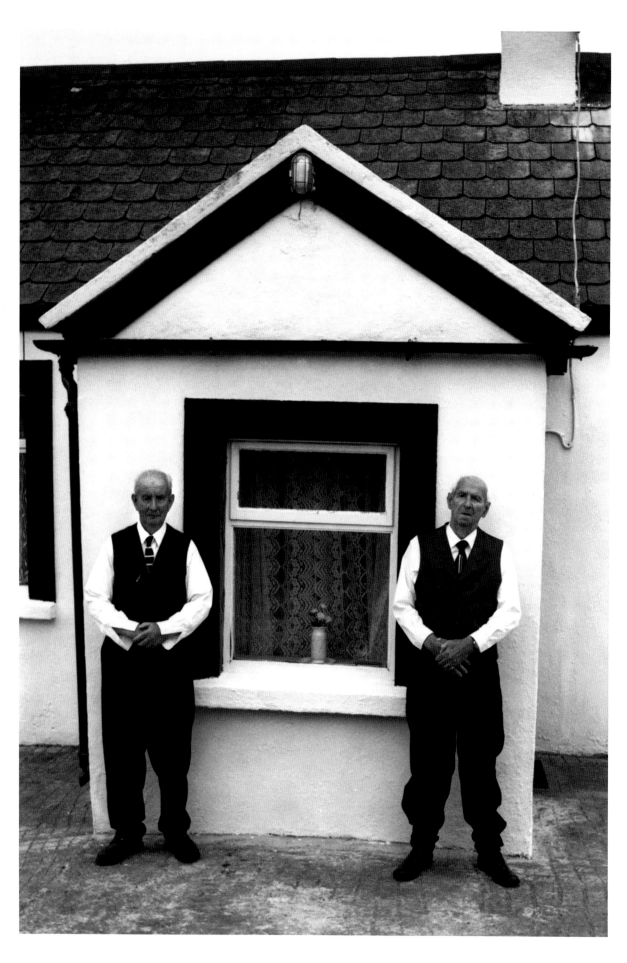

Ferdinando Scianna. John and Joseph O'Toole.
Fashion shoot for Yamamoto. Connemara, 1993

opposite
Ferdinando Scianna. Sharon and Suzanne McNamara.
Connemara, 1993

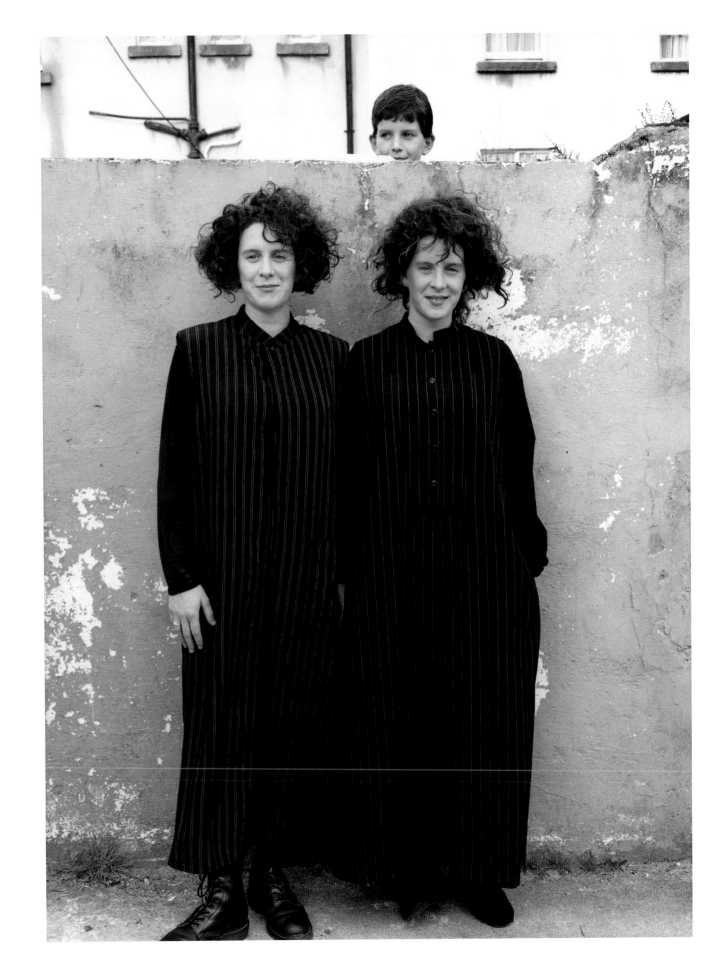

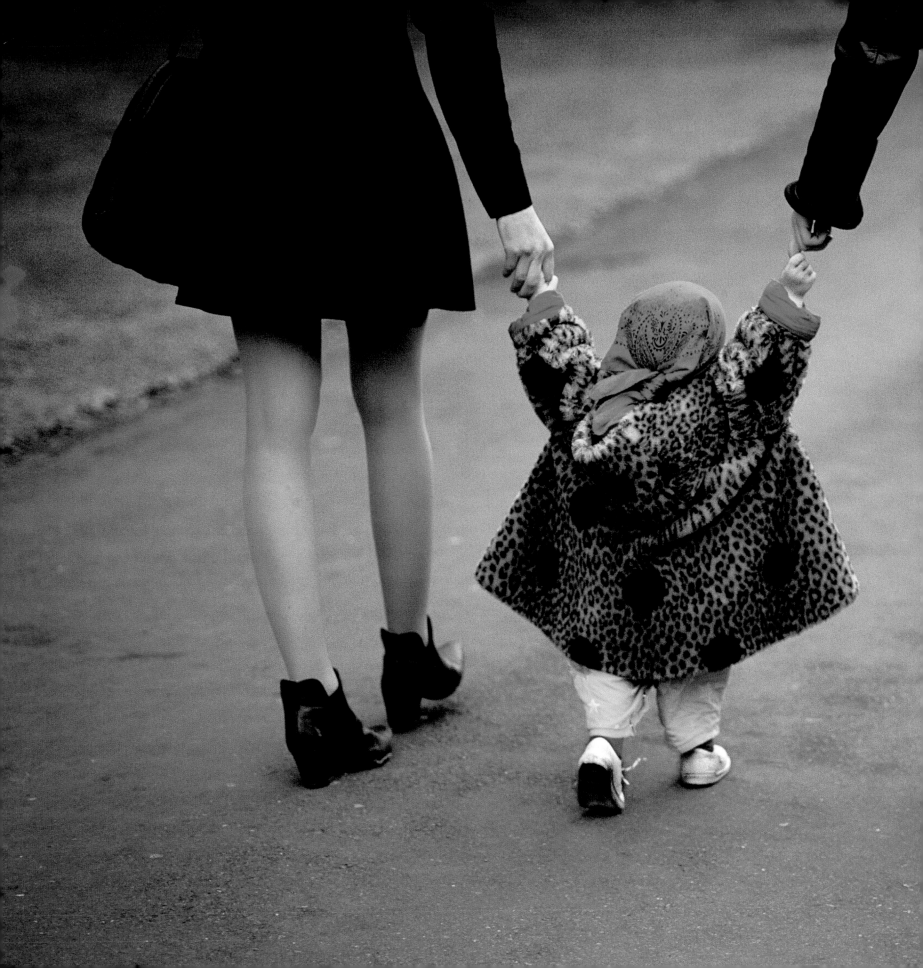

Steve McCurry. Dublin, 1991

'00s

Stuart Franklin

Martine Franck

Carl De Keyzer

Donovan Wylie

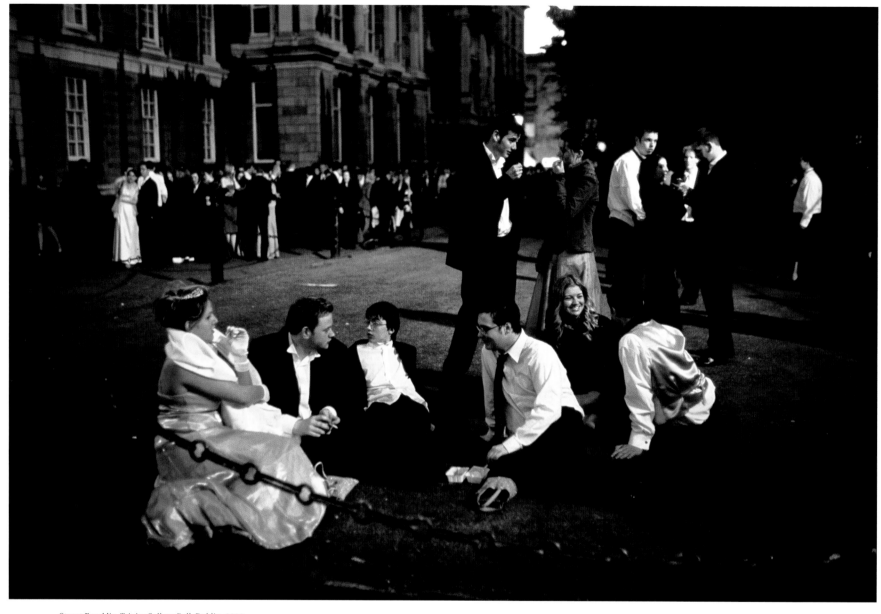

Stuart Franklin. Trinity College Ball, Dublin, 2003

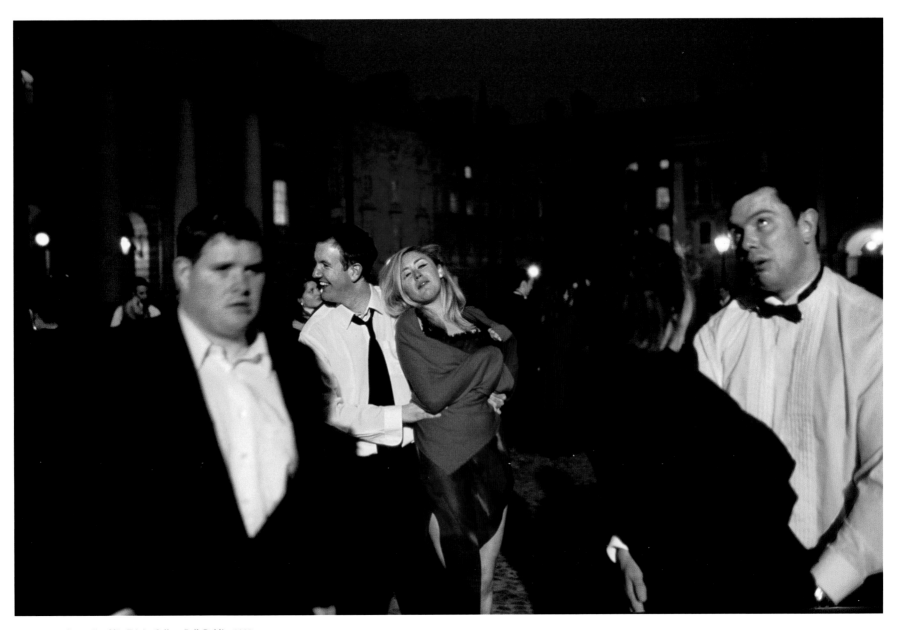

Stuart Franklin. Trinity College Ball, Dublin, 2003

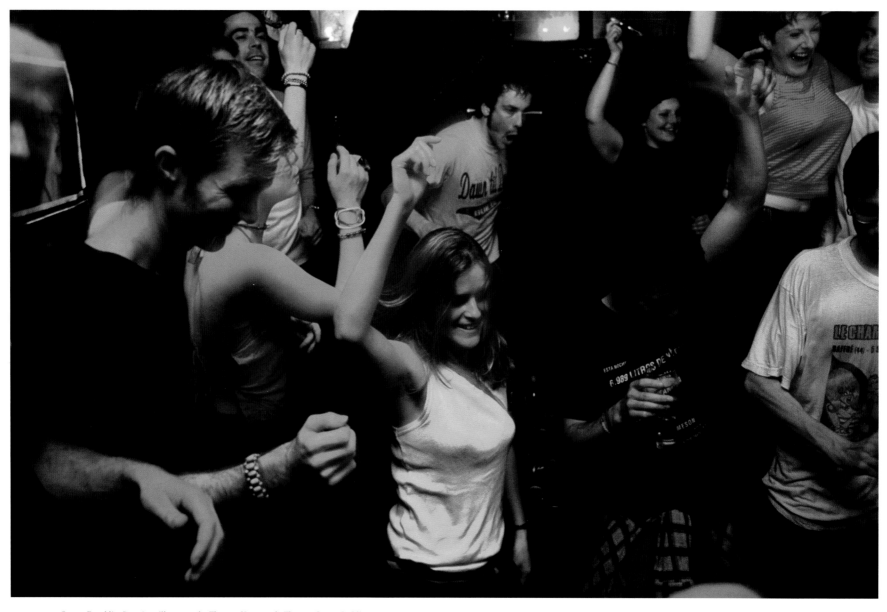

Stuart Franklin. Dancing till 1am at the Thomas House pub, Thomas Street, Dublin, 2003

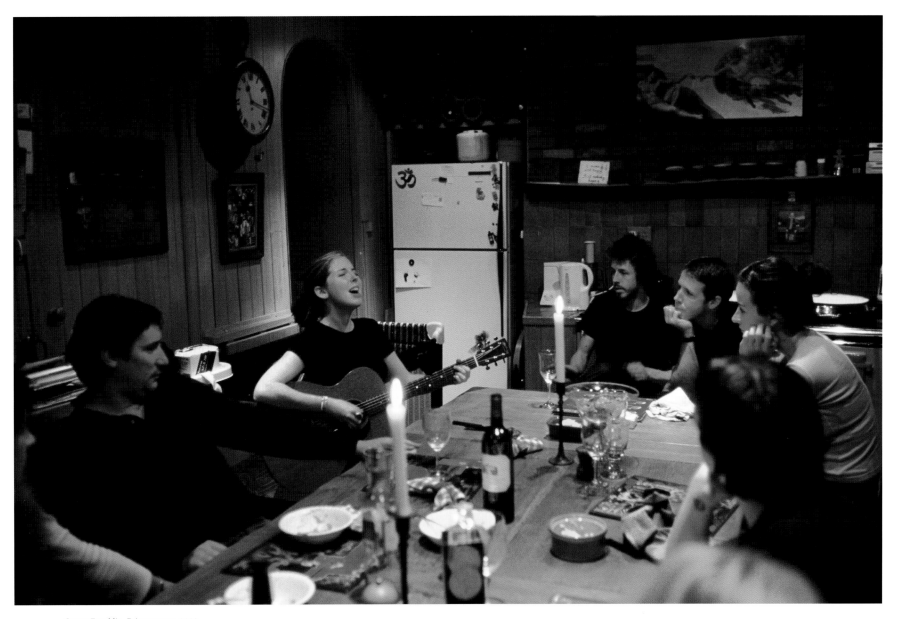

Stuart Franklin. Private party, 2003

Stuart Franklin. Dublin, 2002

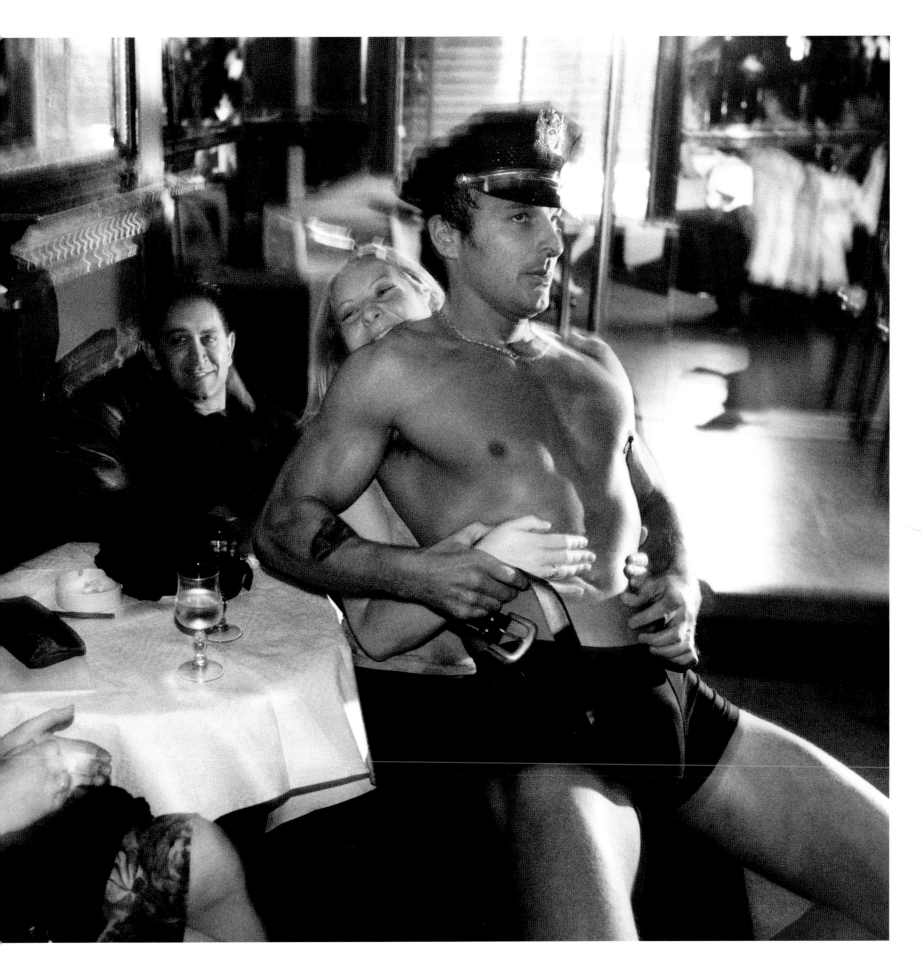

Martine Franck. Summer storm.
Tory Island, County Donegal, 2000

Carl De Keyzer. Kilashee House Hotel. County Kildare, 2005

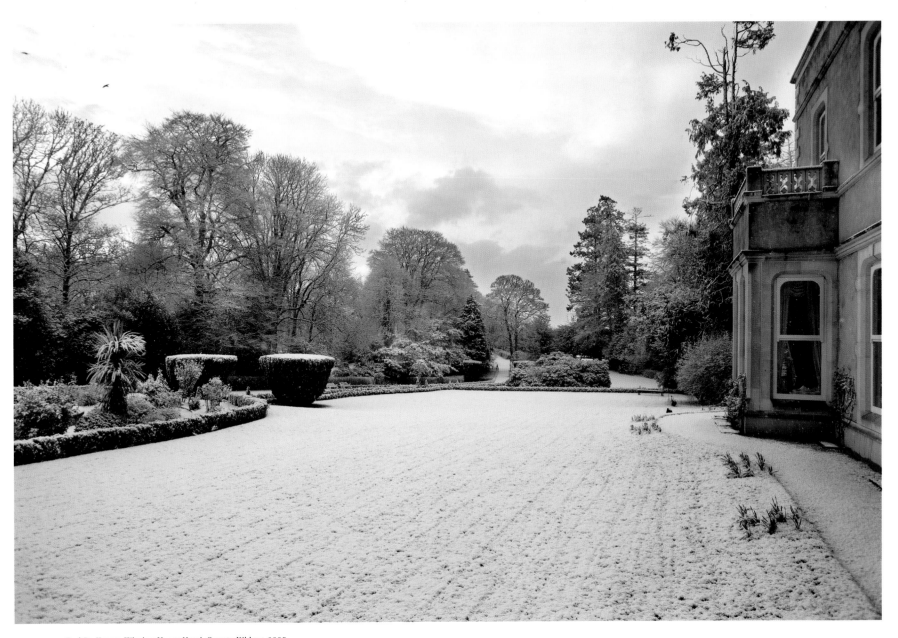

Carl De Keyzer. Kilashee House Hotel. County Kildare, 2005

Carl De Keyzer. Inniskerry. County Wicklow, 2005

top, left and right
Carl De Keyzer. Cherrywood. County Dublin, 2005

bottom, left and right
Carl De Keyzer. Ballymun. Dublin, 2005

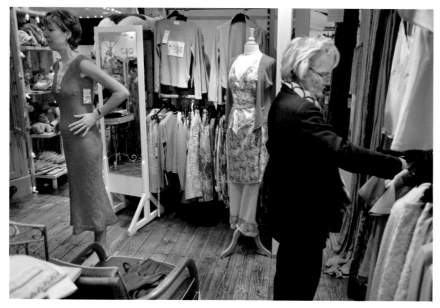

Carl De Keyzer. Avoca Handweavers. Kilmacanogue, County Wicklow, 2005

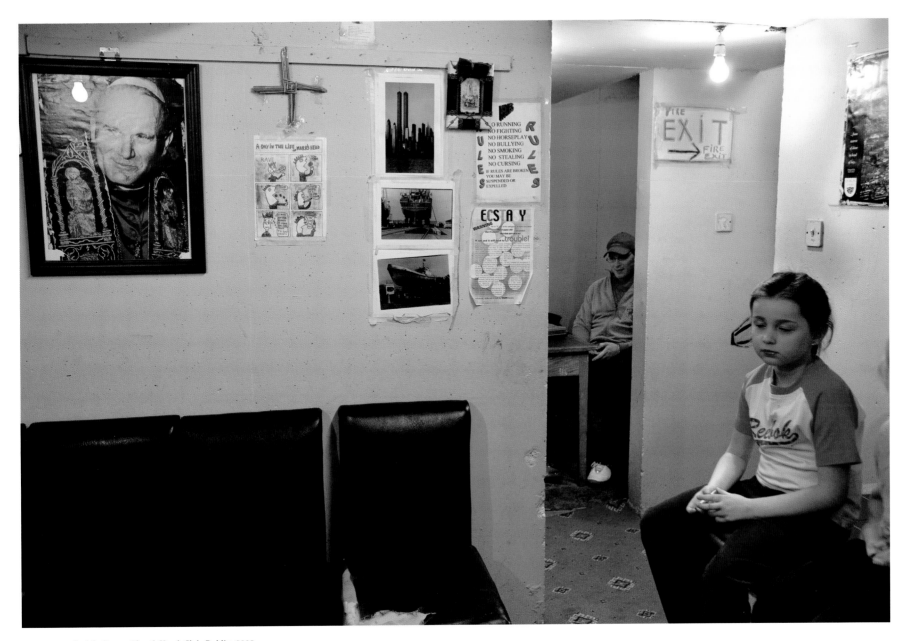

Carl De Keyzer. Plough Youth Club. Dublin, 2005

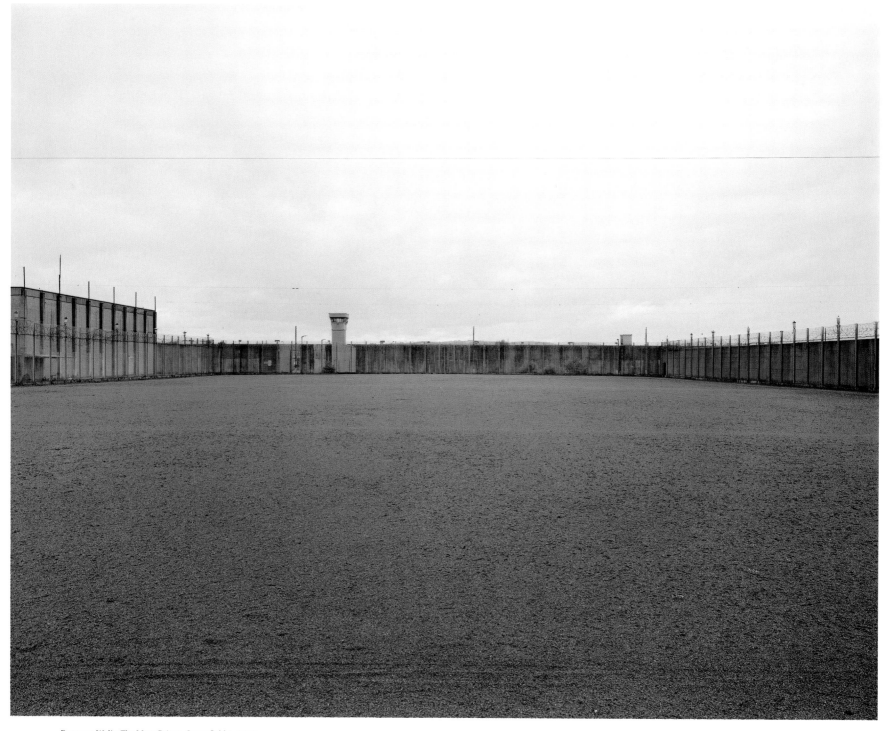

Donovan Wylie. The Maze Prison. Sportsfield 1, 2003

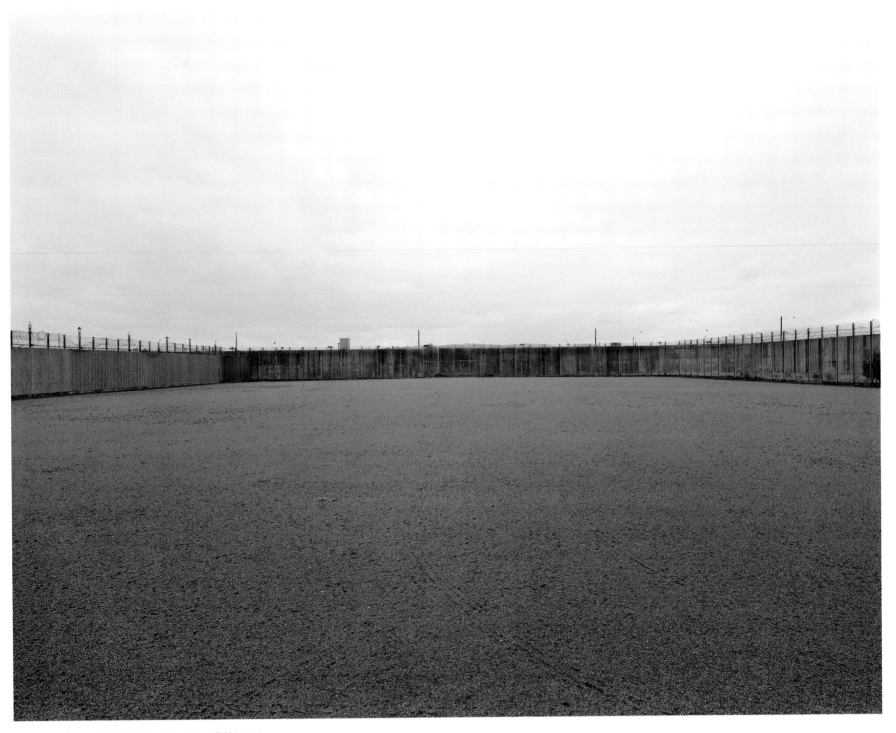

Donovan Wylie. The Maze Prison. Sportsfield 2, 2003

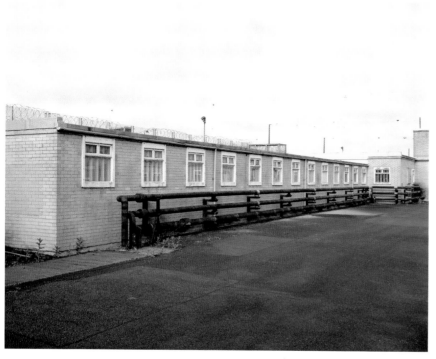

Donovan Wylie. The Maze Prison. H-Block 5, A Wing, 2003

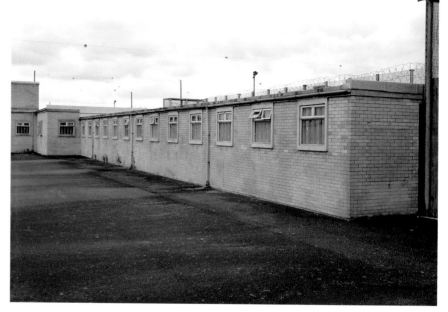

Donovan Wylie. The Maze Prison. H-Block 5, B Wing, 2003

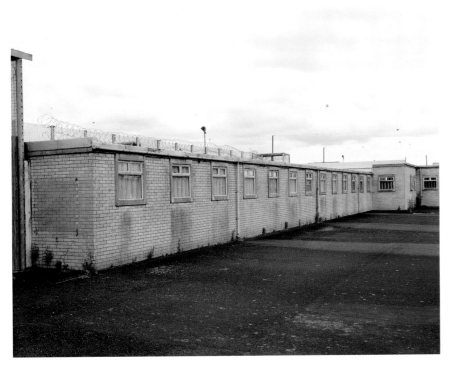

Donovan Wylie. The Maze Prison. H-Block 5, C Wing, 2003

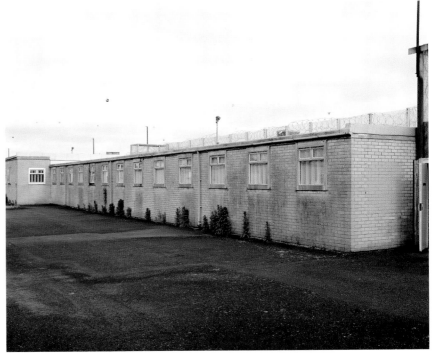

Donovan Wylie. The Maze Prison. H-Block 5, D Wing, 2003

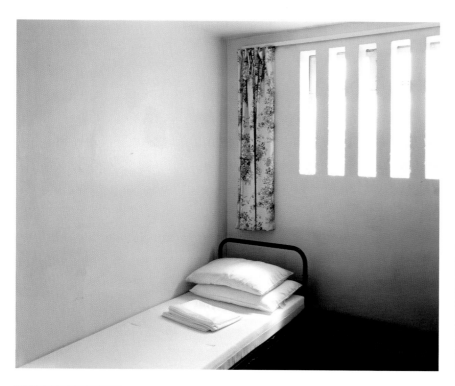

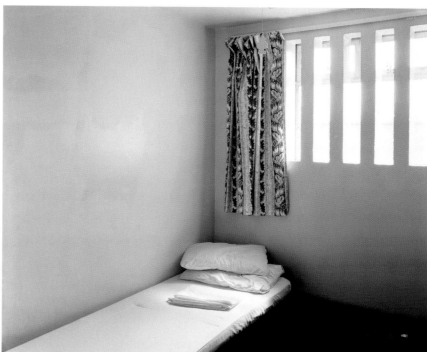

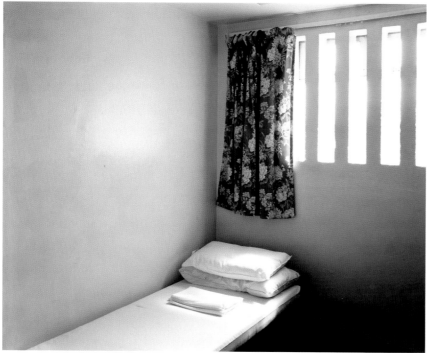

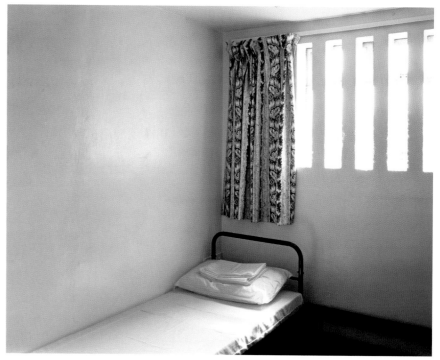

Donovan Wylie. The Maze Prison. Prison cell. H-Block 5, B Wing 2/25, 2003

Donovan Wylie. The Maze Prison. Prison cell. H-Block 5, B Wing 3/25, 2003

Donovan Wylie. The Maze Prison. Prison cell. H-Block 5, B Wing 4/25, 2003

Donovan Wylie. The Maze Prison. Prison cell. H-Block 5, B Wing 5/25, 2003

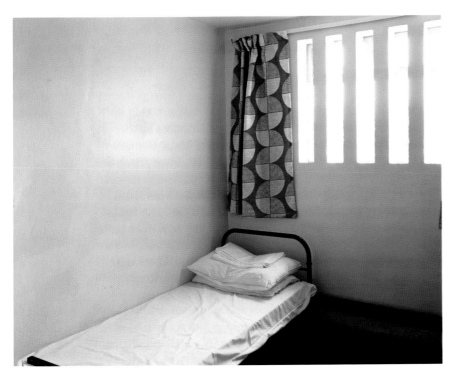

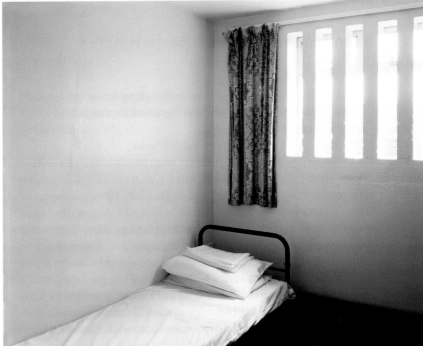

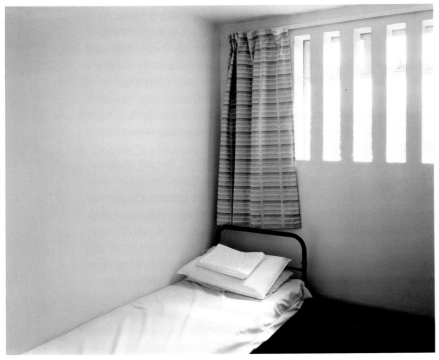

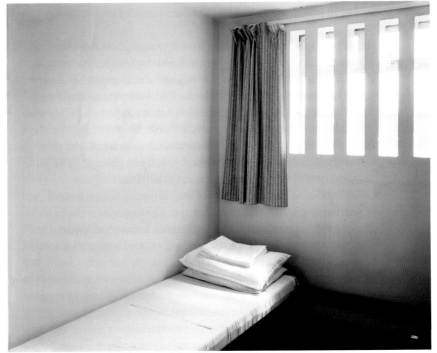

Donovan Wylie. The Maze Prison. Prison cell. H-Block 5, B Wing 6/25, 2003

Donovan Wylie. The Maze Prison. Prison cell. H-Block 5, B Wing 7/25, 2003

Donovan Wylie. The Maze Prison. Prison cell. H-Block 5, B Wing 8/25, 2003

Donovan Wylie. The Maze Prison. Prison cell. H-Block 5, B Wing 9/25, 2003

For many Magnum photojournalists, the editing process which their pictures underwent could also be a re-writing of history. Ian Berry remembers well how selective editing of his work during the 1970s could entirely change its political significance.

When Magnum photographers went to Ireland, they went not as a group, or with a branded identity, but as individuals, with their own very different photographic methodologies. Ian Berry's photojournalism from the North, with its loose, risky construction, is as different as could be from Philip Jones Griffiths' tight densely packed compositions. Elliott Erwitt's Ireland is a very different place to that of Erich Hartmann. Donovan Wylie's photographs, though covering some of the same territory as Martin Parr's, are made from the position of being Irish, of being steeped in the culture and politics that can only be known from growing up in a homeland. Parr was fascinated and amazed by Ireland, by its old fashionedness, by its peculiarities. To Wylie, the layers of politics and history were much more potent.

The new Irish photography establishment is, inevitably, suspicious of the outsider photographer, the visitor, coming for a few days or weeks to record the newsworthy or the exotic. But without this history, of which Magnum photographers are an important part, and this need to challenge it, it is unlikely that there would have been a new Irish photography, that remarkable coming of age, evident in the work of Seawright, Farrell, Haughey and others.

When discussing documentary photography, one hesitates to use the word 'real'. Photographers make fiction just as skilfully as writers do. When the writers in this book remember childhoods and social histories, they edit the past in the same way that photographers edit the present. We viewers bring to photographs our own knowledge of what has occurred since the photographs were taken. In Cartier-Bresson's poetic photographs of clergy in the 1950s, there is no hint of the catastrophe which would overtake the Church, as the scandal of child abuse changed everything in the 1990s. When Erich Hartmann pictured Dublin in the 1960s there was no indication of the coming of the Celtic Tiger, of stag and hen parties from England engulfing these solid streets, of apartment blocks and corporate headquarters. When Inge Morath photographed the shoeless children of rural Ireland in the 1950s, she had no idea that, in 2005, we would see these photographs as icons of a disappeared and tragic past. The Ireland that Michael Mac Liammoir and Edwin Smith so diligently hid from our gaze in the 1960s was found by Magnum photographers. As ragged, as ribald, as moving, as comic and as melancholy as only the best photography can ever be.

Brigitte Lardinois and Val Williams
London 2005

Biographies: photographers

Page numbers on which photographs appear are given after the photographers' names.

ABBAS 4, 91–93
Iranian, b. 1943 Abbas has dedicated his work to the political and social coverage of the developing world. Since 1970, his major work, published in magazines worldwide, includes wars, revolutions and conflict in Biafra, Bangladesh, Northern Ireland, Vietnam, the Middle East, Chile, Cuba and South Africa. From 1978 to 1980, he photographed the revolution in Iran, and then returned in 1997 after a 17-year voluntary exile. From 1983 to 1986, he travelled in Mexico. From 1987 to 1994, from the Xinjiang to Morocco, he photographed the resurgence of Islam. Since 2000 Abbas has been working on photographing the practice and culture of different religions. Abbas has been a member of Magnum Photos since 1981. The picture on p. 92 first appeared in *Newsweek*, 3 April 1972.

EVE ARNOLD 134–35
American, b. 1913 Eve Arnold was born in Philadelphia, Pennsylvania, of immigrant Russian parents. She studied photography with Alexei Brodovitch at New York City's New School for Social Research in 1948. Arnold first became associated with Magnum Photos in 1951, becoming a full member in 1955. She was based in America during the 1950s and came to England in 1962. She received the Lifetime Achievement Award from the American Society of Magazine Photographers in 1980. In 1995 she was made a fellow of the Royal Photographic Society, and was elected 'Master Photographer' – the world's most prestigious photographic honour, awarded by New York's International Center of Photography. In 1996 she was made a member of the Advisory Committee of the National Museum of Photography, Film & Television in Bradford. In 2003, she was appointed honorary OBE (Order of the British Empire).

BRUNO BARBEY 100–3, 212–13
French, b. 1941 Born in Morocco, Bruno Barbey studied photography and graphic arts at the Ecole des Arts et Métiers in Vevey, Switzerland (1959–60). In 1964 Barbey became an associate member of Magnum in 1966, and a full member in 1968. Although Barbey does not consider himself a war photographer, he has covered wars in Nigeria, Vietnam, the Middle East, Bangladesh, Cambodia, Ireland, Iraq and Kuwait. His work has appeared in most major magazines in the world. Barbey is especially known for his free and harmonious use of colour. He has frequently worked in Morocco, the country of his childhood. He has been exhibited internationally and his photographs are in the collections of numerous museums.

IAN BERRY 94–99, 156–59
British Ian Berry made his reputation as a photojournalist reporting from South Africa, where he worked for the *Daily Mail* and later *Drum* magazine. He was the only photographer to document the massacre at Sharpeville. While based in Paris he was invited to join Magnum in 1962 by Henri Cartier-Bresson. He moved to London in 1964 to become the first contract photographer for the *Observer* magazine. He has covered conflict in Israel, Ireland, Vietnam, Czechoslovakia and Congo, famine in Ethiopia and apartheid in South Africa. He has also reported on the political and social transformations in China and the former USSR. Awards include the first ever Nikon Photographer of the Year, Picture of the Year award from the National Press Photographers of America, and British Press Magazine Photographer of the Year. His books include *The English*, and two books on South Africa.

HENRI CARTIER-BRESSON 18–26, 50–61
French, b. 1908, d. 2004 Cartier-Bresson started painting in 1923 and photography in 1931. He was acquainted with many leading members of the French Surrealist movement. He pursued his photographic career in Eastern Europe and Mexico, as well as making films with Jean Renoir. A prisoner of war, he escaped in 1940. He made portraits of artists, including Matisse, Rouault, Braque and Bonnard. In 1945 he photographed and covered the liberation of Paris. In 1947 he founded Magnum Photos with Bill Vandivert, Robert Capa, George Rodger and David Seymour ('Chim'), then spent three years in India, Burma, Pakistan, Indonesia and China.

In 1952 he returned to Europe and in 1954 was the first foreign photographer admitted into the USSR. Best known for his concept of the 'decisive moment' in photography, Cartier-Bresson was the recipient of an extraordinary number of international prizes, awards and honorary doctorates. The Fondation Cartier-Bresson was created in Paris in 2003.

BRUCE DAVIDSON 62–67
American, b. 1933 Bruce Davidson attended the Rochester Institute of Technology and Yale University. During military service in Paris he met Henri Cartier-Bresson. Davidson worked as a freelance photographer for *Life* magazine from 1957 and in 1958 became a member of Magnum Photos. Davidson received a Guggenheim Fellowship in 1962 to photograph the Civil Rights movement. In 1963 the Museum of Modern Art in New York presented his work in a one-man show. In 1966 he was awarded the first grant for photography from the National Endowment for the Arts, and spent two years documenting one block in East Harlem, published in 1970 under the title *East 100th Street* and exhibited that same year at the Museum of Modern Art in New York. The photographs published in this book were taken on his honeymoon.

RAYMOND DEPARDON 90
French, b. 1942 In the 1960s Depardon covered the Algerian War and did his military service as a photographer for the Ministry of Defence. In 1967 Depardon and Gilles Caron founded Gamma. They went on assignments to Africa, Vietnam and Cambodia. In 1969 Depardon made his first film on Jan Pallach and has since directed sixteen films. In 1971 he was imprisoned in Chad with his colleagues Caron, Michel Honorin and Robert Pledge. Following the disappearance of his best friend Caron in Vietnam, Depardon turned away from photojournalism for two years. From 1975 to 1977 Depardon travelled in Chad. He received a Pulitzer Prize in 1977. In 1978 he became a Magnum associate, then a full member in 1979. Depardon has exhibited internationally, and has received numerous awards, including the César Award for Best Documentary and a nomination for an Academy Award.

ELLIOTT ERWITT 50–58
American, b. (Paris) 1928 Born in Paris of Russian parents, Erwitt emigrated to the US with his family in 1939. He studied photography in Los Angeles City College (1942–44) then film at the New School for Social Research (1948–50). After serving as a photographic assistant in the US Army Signal Corps in Germany and in France, Erwitt met Edward Steichen, Robert Capa and Roy Stryker, former head of the fabled Farm Security Administration in 1950, and worked under him for Standard Oil Company. Erwitt became a Magnum associate in 1953 and a full member in 1954. Since the 1970s, he has expanded his activities into feature films, television commercials and documentaries. He has continued to be a prolific photographer and his work has been exhibited in museums and galleries worldwide.

MARTINE FRANCK 210–11, 234–35
b. Belgium Raised in the United States and England, Franck studied at the University of Madrid (1956–57) and at l'Ecole du Louvre in Paris (1958–62). In 1963 she turned to photography, working in China, Japan and India. She became a freelancer for *Life*, *Fortune*, *Sports Illustrated*, *New York Times*, and *Vogue*. Since 1965 she has been a photographer with the cooperative Théâtre du Soleil. In 1970–71 she was a member of the Vu agency in Paris, and in 1972 became oneof the founders of the Viva agency in Paris. In 1980 she became an associate of Magnum Photos, and a full member in 1983. Her work is characterized by warmth and understanding of people, whether photographing young Tibetan spiritual masters, the elderly, the illustrious members of the Collège de France, or the families of Tory Island in County Donegal, Ireland.

STUART FRANKLIN 164–67, 228–33
British, b. 1956 Stuart Franklin graduated in photography and film at West Surrey College of Art and Design and received his PhD in geography at the University of Oxford. During the 1980s Franklin worked as a correspondent for Sygma Agence Presse in Paris before joining Magnum Photos in 1985. Franklin's most well-known photograph is of a man

defying a tank in Tiananmen Square, Beijing, China, 1989, for which he won a World Press award. Franklin was awarded the Tom Hopkinson Award for published photojournalism and the Christian Aid prize for humanitarian photography whilst covering the Sahel famine in 1984–85. Since 1990, Franklin has completed around twenty assignments for *National Geographic Magazine*. This has been work of a social documentary nature that has taken him many times to Central and South America, to China and Southeast Asia, and Europe. Much of his work has been concerned with urbanization and cities.

LEONARD FREED 112–15
American, b. 1929 Born into a working class family of radical Jewish Eastern European immigrants, Freed at first wanted to become a painter. After trips to Europe and North Africa, he returned to the US and in 1954 studied in Alexei Brodovitch's 'design laboratory'. In the 1960s Freed became involved with the American Civil Rights movement. Photography became his way of exploring complex issues such as societal violence, racial discrimination (including a study of the Ku Klux Klan) and police brutality, as well as German society and his own Jewish roots in numerous books and films. He joined Magnum in 1972 and since then has worked on assignment for the international press: *Life*, *Look*, *Paris-Match*, *Die Zeit*, *Der Spiegel*, *Stern*, London *Sunday Times* magazine, *New York Times* magazine, *GEO*, *L'Express*, *Libération*, *Fortune*. He has also shot films for Japanese, Dutch and Belgium television.

PAUL FUSCO 196–97
American, b. 1930 Paul Fusco served as a photographer in the US Army Signal Corps in Korea in 1951–53. He received his BFA from Ohio University in 1957. As well as assignments in the US, he has worked in Russia, the UK, Israel, Egypt, Japan, Southeast Asia, Brazil, Chile, Mexico and an made an extended study of the Iron Curtain from Northern Finland to Iran. Fusco became a Magnum associate in 1973 and a full member in 1974. His photography has been published widely in *Time*, *Life*, *Newsweek*, *New York Times* magazine and others. In the

early 1980s Fusco lived in Mill Valley, California. His most recent work deals with those living with AIDS in California, homelessness and the welfare system in New York, the Zapatista uprising in the Mexican state of Chiapas, and the victims of radiation from the Chernobyl explosion and fallout.

JEAN GAUMY 1
French, b. 1948 Gaumy started his professional career as an editor and photographer in Normandy for a daily newspaper. He then worked with the Gamma agency from 1973 to 1977. His first published documentary was the 1976 *L'hôpital* (The Hospital), a stark statement on the French health system. His 1983 study of French prison life was considered similarly pioneering. In 1977 Gaumy joined Magnum and became a full member in 1986. Since then, Gaumy has expressed himself both through films and photographic reportages made in Europe, the USA, most African countries, the Middle East, Bangladesh, Pakistan, Indonesia and Malaysia.

HARRY GRUYAERT 6, 188–95
Belgian, b. 1941 Harry Gruyaert's work is concerned with the expressive strength of colour, revealing with brilliance its distinctive qualities. For more than twenty years, from Belgium to Morocco, India and Egypt, he has recorded the subtle chromatic vibrations of Eastern and Western light. Born in Antwerp, Gruyaert started as a director of photography for Flemish television. Little by little, photography took over. He has since worked on editorial assignments for *National Geographic*, *GEO*, *Fortune*, *Vogue* and *i-D* among others. Gruyaert won the Kodak prize in 1976. He has been a member of Magnum since 1981.

ERICH HARTMANN 2–3, 68–73
American, b. Germany 1922, d. 1999 Born in Munich, Erich Hartmann emigrated to New York in 1938 with his family. After voluntary military service in Europe (1943–45), Hartmann moved back to New York and learned photography first as the assistant to a portraitist, then more formally at the New School for Social Research (1948–50), with

Charles Leirens, Berenice Abbott and Alexey Brodovitch. Hartmann became known for his poetic approach to industry, science and architecture. First associated with Magnum in 1951, Hartmann became a full member in 1954. From 1969 to 1973, Hartmann devoted much of his time to lecturing and teaching workshops at Syracuse University and the International Fund for Concerned Photography. He received numerous awards including a Photokina Award and Art Director's Club Prize.

THOMAS HOEPKER 132–33
German, b. 1936 Thomas Hoepker studied in Göttingen and Munich from 1956 to 1959, then worked as a photographer for the *Münchner Illustrierte* and *Kristall* (1960–62), joining *Stern* magazine in 1964. Magnum started distributing Hoepker's archives in 1964. He became a freelance photographer in 1968, and in 1972 worked on documentary films for German television, returning to *Stern* in 1973. In 1974 he collaborated with his wife as correspondents for *Stern* in 1976. From 1978 to 1981 Hoepker was director of photography for American *GEO*. From 1987 to 1989 he was art director for *Stern* magazine in Hamburg. He became a member of Magnum in 1989. Hoepker has received numerous awards for his work including the prestigious Kulturpreis of Deutsche Gesellschaft für Photographie in 1968. In October 1999 he received an award from the German ministry of foreign aid, for reporting on third world problems.

DAVID HURN 128–31, 152–55
British, b. 1934 David Hurn has a long-standing, international reputation as one of Britain's leading reportage photographers. Born in England but Welsh by blood, he began photography in 1955 as an assistant at the Reflex Agency. As a freelance photo-grapher he gained his reputation with his international reportage of the Hungarian Revolution. He became an associate member of Magnum in 1965 and a full member in 1967. In 1973, he set up the School of Documentary Photography in Newport, Wales. He has conducted numerous workshops throughout the world. He has received many awards, including the Kodak Photographic Bursary

1975, the USA/UK Bicentennial Fellowship 1979–80, the Imperial War Museum Arts Award 1987–88, and the Bradford Fellowship for 1993–94.

PHILIP JONES GRIFFITHS 74–80, 104–10
British, b. 1936 Born in Rhuddlan, Wales, Jones Griffiths was raised a Welsh speaker. He studied pharmacy in Liverpool and practised in London while photographing part-time for the Manchester *Guardian*. In 1961 he became a full-time freelancer for the London *Observer*. He covered the Algerian War in 1962 then became based in Central Africa, moving from there to Asia. He photographed in Vietnam from 1966 to 1971, resulting in his seminal 1971 book on the war, *Vietnam Inc.* Griffiths began working with Magnum in 1966 and became a member in 1971. In 1973 he covered the Yom Kippur War and then worked in Cambodia (1973–75). In 1977 he was based in Thailand, covering Asia. Griffiths's photographs have appeared in every major magazine in the world, and his assignments have taken him to over 140 countries. He has exhibited widely in the US and Europe, made numerous films for TV and published books including *Agent Orange*, *Viet Nam at Peace* and his retrospective, *Dark Odyssey*.

CARL DE KEYZER 236–41
Belgian, b. 1958 De Keyzer started his career as a freelance photographer in 1982 while supporting himself as an instructor at the Royal Academy of Fine Arts in Ghent (1982–89). He was co-founder and co-director of the XYZ-Photography Gallery. A Magnum nominee in 1990, he became a full member in 1994. De Keyzer, who has been exhibiting his work regularly in European galleries, is the recipient of a large number of awards including the Book Award from the Arles Festival, the W. Eugene Smith Award (1990) and the Kodak Award (1992). The photographs that appear here were taken specially for this project.

JOSEF KOUDELKA 86–89
French, b. Czechoslovakia 1938 Josef Koudelka's detailed study of the gypsies of Slovakia was the subject of an exhibition in

Prague in 1967. In 1968 Koudelka extended his project to gypsy communities in Rumania and that same year recorded the invasion of Prague by Warsaw Pact armies: his dramatic pictures won him the prestigious Robert Capa Gold Medal. In 1970 Koudelka was granted asylum in the UK. He became a Magnum associate in 1971 and a member in 1974, but refused most journalistic assignments: he prefers to wander around Europe in search of pictures of a world that he feels is rapidly disappearing. Koudelka received the Prix Nadar (1978), as well as a Grand Prix National de la Photographie (1989) and a Grand Prix Cartier-Bresson (1991). Koudelka became a French citizen in 1987.

HIROJI KUBOTA 126–27
Japanese, b. 1939 Kubota graduated in Political Science from Waseda University, Tokyo. He moved to New York and then to Chicago and began working as a freelance photographer in 1965. In 1968, Kubota returned to Japan. His work as a photojournalist was recognized by a Publishing Culture Award from Kodansha in 1970. In 1971 he became a Magnum associate. As a photo-reporter in 1975 he witnessed the last few days of Phnom Penh and the fall of Saigon. He worked in North Korea (1978) 13 times and China. By September 1985, Kubota had explored all provinces in China in over 1000 days. The result was the book and exhibition *China* (1985). In 1982 Kubota received the Annual Award from the Photographic Society of Japan, and in 1983 the prestigious Mainichi Art Prize. In 1989 he became a full member of Magnum. Kubota has had solo shows in Tokyo, Osaka, Beijing, New York, Washington, London, Rome, Vienna and Paris, etc.

ERICH LESSING 28–32
Austrian, b. 1923 Erich Lessing emigrated to Palestine and studied at Haifa's Technical College, working on a kibbutz, then as a soldier and taxi driver. During the Second World War Lessing served in the Sixth Airborne Division of the British Army as an aviator and photographer. He returned to Vienna in 1947. He worked as a reporter and photographer for the Associated Press and was invited to join

Magnum by co-founder David Seymour. He became a full member in 1954. He covered political events in North Africa and in Europe for *Life*, *Epoca*, *Picture Post* and *Paris-Match*. From the mid-1950s he established himself as a photographer of fine art. Lessing has received prestigious awards such as the French Prix Nadar. He is a member of UNESCO's International Committee of Museums.

PETER MARLOW 144–47, 186–87
British, b. 1952 Peter Marlow joined the Paris photo agency Sygma in 1976. He has worked for many international publications, including *Arena* magazine, the *Sunday Times* magazine, the *Independent* magazine, the *Telegraph* magazine and *GQ*. As well as documenting political and social conflict in Africa, Kosovo, Ireland and the UK, he has taken arresting images of everyday life, notably in Liverpool and London, as well as Japan, the USA, Ireland, France and Spain. He joined Magnum in 1981 and became a full member in 1986.

STEVE McCURRY 222–23
American, b. 1950 Steve McCurry graduated from Pennsylvania State University. After working at a newspaper for two years, he left for India to freelance. His coverage of rebel-controlled Afghanistan before the Russian invasion won the Robert Capa Gold Medal for Best Photographic Reporting from Abroad. He is the recipient of numerous awards including Magazine Photographer of the Year, awarded in 1984 by the National Press Photographers Association. In the same year he won an unprecedented four first prizes in the World Press Photo Contest. He won the Olivier Rebbot Memorial Award twice. He has been a member of Magnum since 1986. McCurry has covered many areas of international and civil conflict, including the Iran-Iraq war, Beirut, Cambodia, the Philippines, the Gulf War, Yemen, India, Burma and Sri Lanka, and the disintegration of the former Yugoslavia and Afghanistan.

INGE MORATH 34–45
American, b. Austria 1923, d. 2002 Inge Morath worked as a translator, journalist and editor for *Heute*, a US Information Service

Branch publication based in Munich. A friend of photographer Ernst Haas, she was invited to Paris by Robert Capa to join Magnum as an editor. She began photographing in London in 1951, and assisted Henri Cartier-Bresson as a researcher in 1953–54. In 1955, she became a Magnum member. Morath travelled extensively in Europe, North Africa and the Middle East. After her 1962 marriage to playwright Arthur Miller, Morath settled in New York and Connecticut and made her first trip to the USSR in 1965. From 1972, Morath studied Mandarin and obtained a visa to China, making the first of many trips to the People's Republic of China in 1978. She won numerous awards, including being presented with a Doctor Honoris Causa by the University of Connecticut, the Austrian State Prize for Photography, the Gold medal of the National Art Club, and the Medal of Honor in Gold of the City of Vienna.

MARTIN PARR 124–25, 174–85, 214–15
British, b. 1952 Born in Epsom, Surrey, Martin Parr studied photography at Manchester Polytechnic (1970–73) and gained recognition in Europe and abroad in the late 1970s with three successive awards from the Arts Council of Great Britain. Parr lived in the west of Ireland 1980–82 when he produced the photos for his book *On a Fair Day* (1984). To support his career as a freelance photographer, he took on various teaching assignments between 1975 and the early 1990s. Then, after much heated debate because of his provocative photographic style, he became a Magnum member in 1994. His work has been widely exhibited in Europe and the United States and acquired by a large number of public collections. Parr's subject matter – mass tourism, the spiritual crisis of the lower and middle classes, in an environmentally destroyed world – is enlightened by a distinctly British sense of humour. He has shot several film documentaries.

MARK POWER 203–5
British, b. 1959 Mark Power was a member of Network Photographers between 1988 and 2002, when he joined Magnum Photos. His work has been exhibited and published

throughout the world. He is Professor of Photography at the University of Brighton. Awards for his work *The Shipping Forecast* (1992–96) included the Mosaique European Photography Award, the Yann Geffroy International Documentary Prize, and the Special Jury Prize in the Oskar Barnack Award, Germany. *Dome* (1997–2000) documented the construction of the Millennium Dome in London. *The Treasury Project* (2000–2) was made during the refurbishment of the Treasury building on Whitehall, London. More recently he has made an extensive documentary on the launch of the Airbus A380, the biggest aeroplane of its type in the world.

ELI REED 5, 206–7
American, b. 1946 Eli Reed attended the Newark School of Fine and Industrial Arts (1969), and attended the Kennedy School of Government as part of his tenure as a Nieman Fellow at Harvard University (1982–83). He started photography as a freelancer in 1970. In 1983 he joined Magnum and became a full member in 1988. Reed has covered assignments for *National Geographic*, *Life*, *Time*, *Newsweek*, *New York Times*, *People*, *George*, the London *Times*. He has published *Beirut, City of Regrets* (1988) and *Black in America* (1997), a comprehensive study of African-Americans from the 1970s through the end of the 1990s. Reed has received numerous awards including runner-up for the Pulitzer Prize (1981), the Mark Twain Associated Press Award (1981), the Overseas Press Club Award (1983), the Nikon World Understanding Award (1983), the Leica Medal of Excellence (1988), World Press (1988), Kodak's World Image Award for Fine Art Photography (1992) and the W. Eugene Smith Grant in Documentary Photography (1992).

MARC RIBOUD 138–43
French, b. 1923 Marc Riboud was active in the French Resistance from 1943 to 1945. He became a freelance photographer in 1952. He was invited to join Magnum as an associate by Cartier-Bresson and Capa in 1952; in 1955 he became a full member. Riboud made several reportages on North Vietnam and travelled throughout Asia, Africa, the US and Japan.

In 1957 he was one of the first European photographers to go to China; he returned for a lengthy stay in 1965 with writer K. S. Karol. He is best known for his extensive reports on the East. Riboud's photographs have appeared in many magazines, including *Life*, *GEO*, *National Geographic*, *Paris-Match*, *Stern*. He twice won the Overseas Press Club Award (1966 and 1970), and has had major retrospective exhibitions at the Musée d'Art Moderne de la Ville de Paris (1985) and the International Center of Photography, New York (1988 and 1997).

FERDINANDO SCIANNA 220–21
Italian, b. 1946 Ferdinando Scianna spent the first 22 years of his life in Sicily and the island is the subject of several of his books. He studied at the University of Palermo (1961–66). In 1966 Scianna moved to Milan and the following year began working as a staff photographer for the weekly *L'Europeo*. In 1973 he started work as Paris correspondent for *L'Europeo* in 1974, then for *Le Monde Diplomatique* (1976) and *La Quinzaine Littéraire*. Scianna became a Magnum nominee in 1982. The following year he returned to Milan and covered stories in Europe, Africa and the US. In 1989 he became a member of Magnum and has since divided his time between reportage and fashion.

CHRIS STEELE-PERKINS 116–23, 160–63
British, b. 1947 Chris Steele-Perkins moved with his family from Rangoon to London in 1949. He graduated in psychology at the University of Newcastle-upon-Tyne (1967–70) while working as a photographer and picture editor for the student newspaper. In 1971 he moved to London and started working as a freelance photographer. He started his first foreign work in 1973 in Bangladesh followed by work for relief organizations and travel assignments. In 1975 he worked with EXIT, a group dealing with social problems in British cities. He then joined the Paris-based Viva agency in 1976. In 1982, Steele-Perkins became a full member of Magnum and continued working extensively in the Third World. His reportages have received high public acclaim and have won several awards,

including the Tom Hopkinson Prize for British Photojournalism (1988), the Oscar Barnack Prize (1988) and the Robert Capa Gold Medal (1989).

DENNIS STOCK 136–37
American, b. 1928 Dennis Stock won first prize in *Life* magazine's Young Photographers Contest for his picture of the arrival of Eastern Germany refugees in New York's harbour, and became associated with Magnum. Stock met James Dean in Hollywood in 1955 and made memorable portraits of the film star. From 1957 to 1960, Stock made portraits of jazz performers, such as Louis Armstrong, Billie Holiday, Sidney Bechet, Gene Krupa and Duke Ellington. In 1968 Stock created Visual Objectives, a film production company, and he shot several documentaries. In the late 1960s he reported from California. Throughout the 1970s and 1980s, Stock was based in Woodstock, New York, and Provence, France. In the 1990s he went back to his urban origins exploring the modern architecture of large cities. Stock has taught numerous workshops and has exhibited his work in France, Italy, the US and Japan. He has authored 16 photography books, and his photographs have been acquired by most major museum collections.

DONOVAN WYLIE 168–73, 216–19, 242–47
b. N. Ireland, 1971 Donovan Wylie was born in Belfast. Discovering photography at an early age, he began making book dummies of his work after leaving school at sixteen. His first publication was *32 Counties, Photographs of Ireland* (1989). In 1992 he joined Magnum. He made a series of photographs documenting his experiences with a group of itinerant young people in London, resulting in the book *Losing Ground*, 1996. In 1998 he became a full member of Magnum and began nurturing various personal projects which largely dealt with his background in Northern Ireland. Since 2000 Wylie has made various photographic and filmic projects fundamentally looking at post-conflict Northern Ireland. Wylie has cultivated a career in both photography and film, winning a BAFTA in 2001 for best new

director for his Channel 4 film *The Train*. His books include *Losing Ground* and *The Maze*.

PATRICK ZACHMANN 208–9
French, b. 1955 Born near Paris, Zachmann became a freelance photographer in 1976. After producing a reportage on the Naples Mafia, he worked in collaboration with the French Ministry of Culture on a project on highway landscapes (1982–84), while also shooting a personal reportage on young French Arabs in Marseille. From 1979 to 1986 he focused on a personal inquest into his Jewish identity. Still fascinated by the themes of immigration and cultural fragmentation, he embarked on another long-term project (1986–95) on the Chinese diaspora for which he received a Prix Médicis Hors les Murs from the French Ministry for foreign affairs. In 1989, his story on Tiananmen Square, Beijing, was widely published in the international press. Zachmann was a winner of the prestigious French Prix Niepce (1989) and the Art Director Merit Award for his work on prostitution and Aids in Bangkok. He joined Magnum as a nominee in 1985 and became a full member in 1990.

Other contributors

JOHN BANVILLE (b. Ireland 1945) is an award-winning novelist and former literary editor of the Irish Times. His novels include *Long Lankin* (1970), *Nightspawn* (1971), *Birchwood* (1973), *Doctor Copernicus* (1976), *Kepler* (1981), *The Newton Letter* (1982), *Mefisto* (1986), *The Book of Evidence* (1989 – shortlisted for the Booker Prize), *Ghosts* (1993), *Athena* (1995), *The Untouchable* (1998), *Eclipse* (2000), *Shroud* (2002) and *The Sea* (2005). He has also published a play, *The Broken Jug* (1987), which was performed in the Abbey Theatre, Peacock stage, in 1987. He has received many awards, including the Allied Irish Banks Prize, and the Macauley Fellowship (1973), the American-Irish Foundation Literary Award (1976), the James Tait Black Memorial Prize (1976), the Guardian Prize for Fiction (1981), and the Guinness Peat Aviation Award. He lives in Dublin.

ANTHONY CRONIN (b. Ireland 1928) is one of the best-known literary figures in modern Ireland. His many works include novels (*The Life of Riley*, 1964; *Identity Papers*, 1980); poetry (*Poems*, 1958; *Collected Poems, 1950–73*, 1973; *Reductionist Poem*, 1980; *41 Sonnet Poems*, 1982; *RMS Titanic*, 1981; *New and Selected Poems*, 1982; *The End of the Modern World*, 1989; *Relationships*, 1992; *Minotaur*, 1999). His non-fiction includes *Dead as Doornails* (Dublin, Dolmen, 1976); *Heritage Now* (1982); *A Question of Modernity* (1966); *An Irish Eye: Art for the People?* (1985); *No Laughing Matter: The Life and Times of Flann O' Brien* (1989); and *Samuel Beckett: The Last Modernist* (1996). A play, *The Shame of It*, was produced in the Peacock Theatre in 1974. He has been associate editor of *The Bell* and Literary Editor of *Time and Tide*. In 1983 he received the Marten Toonder Award for his contribution to Irish Literature. He is a founding member of Aosdána (an affiliation of creative artists in Ireland), and lives in Dublin.

ANNE ENRIGHT (b. Ireland 1962) has published a collection of stories, *The Portable Virgin* (1991), which won the Rooney Prize that year. Novels include *The Wig My Father Wore* (1995), which was shortlisted for the Irish Times/Aer Lingus Irish Literature Prize; *What Are You Like?* (2000), which won the Royal Society of Authors Encore Prize; and *The Pleasure of Eliza Lynch* (2002). Uncollected short stories have appeared in the *New Yorker*, the *Paris Review* and *Granta*. She was the inaugural winner of the Davy Byrne Award for her short story 'Honey'. Her other work includes a book of essays about motherhood, *Making Babies* (2004).

BRIGITTE LARDINOIS was born in the Netherlands in 1957. She heads the Cultural Department at Magnum Photos, London. From 1986 to 1995 she was exhibition organizer at the Barbican Art Gallery, London, specializing in photography. In 1996 she joined the staff of Magnum where her projects included retrospectives of Eve Arnold (1996) and Martin Parr (2003). She coordinated four major exhibitions in London to celebrate Henri Cartier-Bresson's 90th birthday. Group projects included *Magnum Israel* (1998), *Magna Brava*, the women photographers in Magnum (1999), and Magnum's fiftieth anniversary exhibition, *Our Turning World* (2001).

EAMONN MCCANN (b. 1943) is a journalist and political activist. He was expelled from Queen's University Belfast in 1965 while a student of psychology because of his political activities. He was one of the organizers of the civil rights march in Derry on 5 October 1968, which is often viewed as the start of the Troubles. As a Labour candidate he unsuccessfully contested the Foyle seat for Stormont in 1969 and the Westminster Derry constituency in 1970. He is the author of *War and an Irish Town* and *What Happened in Derry*, about the events on Bloody Sunday.

NUALA O'FAOLAIN grew up in County Dublin, one of nine children. She studied at University College Dublin, Hull and Oxford. She has been a lecturer at University College Dublin, a television producer in the UK and Ireland, and a journalist for, among others, the Irish Times. Her memoir *Are You Somebody?* was an international bestseller. She lives in Ireland and New York.

FINTAN O'TOOLE was born in Dublin in 1958. He has been a columnist and critic with the *Irish Times* since 1988 and was drama critic of the *Daily News* in New York from 1997 until 2001. His books include *A Traitor's Kiss: The Life of Richard Brinsley Sheridan* (1998) and *Shakespeare Is Hard But So Is Life* (2002).

COLM TÓIBÍN (b. Ireland 1955) is a novelist and journalist. Brought up in County Wexford, Colm Tóibín studied History and English at University College Dublin. He moved to Barcelona in 1975, the year of Franco's death. He worked as a journalist and editor before winning an awards for his debut novel, *The South* (1990). The author of historical essays and travel memoirs as well as fiction, his novel *The Master* was nominated for the Man Booker Prize. He has lived in New York, Spain and Ireland.

VAL WILLIAMS is a writer and curator. Recent projects include the Martin Parr Retrospective at the Barbican Art Gallery (2002) and the book *When We Were Young: Derek Ridgers: Street and Club Photographs 1978–1987* (2004). She is Professor of the History and Culture of Photography at the University of the Arts, London, and Director of the UAL Photography and Archive Research Centre, London College of Communication.